KODAK Guide to
35 mm Photography

EASTMAN KODAK COMPANY
ROCHESTER, NEW YORK 14650

D1165959

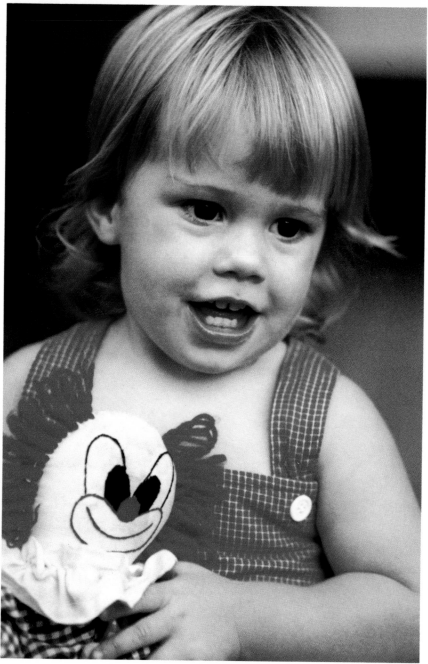

Made on KODACOLOR VR 400 Film.

Norm Kerr

Front cover photograph—made on KODACOLOR VR 1000 Film during inclement weather late in the afternoon.

Marty Czamanske

KODAK Publication No. AC-95
© Eastman Kodak Company, 1980, 1984
Second Edition, 1984 printing
Library of Congress Catalog Card Number 83-083259
ISBN 0-87985-347-6

KODAK
GUIDE TO
35 mm
PHOTOGRAPHY

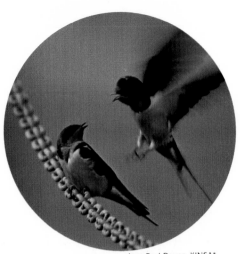

Jean-Paul Doyon, KINSA*

Kodak wants to help you make really good pictures with your 35 mm camera. This book was written with you in mind—whether you're just beginning in 35 mm photography or just beginning to get serious about it. Even if you're an advanced photohobbyist, you can use this book to brush up on the basics.

The book will help you understand and use automatic cameras as well as cameras with manual controls. You'll learn when, where, and how to capitalize on camera features such as fast lenses, interchangeable lenses, a wide range of shutter speeds and lens openings, in-camera rangefinders and exposure meters, and automatic exposure controls. The book presents picture-taking techniques, information on selecting a Kodak film, discussion of outdoor and indoor lighting, guidelines for composition, how-to information for photographing many different kinds of subjects, and hundreds of colorful examples of good pictures, all of which will enlarge the scope of your picture-taking abilities to help you take better pictures.

The results described in this book are possible with 35 mm and other advanced cameras. There are dozens of camera models available today, each of which is unique in some way. So start by studying your instruction manual—with your camera in hand—before reading this book.

Then practice the techniques the book describes one at a time—and take lots of pictures. Study the pictures you take, learn from them, and go on to new techniques. But above all, enjoy your pictures and share them with others. You'll find that photography can be a truly fulfilling hobby.

The Editors

*Courtesy Kodak International
Newspaper Snapshot Awards

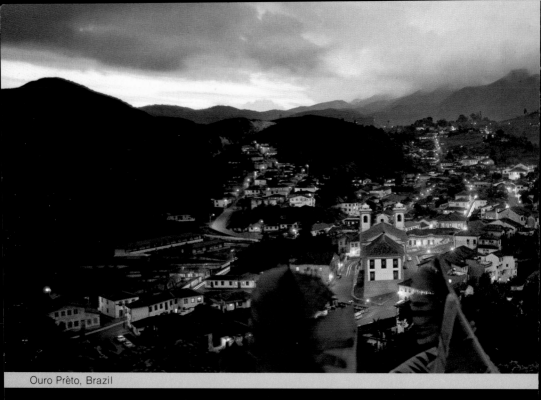

Ouro Prêto, Brazil

CONTENTS

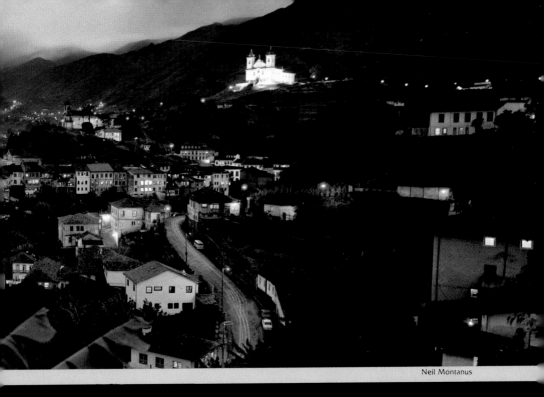

Neil Montanus

Herb Jones

Camera Handling — page 15

Marty Czamanske

KODAK Films
— page 39

Frederic Melnick, KINSA

5

Exposure and Exposure Meters — page 59

Daylight Photography — page 73

Carlos Nesbitt F., KINSA

Flash Photography — page 101

Kent Dannen

Lenses — page 124

Composition — page 151

Robert E. Abernethy, KINSA

Action Pictures — page 192

Bob Clemens

Existing-Light Photography — page 207

Dick Boden

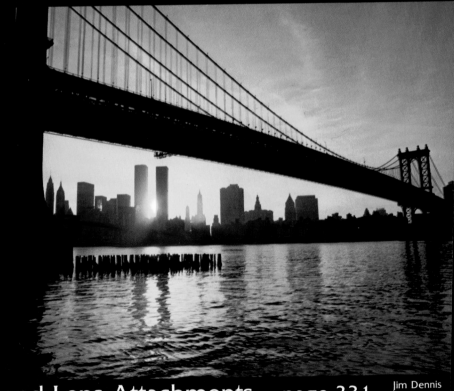

Filters and Lens Attachments — page 231

Jim Dennis

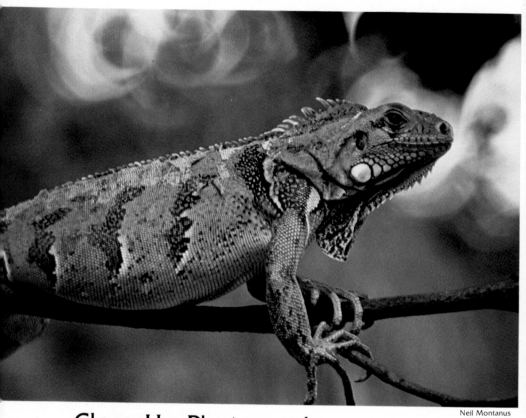

Neil Montanus

Close-Up Photography — page 260

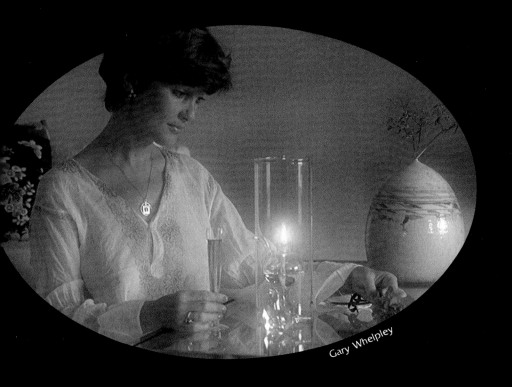

Gary Whelpley

KODAK EKTACHROME 400 Film (Daylight)

Let's begin with the general operation of your camera. Handling your camera with skill and ease may make the difference between getting the picture and being too late or between getting a sharp picture and getting one that's fuzzy. The greatest picture opportunity in the world can go down the drain if a photographer fumbles with the camera, sets the exposure controls improperly, doesn't focus properly, or jiggles the camera as the shutter release is pressed. When handling your camera becomes second nature, the results are consistently better pictures.

A good general rule to follow in handling your camera is not to use force to adjust anything on the camera. Otherwise you could damage your camera or your film. The camera controls should work easily and smoothly.

One of the most important factors in getting sharp, clear pictures is to have a clean camera lens. You've seen what the view is like when you look through a dirty window. Well, your pictures will have a similar hazy, unsharp appearance if you take them through a dirty camera lens. So before you start taking pictures, be sure your camera lens is clean.

If your camera lens needs cleaning, clean the front and back glass surfaces by first carefully blowing away any dust or dirt. Then breathe on the surface of the lens to form a mist and gently wipe the mist away with a soft, clean, lintless cloth or use KODAK Lens Cleaning Paper moistened with KODAK Lens Cleaner.

CAUTION: Do not use solvents or solutions unless they are specifically designed for cleaning camera lenses. Don't use chemically treated tissues intended for eyeglasses.

atrick Walmsley

CAMERA HANDLING

Norm Kerr

To consistently obtain pictures of high quality, you should develop good camera-handling habits. These include keeping your camera lens clean, adjusting your camera for sharp focus, and holding your camera steady.

LOADING
AND UNLOADING
35 mm CAMERAS

In this section we'll provide some general information that applies to most 35 mm cameras. For specific instructions for your particular camera, see your camera manual.

Always load and unload your camera in subdued light—not bright sunlight. (This is especially important for very high-speed films.) If there's no shade around, position your body so it casts a shadow over your camera for loading and unloading. This helps prevent bright light from entering the lip of the 35 mm magazine and causing a streak on the first or second picture. If this happens, the streak is usually orange or clear on color slides or prints but dark on negatives. To avoid streaks, keep the film in its lighttight container before and after exposure.

Loading a 35 mm camera is easy. It takes only a few seconds after you've learned how. However, it is possible to put a 35 mm magazine into the camera the wrong way—there is only one right way. The film slot of the magazine must face the take-up side of the camera; and the light-colored side of the film, the emulsion side, must face the camera lens. Be sure the magazine is correctly seated. When you thread the film onto the take-up spool, make sure you've threaded the film correctly for the direction of rotation of the take-up spool. The take-up spool rotates in one direction in some cameras and in the opposite direction in others, so check your camera manual for proper film threading. When the film is threaded, it should have enough tension to lie flat against the camera. If not, advance the film slowly until the rewind knob starts to turn. See that the film perforations engage the camera sprocket teeth on both sides before you close the camera back.

Jerry Antos

To minimize the chances of bright light fogging the film, always load your camera in subdued light—not in bright sunlight. If it's not convenient to load your camera in the shade, then load the film in the shadow of your body with your back toward the sun.

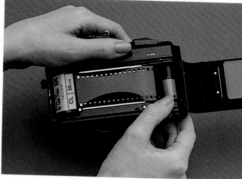

Bob Clemens

When loading your camera, make sure that the film is firmly secured to the take-up spool and that the film perforations engage the camera sprocket teeth on both sides before closing the camera back. For specific loading instructions, see the camera instruction manual.

After you have loaded your camera properly and closed the back, advance the film three exposures so the camera is ready to take the first picture on the third frame. This puts unexposed film in position for the first exposure. If you don't do this, you could make the first exposure on the fogged portion of the film leader and not get the picture. The leading end of the film that you pull out of the magazine for loading before closing the camera back is the fogged portion. If these instructions differ from those in your camera manual, follow the manual.

Film in 35 mm magazines is loaded in lengths for 12, 20, 24, or 36 exposures. (A half-frame camera yields twice as many exposures on the roll.) Extra film is included for a leader at the beginning of the roll and for a trailer at the end. The processing laboratory needs the leader as well as the trailer when processing the film. If you try to squeeze more than 20 exposures (or 12, 24, or 36 depending on the roll) onto a roll of film, the extras may be lost in the processing procedure.

Many cameras have exposure counters that work whether or not the film is advancing. If the film doesn't advance, you could take all your pictures on one frame of film and lose them all. Some cameras have an indicator to tell you if the film is advancing properly. In cameras that don't have such indicators, a loaded camera may appear to be functioning properly. But the film will not advance if it's not loaded correctly, or if it's detached from the take-up spool, or if the sprocket holes are torn. The film may be detached from the take-up spool because the film pulled loose, or the film is broken, or the film was loaded so that neither set of sprocket holes engaged the sprockets for advancing the film.

Here is a way to be sure the film is advancing. Load your camera and then advance the film one exposure after

Bob Clemens

After your camera is loaded, it's easy to forget what kind of film is in the camera and how many exposures are in the film magazine. A good reminder that includes this information is the end flap from the film carton. Some cameras have a holder for the carton flap on the back of the camera. For cameras without a holder, just tape the flap on the camera back or slip it in the camera case if you're using one.

closing the back. Then turn the rewind knob carefully in the direction of the rewind arrow until you feel a slight tension. This takes up the slack in the film so that when you advance the film, you'll see the rewind knob rotate in the direction opposite the arrow. **CAUTION:** Be sure that you never turn the rewind knob the wrong way—opposite to the direction for rewinding—when attempting to take up the slack in the film. This could result in kinking or jamming of the film.

After your camera is loaded, it's easy to forget how many exposures are in the magazine. With a 36-exposure roll, you could waste 16 exposures if you rewind the film after 20 pictures. Also, if you waste film accidentally, you may not have enough when you're ready to take pictures. However, if you *think* you have 36 exposures but actually have 20, you could damage the film by tearing the perforations or you could pull the film loose from the magazine by trying to advance the film. If you pull the film loose you can't rewind it back into the magazine. To avoid confusion, you should have a

reminder of the number of exposures in the film magazine. Both the number of exposures and the film type appear on the end flap of the film box. Tear off the end flap and tape it on your camera or slip it in the camera case along with the film instructions. Then you'll have all the important information at hand. A camera equipped to handle the DX-encoding designations on Kodak films may automatically learn film type, speed, and number of exposures when loaded. The instruction manual will fully explain your camera's automatic capabilities.

Sometimes it's difficult to tell whether a 35 mm camera is loaded with film or not. If the film counter indicates an exposure number, there's probably film in the camera. To make sure, **gently** turn the rewind knob in the direction for rewinding without depressing the rewind button. If you feel resistance to turning the rewind knob, **do not turn it any farther.** Your camera is loaded with film. The film counter in most 35 mm cameras has an S on it that resets when you open the back. If you see the S on the counter, this indicates that the camera back has been opened since the last exposure was made. Therefore, it's safe to open the back again.

With most 35 mm cameras, you must rewind the film from the camera take-up spool back into the original magazine before unloading. If you open the camera back before rewinding the film, the film will be completely exposed, or fogged, as it has no protection from the light. Fogging generally looks like a light, cloudy area covering part or all of a slide or print.

If you can't remember whether you've rewound the film or not, you can check for this before opening the camera back. **Gently** turn the rewind knob in the direction for rewinding without depressing the rewind button as described before. If you feel resist-

ance to turning the rewind knob, the film has not been rewound. If the rewind knob turns freely, the film has been rewound into the magazine providing you have not pulled the film loose from the magazine by forcing the film advance lever at the end of the roll. See the discussion below.

IMPORTANT: When rewinding the film, do *not* turn the rewind knob in the direction *opposite* that of the rewinding arrow. Such action can seriously bend the film and possibly tear it. To prevent torn perforations, keep the rewind button control firmly depressed in the rewind position until you have completely rewound the film. Check your camera manual for specific instructions.

If you don't force the film advance lever, you won't pull the film loose from the magazine which would prevent the normal rewinding of the film back into the magazine, as mentioned before. Pulling the film loose usually results from a photographer's trying to make more exposures than 20 on a 20 exposure roll (or 12, 24, or 36 depending on the roll) at the end of the film. Forcing the film advance lever can also cause overlapping pictures at the end of the roll. If you do pull the film loose from the magazine and open the camera back in the light, you'll fog the film. The solution is to take your camera to your photo dealer and ask to have the film transferred in a darkroom into a KODAK SNAP-CAP 135 Magazine. It is **important** to mark the film type and number of exposures on the magazine so that the processor can identify the film.

What happens if you wind the leader of *unexposed* film back into the magazine? You have not lost the film, because your photo dealer can retrieve the leader. If that's not convenient, here's how you can do it yourself.

NO FILM LEADER???

Each year several thousand magazines of 35 mm film are returned for processing to Kodak and other laboratories by photographers who have accidentally wound **unexposed** film back into the magazine. The most common reason for this happening is improper loading of 35 mm cameras which can cause the film not to advance through the camera as pictures are taken. After the photographer finishes what is thought to be the end of the roll, the film is rewound. Since the film didn't even go through the camera, no exposures were made and all the pictures are lost. Needless to say, this is a big disappointment.

To minimize the chances of winding the film leader into an unexposed magazine, load your camera according to the instructions in your camera manual. Also follow the tips given in this book about determining whether your film is advancing properly. See page 17.

If you discover that you have accidentally wound unexposed film back into the magazine, all is not lost. You can still use the film by retrieving the film leader as demonstrated below.

1. Cut a strip about 1 inch wide and 5 inches long from a material such as sheet film or acetate.

2. Attach about 3 inches of double-coated cellophane tape to one side of the strip, covering one end. Round both corners of this end, which you will insert into the magazine, to reduce the chance of scratching your film.

3. Push 2 to 3 inches of the strip through the lips of the magazine. The sticky side of the strip should face the film core.

4. Pull the strip out gently. Usually the leader will attach itself to the sticky tape. If it doesn't, reinsert the strip. Then rotate the core of the magazine counterclockwise with the long end of the core facing you, and try again by pulling out the strip.

If you accidentally wind the leader of unexposed film into the magazine, you can save the use of the film by retrieving the film leader. To retrieve the leader, insert into the magazine lips an acetate strip with double-sided cellophane tape on one end of the strip. Insert the strip with the sticky side of the tape facing the film core.

After pushing 2 to 3 inches of the strip into the magazine, gently pull out the strip. Usually the film leader will attach itself to the strip. If the leader doesn't come out with the acetate strip, insert the strip and try again. Rotating the film core counterclockwise with the long end of the core facing you will help attach the film to the tape.

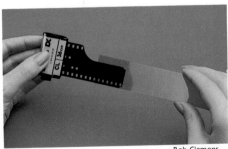

Bob Clemens

It's very important to hold your camera steady in order to obtain sharp pictures. This illustration shows the proper stance—feet somewhat apart, elbows close to your sides, and a firm grip on your camera. For normal- and short-focal-length lenses, it's best to grasp the camera body with both hands with your fingers on the front and thumbs on the back.

It's a good idea to practice your camera-holding technique. You can do this without film in your camera. Tape a small mirror to the front of the camera and shine a flashlight toward the mirror. In a darkened room direct the spot of light from the mirror onto a wall. As you release the shutter, see how steady you can hold your camera so that the spot doesn't move.

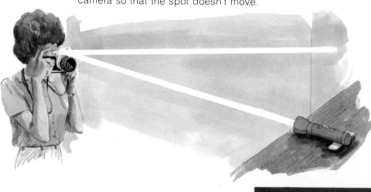

When you're using a long-focal-length lens—telephoto or zoom—it's best to hold your camera by supporting the lens with your left hand close to the front of the camera. Hold the camera body with your right hand so you can actuate the shutter release. Be careful not to move the focus or lens opening settings with your left hand supporting the lens after you have set them. A long-focal-length lens requires that you hold your camera very steady for sharp pictures. Some photographers prefer to also use this method to hold their camera steady with normal- and short-focal-length lenses. Use the camera-holding technique that gives you the steadiest camera with the test shown above and the sharpest pictures.

Brian Stevens

20

CAMERA HOLDING

The way you hold your camera when you release the shutter is important for sharp pictures. Camera jiggle is the most common cause of unsharp pictures—not the obviously blurred pictures, but those lacking the needle sharpness that indicates the touch of a skilled photographer.

The best way for you to hold your camera is the way that's both comfortable and steady. Try to keep your arms against your body—not suspended in air. Plant your feet firmly on the ground, slightly apart. Hold the camera tightly against your face. Take a breath, hold it, and gently squeeze the shutter release. Chances are that you'll make a picture free of camera movement.

Golfers practice their swing. Target shooters practice squeezing the trigger. Photographers can practice their handling techniques with an empty camera. If you want to see how you're doing, try this: Attach a small mirror to the front of your camera as illustrated on the opposite page. Shine a light beam from a projector or flashlight at the mirror. As you squeeze the shutter release, watch the reflected spot of light on a wall about 10 feet away. Practice your shutter-releasing technique until the spot doesn't jiggle.

For extra camera steadiness, brace your elbows on a firm object like a fence, a railing, a car hood, or a large rock.

Jerry Antos

USING THE VIEWFINDER

There are two basic types of viewfinders for 35 mm cameras. One is the direct optical viewfinder, with which you view your subject through a simple window that is separate from the camera lens. Some direct optical viewfinders have a luminous frame which outlines the picture area inside the finder. The direct optical viewfinder is used in cameras commonly called rangefinder—RF—cameras. The second type of viewfinder found on 35 mm cameras is the single-lens reflex viewfinder. When you look through it, you're actually looking at your subject through the picture-taking lens of the camera. Cameras using this kind of viewfinder are known as SLRs— single-lens reflex cameras.

Single-lens reflex cameras have become very popular in recent years. One of the prime reasons is that it's so easy to use interchangeable lenses with them. Since you view your subjects through the taking lens, you can

Rangefinder Camera

There are two types of 35 mm cameras that are widely used by photohobbyists. One type is the rangefinder—RF—camera which has a direct optical viewfinder. The viewfinder is separate from the camera lens. The finder shows approximately the same image as the image that will be on the film. For adjusting the focus, a rangefinder, an easy-to-use focusing scale, or an automatic focusing system is provided. These cameras often have automatic exposure controls. Some models also have manual exposure settings. All of these cameras are commonly called rangefinder cameras even though some of them do not have rangefinders.

Single-Lens Reflex Camera

The other type of 35 mm camera that's widely used is the single-lens reflex—SLR—camera. These cameras have through-the-lens viewing for composing the picture. This kind of viewfinder shows very closely what will appear on the film with various types of camera lenses. Single-lens reflex cameras have in-camera exposure meters and some of them have automatic exposure controls. Manual exposure settings are provided on some models in addition to/or instead of an automatic exposure system.

Note: Shown above are just two of the many models of 35 mm cameras that are available. See your photo dealer or write to the manufacturer or distributor for information about a particular camera.

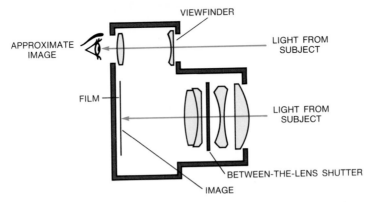

Camera with Direct Optical Viewfinder—This type of viewfinder is used in range-finder cameras.

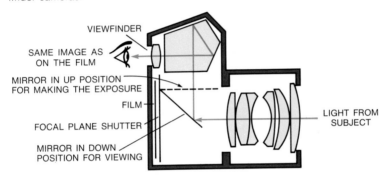

Camera with Single-Lens Reflex Viewfinder—A movable mirror directs the image formed by the camera lens up through a pentaprism in the viewfinder to your eye. When you take the picture, the mirror moves up out of the image path so the image strikes the film. After the exposure is made, the mirror moves back into position in front of the film for viewing.

change from one lens to another and immediately see in the viewfinder the image that will be recorded on your film. This also means that you'll see in the viewfinder some of the perspective changes we mention in the section on lenses. A direct optical viewfinder can be made to show approximately what will be included in the picture with various lenses. But it's more difficult to appraise the effect of the lenses on perspective.

Another plus factor of a single-lens reflex camera is that it's free of parallax—the difference between what the lens sees and what you see through a direct optical viewfinder, especially evident at close distances. We'll talk

more about this in the section on close-up photography on page 268.

No matter what kind of viewfinding system you use, learn to use it with ease and with discernment. Before you shoot, look behind your subject to be sure you haven't included a distracting object. When possible, move around your subject to choose the best viewpoint. Although this may be like saying fire is hot, we can't overemphasize that your final picture will include everything that lies within the boundaries of your viewfinder. So before you snap the shutter, make sure you see in the viewfinder what you want to see in the resulting picture.

FOCUSING

The ability to focus your camera quickly and accurately comes in very handy when sudden or unexpected picture opportunities arise. Some aids to accurate focusing are split-image or coincidence rangefinders and microprism or ground-glass focusing. With split-image and coincidence rangefinders, you look through the viewfinder at your subject and turn the focusing ring on your camera lens until the two images in the viewfinder line up. When

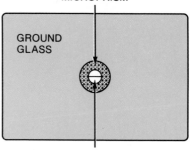

MICROPRISM

GROUND GLASS

SPLIT-IMAGE RANGEFINDER

Typical viewfinder in a single-lens reflex camera that has three focusing aids.

Out of focus	In focus

Split-image rangefinder

Coincidence rangefinder

Microprism focusing aid

Ground-glass image

J. A. Schneider

the images are lined up, you've focused for the correct camera-to-subject distance. If your camera has a microprism area and/or a ground glass for focusing, you just turn the focusing ring until the subject looks sharp in the viewfinder. Then you've focused for the correct camera-to-subject distance.

Some SLR cameras have more than one focusing aid in the viewfinder. A camera may have a split-image rangefinder, a microprism collar, and a ground glass, for example. An area in the center of the viewfinder is a split-image rangefinder surrounded by a microprism collar, and the rest of the viewfinder is used for ground-glass focusing. This lets you choose the type of focusing that you personally prefer or the one that is easier to use with a particular type of subject. For instance, you may prefer split-image focusing when you're photographing a building because there are straight lines to focus on. But if you're taking a picture of a crowd of people where prominent lines are hard to find, the microprism and ground-glass systems of focusing are easier and faster. In addition, microprism focusing is usually faster than ground-glass focusing. But the ground glass offers the advantage of showing you what part of the picture is in the plane of sharpest focus relative to other parts of the picture. The ground glass also lets you preview depth of

field if your camera has the feature that permits this. See page 35.

Practice focusing your camera until you do it so naturally that you don't have to give it a second thought. Also, develop the ability to focus with no more than two motions—one on either side of right on the button—so you don't waste time and possibly miss an opportunity for the best moment to take the picture.

Cameras with Automatic Focus. The 35 mm cameras that have this kind of focusing are equipped with direct optical viewfinders. The viewfinder has an area in the center that shows what part of the scene the camera will focus on. This focus area in the viewfinder is indicated by a small rectangle or oval. To get sharp pictures, aim your camera so that the main subject, such as a person, is centered in the viewfinder focus area. The camera will then focus automatically as you take the picture. Keep your fingers from covering the rangefinder windows on the front of the camera so that the focus is not adversely affected.

Many automatic focusing cameras have a focus lock so that you can let the camera focus on the main subject centered in the viewfinder focus area

and then you can lock the focus. This lets you recompose the scene for better composition with the subject framed off center in the viewfinder for taking the picture. In order for this technique to work, the camera-to-subject distance must not change. The distance the camera focuses on is usually indicated by symbols in the viewfinder or on the camera, such as mountains for distant scenes, full length figures of people for medium distances, and head and shoulders of a person for close-ups.

One precaution with an autofocus camera is not to photograph your subject through a fence or with other objects in front of the subject, like foliage, because the camera would focus on these objects if they are included in the focus area of the viewfinder. This would cause the near objects to be in sharp focus and the main subject to be out of focus, or fuzzy. The focusing system in the camera must have a clear view of the subject to focus properly. So take the picture with your subject in a different location without objects in front of the subject near the camera-to-subject axis. Also, some of these cameras may not focus correctly in low light or darkness. See your camera manual.

Caroline Grimes

An autofocus camera will focus properly on the subject when you aim the camera so that the subject is positioned in the indicated focus area in the center of the viewfinder.

If you frame the scene so that the subject is off-center for better composition, an autofocus camera will focus on whatever detail is in the center of the viewfinder—the background in this picture which will be sharp—but the subject will be fuzzy. Many autofocus cameras have a focus lock so you can prevent this kind of focus error. See the text above.

EXPOSURE CONTROLS

There are two primary exposure settings on adjustable cameras that control the amount of light that reaches the film and exposes it—shutter speed and lens opening. Setting these two variables correctly lets you take properly exposed pictures. Automatic cameras adjust the shutter speed or the lens opening or both automatically, and cameras equipped to handle film with DX-encoding designations even set themselves for the speed of the film you're using. For more on automatic cameras, see Film Speed on page 39 and Exposure and Exposure Meters on page 59.

The shutter speed controls the *length of time* the film is exposed to light. Shutter speeds are marked on the camera with the numbers 1, 2, 4, 8, 15, 30, 60, 125, 250, 500, and 1000. Your camera may not have all of these speeds. These numbers represent fractions of a second (except 1 second) and mean 1/2, 1/4, 1/8, 1/15, 1/30, 1/60, 1/125, 1/250, 1/500, and 1/1000 second. The B setting means the shutter will stay open as long as you press the shutter release. You use this shutter-speed setting for time exposures.

Changing from one shutter speed to a speed that is twice as fast, for example 60 to 125—1/60 to 1/125 second, allows the light to strike the film for 1/2 as long; therefore 1/2 as much light reaches the film. Changing to a shutter speed that holds the shutter open twice as long, for example 60 to 30—1/60 to 1/30 second, lets twice as much light strike the film.

The *size* of the lens opening on your camera is the other factor that controls the amount of light that reaches the film. The different sizes of lens openings are indicated by f-numbers. These numbers form a series, such as 1.4, 2, 2.8, 4, 5.6, 8, 11, 16, and 22, marked on the camera lens mount. The smallest f-number on a lens refers to the biggest lens opening. The largest f-number is the smallest lens opening.

When you change from one lens opening to the next nearest number, you're adjusting the lens by 1 stop. If you move the setting from one lens opening to the next larger one, for example f/11 to f/8, the size, or area, of the opening is doubled, so you expose the film to twice as much light. Changing from one lens opening to the next

The lens openings on cameras are indicated by f-numbers. The larger the f-number, the smaller the lens opening. Each smaller (size) lens opening marked on the lens opening scale lets in one-half the amount of light as the preceding opening. If you change from a small lens opening to the next larger one, the lens will let in twice as much light. On some camera lenses, the maximum lens opening may not let in twice as much light as the next smaller opening. You can also set the lens opening between the marked settings on the lens for finer changes in exposure. The illustrations below the picture show how the lens opening varies with the f-number setting. See the pictures on pages 72 and 114 which show how changing the lens opening changes exposure.

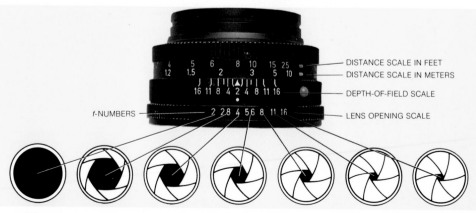

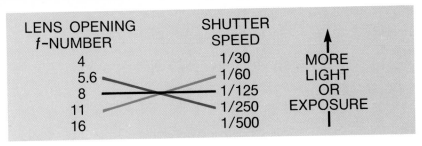

LENS OPENING f-NUMBER	SHUTTER SPEED	↑
4	1/30	MORE
5.6	1/60	LIGHT
8	1/125	OR
11	1/250	EXPOSURE
16	1/500	↓

Using the settings going up each column exposes the film to more light. As the setting in one column is increased, the setting in the other column must be decreased to maintain the same exposure for the lighting conditions in the scene you want to photograph. For example, suppose the correct exposure setting is 1/125 second at f/8. To help stop fast action, you can change the shutter speed to 1/250 second, but you must also change the lens opening to f/5.6 in order to maintain the same exposure. If stopping fast action is not required but you want to increase the depth of field, you could use 1/60 second at f/11 which also maintains the same exposure.

smaller one, for example f/11 to f/16, cuts the light by 1/2.

On some lenses you may find a lens-opening number such as 1.8, 2.5, 3.5, or 4.5. These f-numbers fall between those in the regular series and usually indicate the largest opening on a particular lens. These lens openings are exceptions and are not a full stop from the next number.

CHOOSING THE BEST COMBINATION OF SHUTTER SPEED AND LENS OPENING

There are many combinations of shutter speed and lens opening that will allow the same amount of light to reach the film for proper exposure. These are known as equivalent exposures. If you change from one shutter speed to the next higher speed, this lets half as much light expose the film. You should keep the total amount of light—the exposure—the same by opening the lens to the next larger lens opening. It also works the other way around. If you change to the next slower shutter speed which lets in twice as much light, you should use the next smaller lens opening to let in the same amount of light as before.

An exposure meter or the Daylight Exposure Dial in the KODAK Master Photoguide (AR-21), sold by photo dealers, helps you select the correct lens opening and shutter speed for daylight pictures and also indicates the combination of settings that will provide the same exposure. Other calculator dials in the Master Photoguide or an exposure meter will help you determine exposure for other lighting conditions. The exposure dials in the Master Photoguide are also good to rely on when your exposure meter battery fails unexpectedly or when your meter is in need of repair. Exposure and exposure meters are discussed in greater detail beginning on page 59.

Besides obtaining the proper exposure, you might want to use a particular combination of lens opening and shutter speed for three good reasons:

1. To reduce the effects of camera motion. A good, general-purpose shutter speed to achieve this is 1/125 second. A higher shutter speed of 1/250 second may even produce sharper pictures. With telephoto lenses even higher shutter speeds may be necessary. See page 144. But you do have to use a larger lens opening than normal when you use a higher shutter speed than normal to obtain the same exposure. Remember that you should hold your camera as steady as possible while you press the shutter release, even when using high shutter speeds.

More objects in front of and behind the subject look sharp.

Fewer objects in front of and behind the subject look sharp.

The photo on the left has more depth of field than the photo on the right.

2. *To stop action.* A shutter speed of 1/125 second helps stop the action of someone walking, for instance. However, there may be times when you want to use a higher shutter speed to stop fast action, such as a person running. With a higher shutter speed you have to use a larger lens opening to maintain the same exposure. For example, if the film instructions suggest 1/125 second at *f*/11 for a sunny-day picture, an equivalent exposure is 1/250 second at *f*/8 or 1/500 second at *f*/5.6.

3. *To control depth of field.* By using a small or a large lens opening with the appropriate shutter speed to maintain the correct exposure, you can increase or decrease the range of sharp focus, or the depth of field. See page 30.

GUIDELINES FOR SELECTING THE BEST COMBINATION OF *f*-NUMBER AND SHUTTER SPEED FOR THE PICTURE

SELECTING THE *f*-NUMBER

Lens Opening	Guidelines	Example— 50 mm *f*/2 Lens Normal Focal Length
Maximum for lens	Good for obtaining enough exposure in poor lighting conditions, such as existing light. Minimum depth of field—very shallow. Poorest image quality for specific lens.	*f*/2
One stop smaller than maximum lens opening	Good for obtaining enough exposure in poor lighting. Shallow depth of field. Helpful to throw background out of focus to concentrate attention on subject. Good image quality.	*f*/2.8
Two and three stops smaller than maximum lens opening	Best image quality for specific lens. Better depth of field than with larger lens openings. Good for limited distance range of sharp focus. Good for obtaining proper exposure when lighting conditions are less than optimum, such as on cloudy days or in the shade.	*f*/4 and *f*/5.6
Two stops larger than minimum lens opening	Moderate depth of field. Good all around lens opening to use for outdoor daylight pictures. Excellent image quality.	*f*/8
One stop larger than minimum lens opening	Great depth of field. Good all around lens opening to use for outdoor daylight conditions. Excellent image quality.	*f*/11
Minimum for lens	Maximum depth of field. *Very* slight loss of sharpness due to optical effects. When maximum depth of field is important, the benefits from increased depth of field with this lens opening outweigh the disadvantages from an almost imperceptible loss in sharpness.	*f*/16

28

Guidelines continued on next page

SELECTING THE SHUTTER SPEED

Shutter Speed	Guidelines
B (Bulb)	Use camera support, such as a tripod. Shutter remains open as long as shutter release is depressed. Good for obtaining great depth of field with small lens openings in outdoor night scenes, for photographing fireworks and lightning, and for recording streak patterns from moving lights at night, such as automobile traffic. Long exposures can cause an overall color cast with color films.
1 second and 1/2 second	Use camera support, such as a tripod. Good for obtaining great depth of field with small lens openings and enough exposure under dim lighting conditions, such as existing light or photolamps. Good for photographing inanimate objects and stationary subjects. These shutter speeds can cause a very slight color cast with some color films.
1/4 second	Use camera support. Maximum slow shutter speed for portraits of adults. Good for obtaining great depth of field with small lens openings and enough exposure under dim lighting conditions. Good for stationary subjects.
1/8 second	Use camera support. Better shutter speed than ¼ second for photographing adults at close range. Good for obtaining great depth of field with small lens openings and enough exposure under dim lighting conditions. Good for stationary subjects.
1/15 second	Use camera support. Some people can handhold their camera using this shutter speed with a normal or wide-angle lens on the camera. This is possible if the camera is held very steady during the exposure. Good for obtaining increased depth of field with small lens openings and enough exposure under dim lighting conditions, such as existing light.
1/30 second	Slowest recommended shutter speed for handholding your camera with a normal or wide-angle lens. Camera must be held very steady for sharp pictures. Good all around shutter speed for existing-light photography. Good for obtaining increased depth of field with small lens openings on cloudy days or in the shade. Recommended shutter speed* for flashbulbs with most cameras and for electronic flash with rangefinder cameras.
1/60 second	Good shutter speed to use for daylight pictures outdoors when the lighting conditions are less than ideal, such as on cloudy days, in the shade, or for backlighted subjects. Useful shutter speed for increasing depth of field with a smaller lens opening. Also, good shutter speed to use for brighter existing-light scenes. Less chance of camera motion spoiling the picture than with 1/30 second. Recommended shutter speed* for electronic flash with many SLR cameras.
1/125 second	Best all around shutter speed to use for outdoor daylight pictures. Produces good depth of field with medium to small lens openings under bright lighting conditions, minimizes the effects from slight camera motion, and stops some moderate kinds of action, such as people walking, children playing, or babies not holding still. This is the minimum safe shutter speed for handholding your camera with a short telephoto lens, such as those shorter in focal length than 105 mm. Recommended shutter speed* for electronic flash with some SLR cameras.
1/250 second	Good for stopping moderate fast action like runners, swimmers, bicyclists at a medium speed, running horses at a distance, parades, running children, sailboats, or baseball and football players moving at a medium pace. Good all around shutter speed for outdoor daylight pictures when you don't require great depth of field and you want to stop some action. Helps minimize the effects of camera motion. Good shutter speed to use for handholding your camera with a telephoto lens up to 250 mm in focal length.
1/500 second	Good for stopping fast action like fast moving runners, running horses at a medium distance, divers, fast moving bicyclists, moving cars in traffic, or basketball players. A good shutter speed to use for stopping all but the fastest kinds of action. Gives better depth of field with the appropriate lens opening than 1/1000 second. Excellent shutter speed to use with telephoto lenses. Good for lenses up to 400 mm in focal length with a handheld camera.
1/1000 second	Good shutter speed for stopping fast action like race cars, motorcycles, airplanes, speedboats, field and track events, tennis players, skiers and golfers, for example. This shutter speed gives little depth of field because it requires a large lens opening. Excellent shutter speed to use with long telephoto lenses up to 400 mm in focal length with a handheld camera.
1/2000 second	Best shutter speed for stopping fast action like motor sports, racquet games, and other endeavors where movement may be quicker than the eye. This shutter speed requires the largest lens opening and gives the least depth of field. Outstanding shutter speed for use with long telephoto lenses up to 400 mm in focal length with a handheld camera.

Note: It's important to hold your camera steady for all the shutter speeds recommended for handholding. You can also use slower shutter speeds than those mentioned for telephoto lenses when you put your camera on a firm support like a tripod. If in doubt about stopping the action, use the highest shutter speed you can for the conditions. See page 192 for more on action pictures.

*See your camera manual for recommended shutter speeds for flash pictures.

DEPTH OF FIELD

Depth of field is the distance range within which objects in a picture look sharp. As you gain a sound understanding of depth of field, you can use it as a very effective control for making better pictures.

What are the primary factors affecting depth of field? Depth of field varies with the size of the lens opening, the distance of the subject focused upon, and the focal length of the lens. Depth of field becomes greater as
- the size of the lens opening decreases.
- the subject distance increases.

- the focal length of the lens decreases and subject distance remains unchanged.

An object at the distance focused upon will be the sharpest thing in the picture. But image sharpness doesn't suddenly disappear at the limits shown. Points closer or farther away than the distance focused upon will be less sharp, but will look acceptably sharp to the eye throughout the depth-of-field zone. Objects close to the depth-of-field zone may appear almost sharp. But the farther an object is from this zone, the more out of focus it will

HOW LENS OPENING AFFECTS DEPTH OF FIELD
Shaded area indicates depth of field—range of acceptably sharp focus.
Same focal length, same subject distance

LARGE LENS OPENING

SMALL LENS OPENING

HOW SUBJECT DISTANCE AFFECTS DEPTH OF FIELD
Same focal length, same f-stop

◄—4 FT—►

◄———10 FT———►

————25 FT————————► INFIN

HOW FOCAL LENGTH AFFECTS DEPTH OF FIELD
Same f-stop, same subject distance

LONG FOCAL LENGTH—TELEPHOTO LENS

MEDIUM FOCAL LENGTH—NORMAL LENS

SHORT FOCAL LENGTH—WIDE-ANGLE LENS

INFIN

A small lens opening will give greater depth of field than a large lens opening at the same subject distance with the same focal length lens.

f/2.8 with a 50 mm lens

f/11 with a 50 mm lens

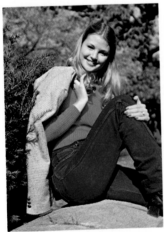

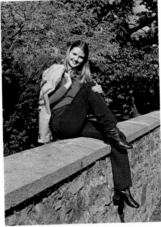

Depth of field increases as the subject distance increases when the lens opening and focal length of the lens remain unchanged.

Subject distance 8 feet, f/11 with a 50 mm lens

Subject distance 15 feet, f/11 with a 50 mm lens

Depth of field decreases as the focal length of the lens increases when the lens opening and subject distance remain unchanged.

John Menihan, Jr.

50 mm lens at f/11, subject distance 12½ feet

105 mm lens at f/11, subject distance 12½ feet

31

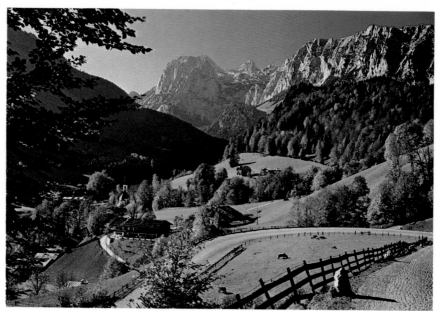

To get great depth of field in your scenic pictures, use a wide-angle lens and a small lens opening.

appear. In looking over these illustrations you can see that there are times when accurate focusing is very important because depth of field is slight. These include times when you're using a long-focal-length lens or a large lens opening or when you are close to your subject. Of course, a combination of these factors makes accurate focusing even more important. For example, let's assume you're using a 135 mm telephoto lens on your camera. (For more on lenses, see page 124.) If you're focused on a subject 14 feet away with a lens opening of $f/4$, your depth of field will extend from about 13½ feet to 14½ feet. This doesn't allow much room for focusing error!

You can use depth of field as a control in your pictures. In some shots you'll want as much depth of field as possible. For example, in shooting a scenic picture you may want to include tree branches in the foreground as an interesting frame. To get both the branches and the distant scene in sharp focus, you may use a wide-angle lens and a small lens opening for great depth of field.

In other situations you may not want so much depth of field. You may be photographing a very interesting subject. But what if the background is confusing? You can use a large lens opening, perhaps combined with a long-focal-length lens, to produce shallow depth of field. The disturbing background will be out of focus so as not to detract from your subject. The shallow depth of field will help focus attention on the main subject.

You'll probably want to have the foreground objects in sharp focus in most of your pictures. But you may want to make exceptions now and then to produce creative results. Sometimes an out-of-focus foreground can add interest, excitement, color, glamour, and intrigue to your photograph.

Bob Clemens

By using a telephoto lens and a large lens opening, you'll get shallow depth of field and a pleasing out-of-focus background.

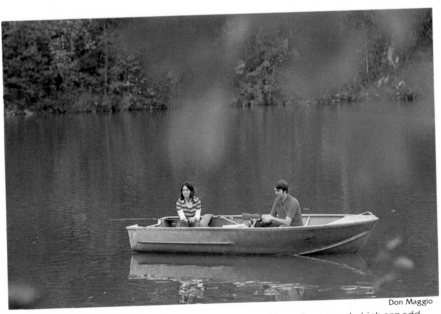

Don Maggio

You can use shallow depth of field to create an out-of-focus foreground which can add color and interest to your pictures.

THE DEPTH-OF-FIELD SCALE

How do you know what part of your subject will fall within the depth of field? The easiest way is to use the depth-of-field scale on your lens. If there's none on the camera or lens, see the depth-of-field tables in your camera or lens instruction manual.

The lens depth-of-field scale not only helps you put the depth of field *where* you want it but also helps you get the *amount* of depth you want. If you're taking a scenic picture, for example, you'll probably want all the depth of field you can get. If you simply focus on the distant scene, you'll be focused on infinity. But that's wasting a lot of depth of field. To have the most distant object in focus and as much foreground as possible in focus as well, set the infinity mark on the camera focusing scale at the far-limit indicator on the depth-of-field scale.

When you set the focus this way, you have focused your camera on the hyperfocal distance. Hyperfocal distance is just a special application of depth of field. When you focus a lens on infinity, the distance beyond which all objects are in acceptably sharp focus is the hyperfocal distance. For example, focus a lens with a focal length of 50 mm on infinity with the lens opening set on $f/16$. The near-limit indicator on the depth-of-field scale shows that all objects from 15 feet to infinity will look sharp. The hyperfocal distance is therefore 15 feet.

If you refocus the lens on the hyperfocal distance, 15 feet in this example, objects from half of the hyperfocal distance, approximately 7½ feet, to infinity will appear in sharp focus. (See illustration.) This gives you the greatest depth of field for that particular lens opening. As you open the lens aperture to larger openings, the hyperfocal distance increases and the depth of field decreases.

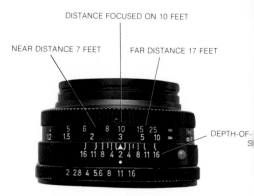

DISTANCE FOCUSED ON 10 FEET

NEAR DISTANCE 7 FEET FAR DISTANCE 17 FEET

DEPTH-OF-S

Many camera lenses have depth-of-field scales printed on them. The most common type of scale is a double series of numbers representing the lens openings, on both sides of the focus indicator. Subjects within the distance range between the marks for the lens opening you're using will appear in sharp focus. Here the lens is set on $f/11$ and everything from about 7 feet to 17 feet will be in focus. (See the orange numbers.)

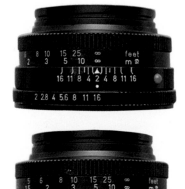

The same lens is set at $f/16$ in both pictures. On the top lens the depth-of-field scale shows that objects from 15 feet to infinity will be in focus. To get maximum depth of field, the infinity mark for the lens on the bottom is set opposite the far depth-of-field limit. This focuses the lens on the hyperfocal distance. At this focus setting, everything from 7½ feet to infinity will be in focus.

Don McDill

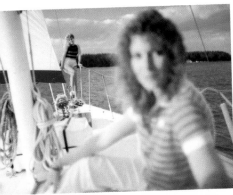

When you focus the lens on infinity, distant objects will be sharp, but the foreground may be fuzzy.

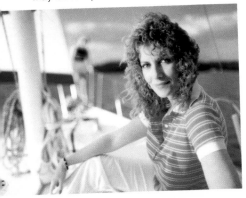

If you focus the lens on the foreground, objects in the distance may be fuzzy.

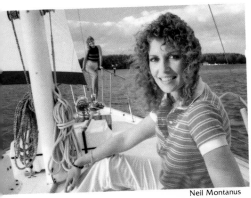

Neil Montanus

By focusing the lens on the hyperfocal distance, you may be able to make everything sharp. This is often desirable in pictures of scenic views.

With many single-lens reflex cameras, you can view the subject on the ground glass with the lens wide open *or* with the lens set at the opening you're going to use to take the picture. Normally the lens is automatically at its maximum opening for viewing purposes regardless of the lens opening set on the camera. This makes the viewfinder as bright as possible and makes focusing easier because of the limited depth of field at the widest lens opening. However, you can't judge depth of field at the maximum lens opening unless you're going to take the picture at that opening.

When the lens is set at the opening you're going to use to take the picture, you can preview the depth of field by pressing a button or lever on the camera for this purpose. This temporarily changes the lens opening to the one you're going to use for the picture and gives you a preview of the depth of field. The subjects that appear in focus in the viewfinder will be in focus in your picture. When you're using a small lens opening though, the image on the ground glass becomes dim and sometimes difficult to see clearly.

It's not necessary to press the depth-of-field lever when you take the picture because the camera will automatically stop the lens down to the lens opening you've set on the camera. Some cameras do not have a depth-of-field preview feature.

Very often it's beneficial to know what distance to focus your camera on to get everything sharp within a range of medium distances. This is especially helpful when you're taking pictures rapidly without enough time to consult the depth-of-field scale or if there is no such scale on your lens. As a general rule, approximately 1/3 of the depth of field is in front of the point of sharpest focus with 2/3 of the depth of field behind. As a result, you should focus on a distance 1/3 of the way from the

nearest object you want sharp to the farthest. For example, for objects within a 5 to 20-foot range, you should focus on 10 feet and use the smallest lens opening that you can. This rule does not apply to subjects very close or to those at great distances from the camera including those at infinity. While this is a fast procedure for determining the best distance to focus on, you may not get everything you want in sharp focus if depth of field is limited, such as with a large lens opening.

HELPFUL HANDLING HABITS

People who earn their living by making photographs usually develop habits that are timesaving, money-saving, and picture-saving. These aren't all photography in the strict sense, so they don't often find their way into print. Here are a few such working ideas that you may find useful.

When you plan to shoot lots of pictures in a short time—whether it's at a football game, a party, or a newsworthy event—take your film supply out of the cardboard cartons to save time later, and put all of your unexposed film into one section of your gadget bag. Then when you need a new roll of film, all you'll need to do is open the film can.

When you finish a roll of 135 film, rewind it into the magazine right away. Then if you accidentally open the camera, you won't expose the film. In addition, wind the end of the film all the way into the magazine. This way, you won't accidentally reload the film into your camera and double-expose it.

Keep your exposed film in a separate compartment of your gadget bag. If you keep your exposed and unexposed film separated, you won't have to waste time at a crucial moment looking for fresh film.

As you take your pictures, you'll probably have to adjust focus or exposure settings for some other-than-normal situations. Suppose you go from distant shots of a road race in bright sunlight to a close-up of a car refueling in the shade. As soon as you're through making the close-ups in the shade, readjust your focus and exposure settings for your normal picture-taking. Then you'll be ready to take pictures where the next opportunity is most likely to arise.

When you find an especially good subject, take at least two or three pictures of it. This will give you a choice of viewpoint, pose, expression, or composition, as well as insurance in case one negative or slide gets damaged. We'll talk about bracketing for exposure insurance in the exposure section on page 72.

AUTOWINDERS AND MOTOR DRIVES

When you want to take pictures rapidly, a handy accessory is either an autowinder or a motor drive. Each automatically advances the film to the next frame and cocks the shutter. The autowinder readies the camera for the next exposure at a rate of about two frames per second, faster than you can do it manually. You can take either single pictures or a sequence of pictures as fast as the winder recycles the camera. The winder fits on the bottom of the camera. Motor drives, which advance the film even faster, are similar to autowinders and usually more expensive.

An autowinder (or motor drive) offers several advantages. It lets you take pictures quickly of fast action, such as sports or parades, where you can just keep the subject centered in the viewfinder as you click off several photos. An autowinder is great to help you

capture the ever-changing opportunities for candid pictures of children, pets, or people at occasions where you don't want to miss a choice picture while you manually advance the film. An autowinder is equally helpful for informal portraits when you want to be ready for the best expressions which may only last a moment.

An added advantage of an autowinder is that you can hold your camera steady up to your eye as you click the shutter for several pictures without having to move the camera to advance the film. This advantage is especially useful when you're using telephoto lenses. (See page 137.) You don't have to release your steady grip on the camera or take time to recompose the picture in the viewfinder each time the film is advanced as you would if you advance it manually. An autowinder lets you concentrate on holding your camera steady for several shots. With an autowinder, you may be able to use a longer focal-length telephoto lens or a slower shutter speed than you could otherwise and handhold your camera.

Another kind of photography where an autowinder is beneficial is close-up pictures (page 260), especially those of live subjects like insects or small animals. Since these subjects move, you have to keep them properly framed in the viewfinder and sharply focused, which is more difficult to achieve in close-ups. An autowinder makes this easier since you can keep your eye at the viewfinder and just press the shutter release for successive pictures.

Check with your photo dealer to see if an autowinder or motor drive is available for your camera.

Don Maggio

When you want to shoot pictures fast to capture events that are rapidly changing, such as the fleeting expressions at a wedding, an autowinder will help you get the results you want. An autowinder not only advances the film and cocks the shutter for you; it also lets you keep the camera up to your eye with your finger on the shutter release for rapid shooting. You don't have to waste time by moving your camera away from your face to advance the film and then recomposing the picture in the viewfinder each time before you press the shutter release.

An autowinder on your camera is great for candid pictures around home, too. You can just snap away while your subjects are engrossed in an activity without missing those heartwarming expressions. People are at their best when they're not aware they're being photographed and they don't have to "hold it" while you take the picture. They are more natural when you shoot fast and don't interrupt what they're doing.

Robert Kretzer

The wide range of superb Kodak films combined with today's array of sophisticated 35 mm equipment offers the photographer more exciting picture opportunities than ever before. Made in Finland on KODACOLOR VR 400 Film.

KODAK FILMS

Before taking pictures you'll want to select the kind of film you plan to use. Do you want color or black-and-white? Prints or slides? Kodak offers a variety of films for 35 mm cameras. The tables in this section describe the characteristics of several Kodak films. Knowing the characteristics of these films will help you select the best one for the kind of pictures you want to take.

FILM SPEED

The film speed indicates relative sensitivity to light. The speed is expressed as an ISO (ASA) speed number. The higher the speed, the more sensitive or faster the film; the lower the speed, the less sensitive or slower the film. A fast film requires less light for proper expo-

sure than a low-speed film. As an example, a film with a speed of ISO (ASA) 25 is slower—requires more light—than a faster film with a speed of ISO (ASA) 200. To find the speed number for your film, look on the film carton, in the film instructions, or on the film magazine. You set the ISO (ASA) speed on exposure meters and on 35 mm cameras with built-in meters in order to obtain the correct exposure. Setting the ISO (ASA) speed on an automatic camera programs the camera automatically to determine the proper exposure. Some cameras may sense the film speed, exposure latitude, and number of exposures electronically from DX-encoded film magazines when you load the camera.

Film speed is one of the most important facts you have to know in order to use a film properly. The speed of the film is given on the film carton, the film magazine, and in the film instructions.

ISO speeds are being given in anticipation of future replacement of ASA speeds. ISO speed numbers are numerically the same as ASA speed numbers. For example, if the speed of a film is ISO (ASA) 200, you would set 200 on the ISO (ASA) dial of your camera or exposure meter. The ASA designation has been dropped for Kodak color negative films—only ISO speeds are provided.

Graininess and sharpness are usually best with low-speed films. Graininess is the sand-like, granular appearance given to an image by the structure of the light-sensitive emulsion. As film speed increases, graininess increases. As a result of modern technology, however, a high-speed film such as KODACOLOR VR 400 Film can produce excellent photographs with a minimum of graininess.

KODACOLOR VR 100 Film offers extremely fine grain and very high sharpness for maximum enlargeability. It is desirable for most picture-taking conditions where optimum image quality is required in a color negative.

ISO (ASA) SPEEDS

The speeds in heavy type are the ones usually marked on the ASA speed dial on cameras with built-in exposure meters and the calculator dial of handheld exposure meters.

6	40	250	**1600**
8	**50**	320	2000
10	64	**400**	2500
12	80	500	**3200**
16	**100**	640	4000
20	125	**800**	5000
25	160	1000	**6400**
32	**200**	1250	

Neil Montanus

KODACOLOR VR 200 Film is a logical choice for your general-purpose negative film. It offers plenty of speed (ISO 200) for moderate action and some existing-light applications, as well as extremely fine grain and sharpness nearly as high as that of KODACOLOR VR 100 Film.

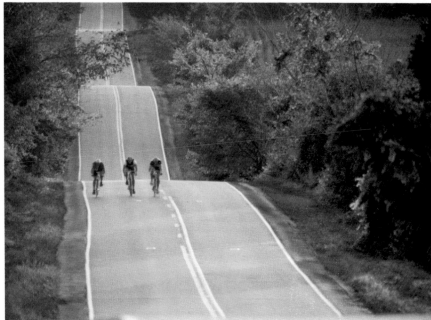

KODACOLOR VR 400 Film is a high-speed color negative film that gives enormous flexibility in any situation where the light is less than ideal and where there are other requirements such as extended depth of field, long-focal-length lenses, high shutter speeds, or a handheld camera.

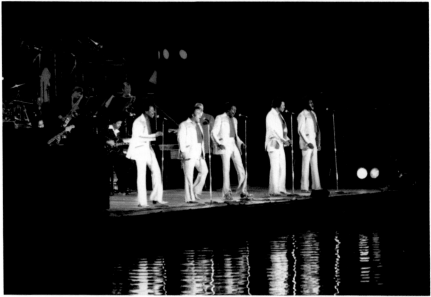

The very high speed of KODACOLOR VR 1000 Film will allow you to capture nearly any image that you can see. This spectacular film for prints is designed to tame the extremes in your photography—the longest lenses, the fastest action, the dimmest light.

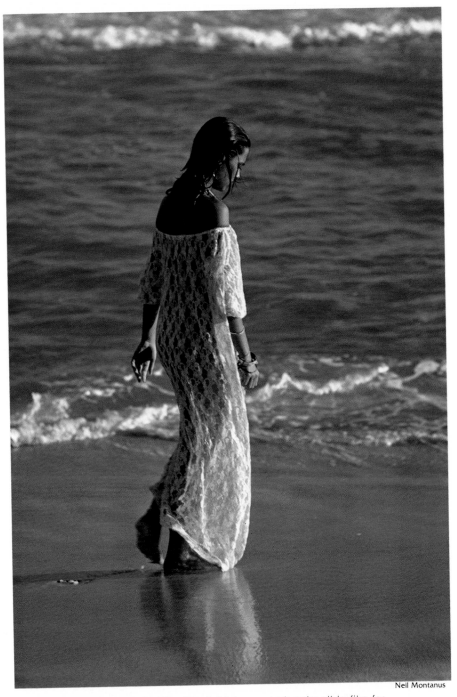

KODACHROME 25 Film (Daylight) is a superb color-slide film for photographing in bright-light situations where you don't need a lot of film speed and you want the best possible image quality and excellent color rendition. The speed was specified at ISO (ASA) 25 to offer you our highest sharpness and finest grain in a color-slide film for general use.

43

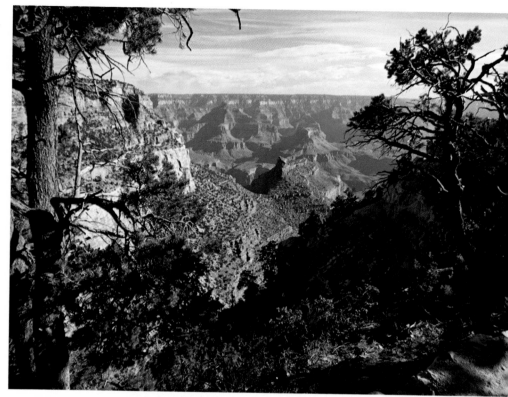

KODACHROME 64 Film (Daylight) is an excellent film for general picture-taking when you want color slides. This film is 1⅓ stops faster than KODACHROME 25 Film, which lets you take pictures at higher shutter speeds, smaller lens openings, or in lighting conditions that are less than ideal. KODACHROME 64 Film, Grand Canyon

KODACHROME 64 Film, used for this picture, produces excellent color rendition with sharpness, resolution, and grain almost as good as KODACHROME 25 Film.

John Menihan

For all-around use for color slides, you can choose KODAK
EKTACHROME 100 Film (Daylight). This film has vivid color rendition
and high image quality for producing slides with saturated colors
and fine detail.

EKTACHROME 100 Film [ISO (ASA) 100] is slightly faster than KODACHROME 64 Film [ISO (ASA) 64], and the sharpness and grain are nearly as good. It's very difficult to see the difference. The choice between the two is a matter of personal preference—they're both excellent films. The photographer chose EKTACHROME 100 Film for photographing the colorful pageantry above.

47

Gary Whelpley

If you're a color-slide fan and need a film with high definition image quality that can capture fast action, KODAK EKTACHROME 200 Film (Daylight) is a good film to use. Its ISO (ASA) 200 speed is very useful for taking action pictures under less-than-bright lighting conditions. This versatile film is an excellent choice when you want to take pictures in lighting conditions ranging from dim existing light (page 207) to bright sunlight.

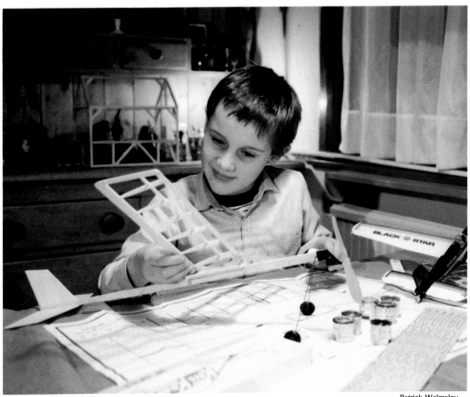

Patrick Walmsley

KODAK EKTACHROME 160 Film (Tungsten) is a color-slide film designed for 3200 K lighting. It's an excellent film for taking pictures under tungsten household lighting and other existing tungsten illumination. Its color quality and definition characteristics are similar to those of EKTACHROME 200 Film (Daylight).

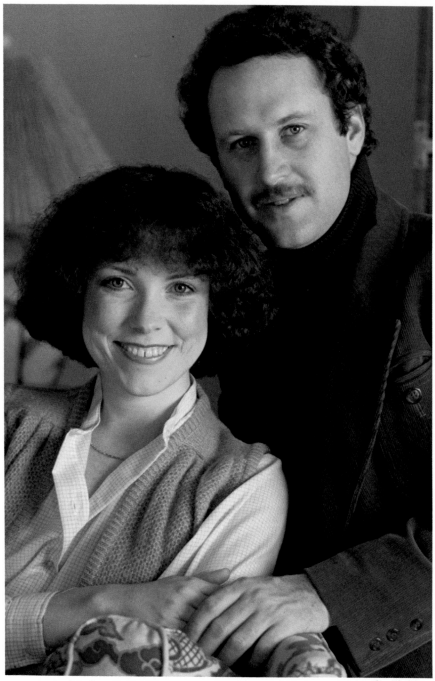

Gary Whelpley

KODAK EKTACHROME 400 Film (Daylight) is a high-speed Kodak color-slide film that is great for existing-light photography, for stopping action in poor light or with telephoto lenses, or for extending depth of field without using slow shutter speeds. The color quality of this film produces saturated colors with full tonal values. This film also produces good results under artificial light if color fidelity is not critical. This couple was photographed by existing daylight coming through a window.

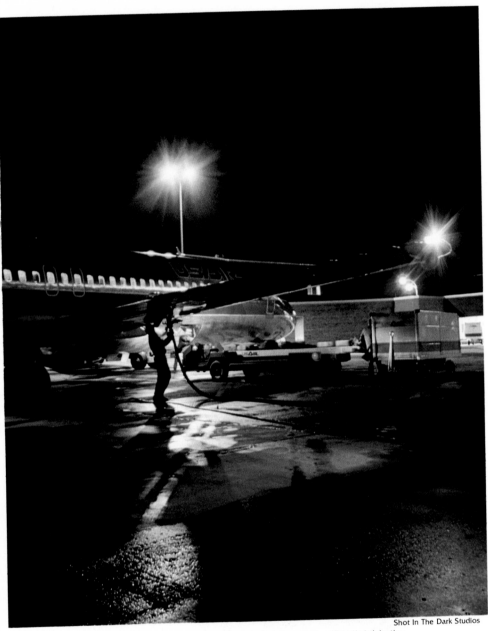

KODAK EKTACHROME P800/1600 Professional Film (Daylight) is the highest speed Kodak color-slide film. With special push processing, EKTACHROME P800/1600 Professional Film offers the choice of two very high film speeds—EI 800 or 1600—that allow small apertures and high shutter speeds in low light. EKTACHROME P800/ 1600 can yield acceptable results when exposed at EI 400 or even at 3200. Film instructions provide information for use at EI 400, 800, 1600 and 3200. (Note, the whole roll must be exposed at the same speed.) This evening exposure was made with EKTACHROME P800/1600 Professional Film (Daylight) exposed at EI 1600, 1/30 second, f/4.5.

Black-and-white photography is still a popular medium because the absence of color creates an artistic, monochrome impression. With extremely fine grain and very high sharpness, KODAK PANATOMIC-X Film can make high-quality enlargements from small negatives. This film offers a full range of tones from textured shadows to sparkling highlights.

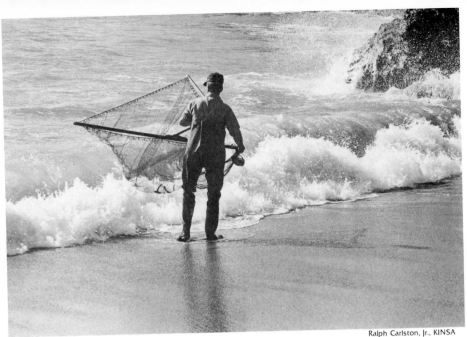

KODAK PLUS-X Pan Film is top notch for all-around black-and-white picture-taking, as demonstrated above. This film has the optimum combination of long tonal gradation, extremely fine grain, excellent sharpness, and medium speed for producing high-quality prints.

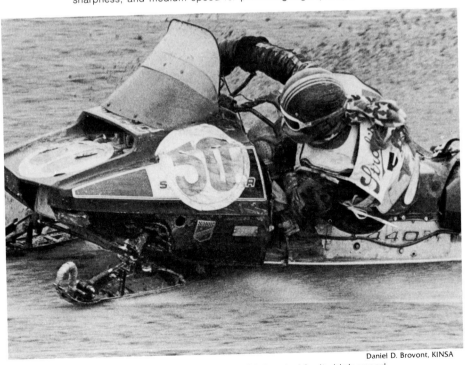

KODAK TRI-X Pan Film, ISO (ASA) 400, is noted for its high speed, versatility, and excellent quality. It can cover a wide range of lighting conditions—from existing light to bright sunlight—and freeze explosive action as shown in the snowmobile scene.

KODAK COLOR FILMS FOR 35 mm CAMERAS

KODAK Film	Description	Type of Picture	For Use with	ISO (ASA) Speed and Filter			Number of Exposures Available	Processed by
				Daylight	Photolamps 3400 K	Tungsten 3200 K		
Color Negative Films								
KODACOLOR VR 100	This film features very high sharpness and extremely fine grain to allow for a high degree of enlargement and wide exposure latitude. It is an excellent film for use in general lighting conditions where maximum image quality is desired for big enlargements.	Color prints	Daylight, Electronic Flash, or Blue Flash	100	32 No. 80B	25 No. 80A	135-12 135-24 135-36	Kodak, other labs, or user
KODACOLOR VR 200	With the same extremely fine grain and nearly as high sharpness as KODACOLOR VR 100 Film, this film provides twice the speed. It is a good choice for general lighting conditions when higher shutter speeds for capturing action or smaller apertures for increased depth of field are desired.	Color prints	Daylight, Electronic Flash, or Blue Flash	200	64 No. 80B	50 No. 80A	135-12 135-24 135-36	Kodak, other labs, or user
KODACOLOR VR 400	A high-speed film for existing-light situations, fast action, great depth of field, and extended flash-distance ranges. Medium sharpness and extremely fine grain offer good quality for a moderate degree of enlargement.	Color prints	Existing Light, Daylight, Electronic Flash, or Blue Flash	400	125 No. 80B	100 No. 80A	135-12 135-24 135-36	Kodak, other labs, or user
KODACOLOR VR 1000	The very high speed of this medium-sharpness, very-fine-grain film suits it for use in low-light conditions when fast shutter speeds, small apertures, or telephoto lenses are required.	Color prints	Existing Light, Daylight, Electronic Flash, or Blue Flash	1000	320 No. 80B	250 No. 80A	135-12 135-24 135-36	Kodak, other labs, or user
Color Slide Films								
KODACHROME 25 (Daylight)	A popular color-slide film noted for excellent color and high sharpness. It has extremely fine grain and good exposure latitude.	Color slides	Daylight, Electronic Flash, or Blue Flash	25	8 No. 80B	6 No. 80A	135-20 135-36	Kodak and other labs
KODACHROME 40 5070 (Type A)	A color-slide film designed for use with 3400 K photolamps. It gives high-quality color rendition and exceptional definition. This film is excellent for informal portraits, close-ups, title slides, and for copying color originals. You can also take pictures in daylight with the recommended conversion filter.	Color slides	Photolamps 3400 K	25 No. 85	40	32 No. 82A	135-36	Kodak and other labs
KODACHROME 64 (Daylight)	A medium-speed, general-purpose film for color slides. Its extra speed is an advantage in many situations, especially when lighting conditions are	Color	Daylight, Electronic	64	20	16	135-20	Kodak and

Film	Description	Type	Light Source	Speed	Filter Speed	Filter Speed	Film Sizes	Processing
EKTACHROME 100 (Daylight)	A medium-speed, color-slide film for general all-around use. It has sufficient speed to let you use higher shutter speeds or smaller lens openings in normal lighting or to let you take pictures when the lighting is somewhat subdued. This film produces vivid color rendition and excellent sharpness and graininess characteristics.	Color slides	Daylight, Electronic Flash, or Blue Flash	100	32 No. 80B	25 No. 80A	135-20 135-36	Kodak, other labs, or user
EKTACHROME 200 (Daylight)	A medium-speed, color-slide film for existing light, fast action, subjects requiring good depth of field or high shutter speeds, and for extending the flash-distance range. It has very fine grain and excellent sharpness. This film can be push-processed to double the speed.	Color slides	Daylight, Electronic Flash, Blue Flash, or Existing Daylight	200 / 400*	64 No. 80B / 125* No. 80B	50 No. 80A / 100* No. 80A	135-20 135-36	Kodak, other labs, or user
EKTACHROME 160 (Tungsten)	A medium-speed, color-slide film for use with 3200 K tungsten lamps and existing tungsten light. It features the same very fine grain and excellent sharpness as the 200-speed Daylight film. This film can be push-processed to double the speed.	Color slides	Tungsten Lamps 3200 K or Existing Tungsten Light	100 No. 85B / 200* No. 85B	125 No. 81A / 250* No. 81A	160 / 320*	135-20 135-36	Kodak, other labs, or user
EKTACHROME 400 (Daylight)	A high-speed, color-slide film for existing light, fast action, subjects requiring good depth of field and high shutter speeds, and for extending the flash-distance range. It has fine grain and good sharpness and can be push-processed to double the speed.	Color slides	Daylight, Electronic Flash, Blue Flash, or Existing Daylight	400 / 800*	125 No. 80B / 250* No. 80B	100 No. 80A / 200* No. 80A	135-20 135-36	Kodak, other labs, or user
EKTACHROME P800/1600 Professional Film (Daylight)	A very high-speed color-slide film for existing light, fast action, and subjects requiring good depth of field and high shutter speeds. This film exposed at EI 800 or EI 1600 provides good results in adverse lighting conditions. It can be push-processed as high as EI 3200 for extremely dim situations with some loss in quality. You can also expose the film at EI 400 which requires a CC10Y† filter.	Color slides	Existing Daylight, Daylight, Electronic Flash, or Blue Flash	800* / 1600*	250* No. 80B / 500* No. 80B	200* No. 80A / 400* No. 80A	135-36	Kodak, other labs, or user
EKTACHROME Infrared 2236	A false-color film for color slides. It's used in such fields as aerial photography, science, and medicine, but it's also useful for unconventional pictorial photography where abstract, unrealistic colors are desired.	Color slides	Daylight, Electronic Flash, or Blue Flash	100 No. 12 or 15	50 No. 12 or 15 plus CC50C-2	—	135-20	Kodak or other labs

*With KODAK EKTACHROME 160, 200, and 400 Films in 135 size, you can use these higher film speeds—2 times the normal film speed—when you send your film for processing in the KODAK Special Processing Envelope, ESP-1, sold by photo dealers. Special processing with the ESP-1 envelope (Push 1), or equivalent, is required for EKTACHROME P800/1600 Professional Film exposed at EI 800. Your photo dealer can make arrangements to have your EKTACHROME P800/1600 Professional Film processed when exposed at EI 1600 (Push 2), or 3200 (Push 3). When you expose the film at EI 400, have it processed normally. See page 57.

†KODAK Color Compensating Filter, CC10Y, sold by photo dealers.

KODAK BLACK-AND-WHITE FILMS FOR 35 mm CAMERAS

KODAK Film	Description	ISO (ASA) Speed	Number of Exposures Available
PANATOMIC-X	An extremely fine-grain panchromatic film with very high sharpness for big enlargements.	32	135-20 135-36
PLUS-X Pan	An excellent, general-purpose panchromatic film that offers the optimum combination of medium speed and extremely fine grain.	125	135-20 135-36
TRI-X Pan	A high-speed panchromatic film especially useful for photographing existing light subjects, fast action, subjects requiring good depth of field and high shutter speeds, and for extending the flash-distance range. This film has fine grain and excellent quality for such a high speed.	400	135-20 135-36
Recording 2475	A very high-speed panchromatic film for use in situations where the highest film speed is essential and fine grain is not important to you, such as for taking action photographs where the light is extremely poor. The film has extended red sensitivity and coarse grain.	1000	135-36
High Speed Infrared 2481	An infrared-sensitive film which produces striking and unusual results. With a red filter, blue sky photographs almost black and clouds look white. With this film and filter, live grass and trees will appear as though they are covered by snow. This film has fine grain.	125 tungsten*	135-20
Technical Pan 2415	A panchromatic film with extremely fine grain and extremely high resolving power that gives large format performance with 35 mm convenience. Great enlargeability is possible when careful camera handling and processing techniques are employed. It is suitable for a wide number of general and scientific applications depending on the exposure and processing used. Outstanding pictorial results, photomicrography, precision copying, and title slides are all within the capability of this film.	25 **	135-36

*Use this speed as a basis for determining your exposures with tungsten light when you expose the film through a No. 25 filter. In daylight, follow the exposure suggestions on the film instruction sheet.

**Use this speed for daylight pictorial photography only when processed in KODAK TECHNIDOL LC Developer, or the equivalent. Other speeds for different applications require alternative developers and give appropriate results. See the instructions packaged with the film.

Note: Panchromatic means that the film is sensitive to all visible colors.

KODAK Processing Mailers let you send your Kodak color film for processing by Kodak right away, without delay. This is especially convenient on trips. Your pictures may even be waiting for you at home when you return.

PROCESSING

Have your film processed promptly after exposure. Return Kodak film to your photo dealer for processing by Kodak or another lab. You can also mail Kodak color film directly to Kodak in the appropriate prepaid KODAK Processing Mailer.

You can process many Kodak 35 mm films for general picture-taking yourself. You'll need a film processing tank, a room that you can make totally dark, an accurate thermometer, and chemical kits that are available from your photo dealer. For black-and-white film ask for the KODAK HOBBY-PAC™ Black-and-White Film Processing Kit. Instructions are provided with the processing kit. The KODAK HOBBY-PAC Color Negative Film Kit for Process C-41 is available to process KODACOLOR VR Films. With most KODAK EKTACHROME Films, use the KODAK HOBBY-PAC Color Slide Kit, Process E-6. The exception, however is KODAK EKTACHROME Infrared Film 2236 which requires Process E-4 chemicals (not available in kit form). Incidentally, to expose EKTACHROME P800/1600 Film at either EI 800 or 1600 requires push processing. A higher speed of EI 3200 is obtained with even more push processing, but with some loss of quality. See the pro-

cessing chemical instructions.

You can't process KODACHROME Films successfully in your own darkroom because the process, which is highly complex, requires commercial photofinishing equipment.

SPEED BOOSTER FOR *EKTACHROME* FILMS

There will undoubtedly be times when you'll want to use a very high-speed 35 mm color-slide film. This may be when you're shooting by existing light, when you want to use a fast shutter speed combined with a small lens opening, or when you need a small lens opening to get good depth of field under dim lighting conditions. Kodak's special push-processing service doubles the speeds of these 135-size films—from ISO (ASA) 400 to ISO (ASA) 800 for EKTACHROME 400 Film (Daylight); from ISO (ASA) 200 to ISO (ASA) 400 for EKTACHROME 200 Film (Daylight); and from ISO (ASA) 160 to ISO (ASA) 320 for EKTACHROME 160 Film (Tungsten). When necessary, you can also use the special processing to increase the speed of EKTACHROME 100 Film (Daylight) from ISO (ASA) 100 to ISO (ASA) 200.

Push processing is required for EKTACHROME P800/1600 Professional Film (Daylight) exposed at EI 800 or 1600. Kodak offers push processing for both speeds. A film speed of EI 3200 is possible with push processing available from some independent processors. If desired, Kodak and other labs can process EKTACHROME P800/1600 Film normally for a film speed of EI 400. [Color balance and other variables are optimized in manufacture for the EI 800-1600 range. Use a CC10Y yellow filter if you need to expose EKTACHROME P800/1600 Film at EI 400.] To get this special processing

and 100 Films by push-processing the films yourself with a KODAK HOBBY-PAC Color Slide Kit, Process E-6. Simply increase the developing time in the first developer as recommended in the processing instructions that come with the chemicals. For all the other steps, just follow the normal processing times in the instructions. The procedure that gives a one-stop push process for most EKTACHROME Films, Process E-6, will give an EI 800 film speed for EKTACHROME P800/1600 Film. Follow the processing instructions for greater increases in speed.

VERSATILITY OF *KODAK* COLOR FILMS

While the color films in the charts on pages 54 and 55 are designed specifically to produce color slides or color negatives for color prints, they also give you a great deal of versatility. You can have color slides made from your color negatives and color prints made from your color slides. You can also have color prints made directly from finished color prints. Kodak Processing Labs and other photofinishers offer these services. See your photo dealer.

In addition, you can have black-and-white prints made from your color negatives. Or you can make them yourself. Kodak manufactures KODAK PANALURE II RC Paper specially for this purpose. When color negatives are printed on KODAK PANALURE Paper, the tones of gray in the print accurately represent the tonal relationships in the original scene. When color negatives are printed on regular black-and-white printing paper, you don't get this accurate tonal relationship. Black-and-white prints from color negatives are not made by Kodak Processing Labs. Other photofinishers may offer this service.

Shot In The Dark Studios

KODAK EKTACHROME P800/1600 Professional Film (Daylight) exposed at EI 800 —1/30 second, f/5.6—effectively captured the tranquil mood of this kitchen worker's coffee break.

service, use a KODAK Special Processing Envelope, ESP-1, sold by photo dealers. The price of the envelope is in addition to the regular cost of processing by Kodak.

Expose the entire roll of film according to the instructions that come with the ESP-1 Envelope. Mark an exposed magazine of EKTACHROME P800/1600 Film in the appropriate place for the EI used—P1 (Push 1) for EI 800 or P2 (Push 2) for EI 1600. Put the exposed film into the ESP Envelope. Then either return it to your photo dealer, who will send it to Kodak for processing, or put it into the appropriate KODAK Mailer and send it directly to any Kodak Processing Laboratory in the United States.

You can also increase the speed of KODAK EKTACHROME 400, 200, 160,

EXPOSURE AND
EXPOSURE METERS

As dusk approaches, an exposure meter helps you continue taking properly exposed pictures as the twilight diminishes. The meter tells you when there is insufficient light for picture-taking without flash.

With an exposure meter it's easy to determine the exposure for subjects evenly lighted by the interior existing lighting.

Picture, page 59

An exposure meter, of course, is a big help in determining the correct exposure. A meter is a must for unusual lighting and atmospheric conditions.

Accurate exposure is one of the prime ingredients in producing a high-quality photograph. If you made all your photographs under the lighting conditions that are covered in the exposure table in the film instructions, exposure calculation would amount to reading that table and adjusting the camera accordingly. But the versatility of your camera makes it possible for you to shoot pictures under a great variety of lighting conditions. You may want to take pictures at sunrise, during a blizzard, in your family room, or at the auto show. For unusual lighting situations, an exposure meter is a must.

Most 35 mm cameras have built-in exposure meters. And for proper exposure almost all depend on the film speed—ISO (ASA)—that you set when you load your camera. All DX-encoded films from Kodak, however, have a Camera Auto Sensing Code that may program properly equipped cameras with the film speed, exposure latitude, and number of exposures. (Your camera instructions will explain how it works.)

Some built-in meters take the reading through the camera lens, while others are separate from the lens. Built-in meters are used in different ways, depending on the type of camera.

- With a manually adjustable camera, you select the shutter speed and the meter reading indicates a lens opening for you to use.

- With some automatic cameras, you select the lens opening, and the meter automatically selects the correct shutter speed. After you choose the lens opening for the depth of field you want to achieve, the meter automatically selects the correct exposure time—to as long as several seconds depending on the camera. The exposure system in these cameras is called *aperture preferred.*

- With other automatic cameras, you select the shutter speed appropriate for the subject and the meter automatically selects the correct lens opening. This exposure system is called *shutter-speed preferred*.

- With completely automatic cameras —some are called "programmed automatics"—the meter selects both the shutter speed and the lens opening for proper exposure.

For handy reference keep the exposure chart with your camera.

There are automatic cameras that have both aperture-preferred and shutter-speed-preferred exposure systems. Some of these cameras also have a programmed automatic mode which sets the best shutter speed and aperture combination for the lighting conditions. Many automatic cameras have a manual override feature so that you can also set the shutter speed and lens opening manually. With cameras that have more than one method of determining exposure, you can choose the method that you prefer for the picture-taking situation. In addition, most automatic cameras provide a means of altering the exposure for unusual scenes or lighting conditions when the camera is set for automatic exposure. See page 67.

Most exposure meters today including those in cameras are powered by batteries. These batteries may last about a year depending on the amount of use. It's important that the meter batteries be in good condition for the meter or the exposure system in the camera to work properly. Many cameras and exposure meters have a battery-check indicator to tell you whether the batteries are okay. See the instruction manual for your equipment. If your camera or meter doesn't have a battery-checking device and the exposure meter is not working properly, it usually means that the batteries need to be replaced or possibly need to be cleaned. Try cleaning the battery con-

It's a good idea to be aware of the exposures required for different kinds of lighting conditions by paying attention to the exposures indicated by your exposure meter rather than just blindly following your meter. In addition, a good way to become familiar with the exposures you may want to use is to study the exposure tables in film instructions like those shown above, in photo books, and in other photographic publications. This exposure information will help you use your meter correctly and will give you suggested exposures if your meter stops working. Also, knowing ahead of time what exposures will be required helps you choose a film with an appropriate speed and select a lens with an adequate maximum lens opening and depth of field.

tacts in your camera and on the batteries with a rough cloth; if this doesn't solve the problem, then replace the batteries with fresh ones. (Also, see page 122.)

WARNING: Never dispose of used batteries in a fire, as they can explode.

Regardless of whether you use an exposure meter built into the camera or a separate exposure meter, the information in this chapter will help you get the most out of your meter. In addition, read and follow the instructions for your equipment.

EXPOSURE LATITUDE

You'll get the best picture quality when your films are properly exposed, so it's best to use the precisely correct exposure setting every time. However, be-

cause of the exposure latitude of most films, you can vary exposure slightly and still get good pictures. (The Camera Auto Sensing Code on all 35 mm Kodak films with DX-encoding designations may program the meter on a compatible camera with film exposure latitude as well as speed.)

You'll usually get good exposure with color-slide films if your exposure setting is no more than ½ stop over or under the ideal exposure. You have somewhat more latitude with color or black-and-white negative films for prints. With negative films, you usually have more exposure latitude for overexposure than for underexposure.

The key to the difference in exposure latitude with the two types of film lies in the printmaking process. Prints made from incorrectly exposed negatives can appear properly exposed if enough correction can be made during printmaking. Slides, on the other hand, don't have the print medium in which to correct for underexposure or overexposure. Since the finished slide is the same film that you exposed in your camera, color-slide films have less exposure latitude.

REFLECTED-LIGHT EXPOSURE METERS

The exposure meters built into cameras are reflected-light meters. Once you've set the film speed on your camera or your meter (not necessary with a camera that senses films with DX-encoding designations), you're ready to take the meter reading. Aim your camera or, if you're using a separate reflected-light meter, point the meter at the scene you are going to photograph to measure the average brightness of the various areas in the scene. Then, using the exposure information determined by your meter, set your camera accordingly.

John F

It's easy to determine the exposure for a normal scene. Just make the meter reading from the camera position by aiming your exposure meter or camera with built-in meter toward the subjects. When lighting conditions remain unchanged during most of the day, such as in bright sunlight, you can use the same exposure for similar subjects and lighting direction without having to make a separate meter reading every time you take a picture. You will have to make meter readings in early morning or late afternoon when the daylight is not as bright. Bernard, Mt. Desert Island, Maine

John Fis

When there are scattered clouds with areas of clear, blue sky and the sun is unobscured by a cloud, the exposure should be the same as when there is a cloudless, blue sky. If a cloud does obscure the sun you'll have to make a meter reading and increase exposure as indicated by your meter. Farm in Vermont

If your camera is automatic, the exposure system determines the correct exposure automatically. Making the meter reading from the camera position works well for most pictures because most subjects have average reflectance.

There is an exposure precaution you should be aware of when you're taking pictures with an automatic-exposure single-lens reflex camera on a tripod with your eye not directly at the viewfinder. With your eye away from the viewfinder, such as when you're using a cable release or the self-timer, light can enter the eyepiece. This can inflate the meter reading on some SLR cameras causing underexposure. To prevent an erroneous automatic meter reading, cover the eyepiece of the viewfinder with your hand or a piece of black tape or a dark cloth. Check your instruction manual to see if this is necessary with your camera.

SELECTIVE METER READINGS

Very contrasty scenes that have large dark or bright areas may require selective meter readings. An overall meter reading from the camera position is affected by the large areas in the scene, such as light or dark foregrounds or backgrounds. If either a large moderately dark area or a large moderately light area is the area of most importance, the meter reading from the camera position should yield a properly exposed picture. But if the main subject is surrounded by a large area that is much lighter or darker than the subject, the meter will indicate an exposure that's incorrect for the main subject. In situations such as this you should make a selective meter reading. For example, make a close-up reading of the subject that excludes the unimportant light or dark area. When you make a close-up reading, be careful

Pete Culross

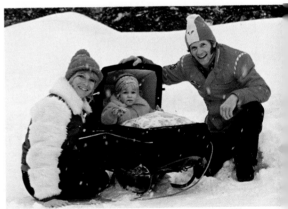

Neil Montanus

A reflected-light exposure meter can be fooled when the surroundings are brighter than your subjects, such as on a white-sand beach or during the winter when there is snow on the ground. The meter is influenced by the bright areas in the scene causing a meter reading that's too high which results in underexposure. The solution for proper exposure is to make a close-up meter reading of the subjects.

not to measure your shadow or the shadow of the camera or meter.

With cameras that have built-in exposure meters, you can usually make selective meter readings if you can make the reading and set the shutter speed and lens opening manually. If you're using an automatic camera, you can also usually make the selective

63

The reverse of the bright background situation is a background darker than the subject which can mislead your exposure meter. Surroundings darker than your subject can cause a meter reading that's too low resulting in overexposure. To obtain the right exposure, make a close-up meter reading of the subject.

meter readings described here to obtain the correct exposure. How you do this depends on the recommendations for the exposure system in your camera. See page 67.

Another situation that requires a selective meter reading is a scene that includes a large proportion of sky. Since the sky is usually brighter than other parts of the scene, your exposure meter may indicate too little exposure. As a result, a subject that's darker than the sky may be underexposed. This effect is even greater with overcast skies than with blue skies. Some manufacturers of reflected-light meters suggest tilting the meter downward slightly to avoid undue influence from the sky. The exposure meters in some cameras are designed to reduce the effects of a bright sky.

In backlighted scenes, the background is often sunlit and therefore brighter than the subject. Also, light may shine into the light-sensitive meter cell. Both of these factors cause the meter to read too high, resulting in underexposure of the subject. The solution is to take a close-up meter reading of the subject while you shade the meter with your hand or some other object.

When you need to make a close-up meter reading and you use a zoom lens (page 148) with a camera that has a through-the-lens meter, you may be able to set the lens on a long focal length and make the close-up meter reading without moving from where you want to take the picture. After making the meter reading, reset the zoom lens to its original focal-length setting for taking the picture.

Sometimes a large very light area or a large very dark area is an important part of the picture. Scenes that have large areas of snow, white sand, or white concrete, where you aren't taking close-ups of people, fall into this

Margaret Williamson Peterson

A blue sky near the horizon is usually brighter than the rest of the scene. For correct exposure tilt the meter down so it doesn't measure the sky if the lower part of the scene has normal reflectance or make a close-up reading of the subjects.

John J. Bright, KINSA

In backlighted scenes, the background is often brighter than the subject, so here again take a close-up meter reading of the subject. Also, the sun can shine into the meter cell or camera lens on a camera with through-the-lens metering causing a meter reading that's way too high and thus underexposure. To avoid this, hold your hand or some other object so it blocks the sun from shining on your meter or camera lens. Be careful not to include your hand or other object in the meter or camera field of view.

A reflected-light meter reading of a snow scene can result in gray looking snow because the meter measures the white snow and tries to make it look like a normal subject. Increase the exposure indicated by the meter by 1 stop for good exposure.

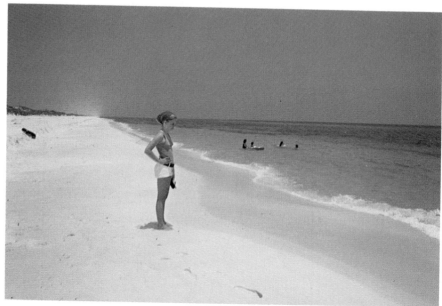

Like a snow scene, white-sand beaches such as those in Florida can cause a meter reading that's too high resulting in sand that's too dark in the picture. To correct for this situation, open the lens 1 stop more than the indicated exposure. It's a good idea to bracket your exposure because the brightness of sand varies considerably. The people in this scene are a small part of the picture and therefore do not influence the exposure.

category. If you exposed according to an overall meter reading, the scene would be underexposed—too dark. The light area would come out gray. This type of light scene usually requires 1 stop *more* exposure than indicated by the meter. It's a good idea to compare the camera settings you have determined with the exposure recommended for snow or light sand in the film instructions. If your exposure is much less, you'll probably get better results by following the instructions.

When you encounter a dark scene, for example a black horse against a dark background of woods with deep shade, use 1 stop *less* exposure than the meter indicates to avoid having the picture come out too light. For a scene that is difficult to meter, it helps to bracket your exposures in order to get a properly exposed picture, as described on page 72.

If a scene has both bright and dark areas, make reflected-light meter readings of the brightest and darkest areas that are important to the picture and use an *f*-number midway between those that the meter indicates.

Selective Meter Readings with Automatic Cameras: The exposure system in automatic cameras gives the correct exposure for most scenes. However, for those scenes just described that would mislead the camera exposure meter, you should alter the exposure settings determined by the camera to obtain the best exposure. The way you can do this varies with the features available on your camera.

Some automatic-exposure cameras have a memory-lock button. This lets you make a selective meter reading and hold the reading while you recompose the picture in the camera viewfinder and then take the picture. For example, if you needed to make a

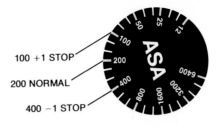

100 +1 STOP

200 NORMAL

400 −1 STOP

For an automatic camera with no manual override or exposure compensation dial, alter exposure with the film-speed setting. With an ISO (ASA) 200 film, set the film speed at 400 for one stop less exposure, 100 for one stop more. Use the 1/3-stop increments for finer adjustments—see page 41. **Reset the film-speed correctly after you take your special situation picture.**

close-up meter reading of the subject, you could move in close to make the reading, push the memory-lock button to hold the exposure, and then move back to your original position to take the picture.

If your camera doesn't have this feature, it may have a shutter release that will let you hold the meter reading when you press the release partway down. This lets you make a selective meter reading and hold the reading until you have the composition you want. Then you press the shutter release all the way down to take the picture. As we mentioned before, if your camera has manual override which lets you determine exposure manually, you can always use the manual method to make selective meter readings as you would if you were using a separate exposure meter.

Another way of altering exposure on some automatic-exposure cameras is to use the exposure compensation dial. This dial lets you change the exposure determined by the camera by usually plus or minus 2 stops in half-stop increments. Instead of a dial compensation control, some automatic exposure cameras have an exposure compensation button that increases exposure by a fixed amount—usually 1½ to 2 stops

and is most commonly used for backlighted subjects.

If your auto camera doesn't have these exposure controls, it may be possible to change the exposure that would be determined automatically by changing the setting of the film speed dial on your camera. The numbers on this dial, such as 32, 64, and 125, are a full *f*-stop apart. There are two index marks which are 1/3-stop apart between each pair of numbers. This lets you change the setting on this dial by 1/3-stop increments.

In order to correct the exposure with the exposure compensation dial or the film speed dial for scenes that would fool the automatic exposure system in the camera, you can either estimate the exposure correction required or make a selective meter reading with the camera meter. Estimating the correction required is a good procedure for overall light or dark scenes when you're not photographing people. For example, with a brightly lighted snow scene, the camera exposure meter would be influenced by the bright snow and the scene would be underexposed. Since this kind of scene usually requires 1 stop more exposure than indicated by the meter, set the exposure compensation dial for 1 stop more exposure. If your camera doesn't have this dial, divide the film speed by 2 and set the lower film speed number on the film speed dial. If the speed of your film is ISO (ASA) 200, set 100 on your camera.

If you were photographing a very dark scene that the camera would normally overexpose, set the exposure compensation dial for 1 stop less exposure or multiply the film speed by 2 and set the resulting higher number on the film speed dial. In our example for ISO (ASA) 200 film, set 400 on the film speed dial.

After you have photographed the scene that required a correction in exposure, remember to return the setting on the exposure compensation dial or the film speed dial to the normal setting.

When you want to make selective meter readings, such as a close-up reading of the main subject, with an automatic camera that does not have a memory-lock button or a shutter release that will hold the reading, you can use the exposure compensation dial or the film speed dial on your camera. First make the selective meter reading with the exposure compensation dial or the film speed dial set normally. Note the indicated lens opening and shutter speed the camera would use for the selected area for metering. Next compose the scene in the camera viewfinder the way you want to take the picture. Then adjust the exposure compensation dial or the film speed dial until you obtain the same lens opening and shutter speed as indicated by the selective meter reading. This should give you the correct exposure. **Return the exposure compensation dial or the film speed dial to the normal setting after photographing the scene that required an exposure adjustment.**

SUBSTITUTE READINGS

What if you can't walk up to your subject and take a meter reading? Try a reading of the palm of your hand, if your hand is illuminated by the same light as your subject. Then use a lens opening 1 stop larger than the meter indicates since your hand is about twice as bright as an average subject. Or you can make a substitute meter reading from a test card such as the KODAK Gray Card, that has a gray surface with average reflectance.

A spot meter is useful for scenes with uneven lighting when you want to make the meter reading from the camera location.

SPOT EXPOSURE METERS

Spot meters measure the brightness of only a small area of the scene from the camera position. Therefore, these meters aren't influenced by areas surrounding the main subject. This lets you make selective meter readings without moving close to your subject. This type of meter is especially useful for telephoto pictures that include only a small portion of the scene and for scenes with very high contrast. However, since a spot meter reads only a small area at a time, you must decide which areas in the scene are important to your picture and measure these areas. This is especially true when you take pictures with a normal or wide-angle lens and the scene includes areas of many different brightnesses. To determine correct exposure in these

situations, use the exposure that is halfway between the correct exposures for the lightest important area and the darkest important area.

Some cameras have through-the-lens exposure meters that work on the same principle as spot meters. They read only a small segment of the scene. Other through-the-lens meters read the entire picture area. Still others take a weighted reading. In meters that weight the reading, the center spot has the greatest influence on the exposure determination. But the remaining picture area also exerts some influence on determining the exposure. As always, it's a good idea to check the equipment instruction manual for the manufacturer's suggestions on how to use your particular equipment for best results.

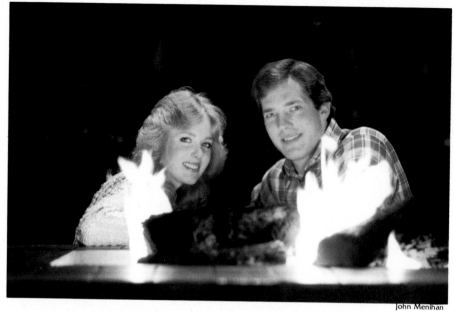

A conventional meter reading from the camera position would lead to overexposure because of the dark surroundings. With a spot meter you could make a meter reading of the subjects' faces without moving from where you want to take the picture. Made on KODACOLOR VR 1000 Film.

INCIDENT-LIGHT EXPOSURE METERS

Incident-light meters measure the illumination falling on the scene. You hold this type of meter in the same light that's illuminating the subject, usually near the subject, and point the meter at the camera (unless the instruction manual for your meter recommends a different technique).

Exposure determined by an incident-light meter assumes that the subject has average reflectance. Fortunately, most scenes have average reflectance, so the exposure indicated by an incident-light meter is good for most picture-taking situations. However, if a very bright or very dark area is an important part of the picture and detail recorded in that area in the picture is wanted, you should modify the exposure indicated by the meter:

- Use a lens opening ½ to 1 stop smaller than the meter indicates if a bright subject is the most important part of the picture.

- Use a lens opening ½ to 1 stop larger than the meter indicates if a dark subject is the most important part.

If the scene is unevenly lighted and you want the best overall exposure, make incident-light readings in the lightest and darkest areas of illumination that are important to the picture. Then use the ƒ-number that's midway between those that the meter indicates.

With an incident-light meter, you point the meter toward the camera position to make the reading. The meter measures the incident light illuminating the subject. An incident-light meter is not influenced by the brightness of the subject. If the lighting at the camera position is the same as the lighting on the subject, you can make the meter reading at the camera position with the meter facing the camera. If the lighting is different at the subject, then you have to make an incident-light reading at the subject location.

Mark Gibson, KINSA

One advantage of an incident-light meter is that it isn't misled by surroundings darker or lighter than the subject. Here an incident-light reading made a short distance away from the subjects in the same lighting would not be influenced by the dark foreground and background.

BRACKETING EXPOSURES

There may be times when very unusual lighting or subject brightness will exhaust the versatility of you and your meter. To assure yourself of getting the best exposure when this happens, it's wise to bracket your exposures. Take a picture at the exposure setting indicated by your meter, another at 1 lens opening smaller, and a third at 1 lens opening larger. If it's a case of now or never, also shoot pictures at 2 stops more and 2 stops less exposure than the meter indicates.

1/60 sec f/8, 1 stop overexposed

1/60 sec f/11, film speed ISO (ASA) 64, normal exposure

Bracketing your estimated exposure is good insurance for getting a picture with proper exposure when you're not sure what the exposure should be. These pictures show exposure bracketing of 1 stop on either side of the estimated exposure. Strasenburgh Planetarium, Rochester, New York

1/60 sec f/16, 1 stop underexposed Caroline Grimes

R. Dorman

Bright sunlight is very popular for outdoor photography. Colors are at their brightest when the sun is shining. The bright colors and the sparkling highlights and interesting shadows created by a radiant sun produce brilliant pictures.

DAYLIGHT PHOTOGRAPHY

The lighting outdoors in the daytime is quite variable. Sometimes it's brilliant sunlight that might be shining on the front, side, or back of your subject. At other times it may be the shadowless light of an overcast day or the dim light of a deep forest. Knowing how to make the most of the various daylight lighting situations will mean better pictures for you. Understanding outdoor lighting will make you aware of more interesting picture possibilities and increase your creative abilities.

Midday

Late afternoon

Sunset Herb Jones

Since the appearance of a scene varies with the time of day and the outdoor lighting conditions, you'll get better pictures by observing these differences and taking the picture when the conditions are optimum for the effect you want to create. Half Dome, Yosemite National Park, California

DESCRIPTIONS OF BASIC DAYLIGHT LIGHTING CONDITIONS

To become familiar with the nature of outdoor lighting, you should have a clear impression of the basic daylight lighting conditions and the exposures they require. Even though most 35 mm cameras have built-in exposure meters, you can use the exposure guidelines to verify that you're using your exposure meter correctly or to determine the correct exposure to use if your meter is not working properly.

BRIGHT OR HAZY SUN, AVERAGE SUBJECTS

The sun is shining with a blue sky or the sun is covered with a thin haze. The sun is unobstructed and clearly defined, though scattered clouds may be present. Shadows are sharp and distinct.

You can determine the basic exposure for frontlighted, average subjects in bright or hazy sun by a simple formula:

$$\frac{1}{\text{Film Speed}} \text{ second at } f/16$$

For example, if you're using a film with a speed of ISO (ASA) 64, the exposure would be 1/64 second at f/16. Use 1/60 second, the speed nearest to 1/64 on your camera. You can use this formula to find the exposure if you don't have an exposure meter or if your meter is in need of repair. We will refer to this basic exposure in our discussion of other lighting conditions.

BRIGHT OR HAZY SUN, ON LIGHT SAND OR SNOW

The sun and sky condition is the same as for the first lighting condition given above, but the subjects are on very light sand or snow. Since these bright surfaces reflect a lot of light, the

It's easy to take pleasing pictures in bright sunlight when bright colors are more abundant and people are happy with sunny dispositions. An average subject, frontlighted in bright sunlight, forms the basis for comparing the exposures required for other daylight lighting conditions.

Neil Montanus

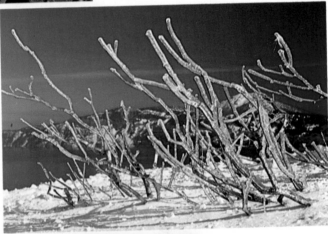

Winter scenes with snow and ice and scenes with bright sand are brilliant subjects. In bright sunlight, these subjects require about 1 stop less exposure than for average subjects.

White Sands National Monument, New Mexico

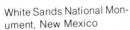

Keith Boas

75

recommended exposure is 1 stop less than the basic exposure for average subjects.

Note that the exposure corrections given in this section are for use with the basic daylight exposure defined on page 74, not with exposure meter readings. Refer to the chapter on exposure beginning on page 59 for how to use in-camera and handheld exposure meters. Also, see page 67.

Because reflected-light exposure meters can be fooled by such light backgrounds, to determine the proper exposure make a close-up reading of the subject. If this is not practical, be suspicious of a meter reading that calls for an exposure much less than 1 stop less than the basic exposure for average, frontlighted subjects in bright or hazy sunlight. If the meter reading is too high because of the bright background, you'll probably get better results using the exposure recommendations given here.

WEAK, HAZY SUN

The light from the sun is weakened by a heavy haze and the sun's disk is visible but diffusely outlined. Shadows are weak and soft but readily apparent. Since there are no harsh shadows, these conditions are wonderful for photographing people.

With weak, hazy sun, you use 1 stop more exposure for average subjects than the basic exposure for bright sunlight.

Lee Howick

Weak, hazy sun is flattering lighting for informal portraits. Shadows are softer and it's easier for people to have natural expressions when the sunlight is not so bright for their eyes.

Marty Czamanske

Under cloudy bright sky conditions there are no shadows so you don't have to be concerned with the direction of the lighting. (See Sidelighting and Backlighting, page 81.) Made in Sweden on EKTACHROME 100 Film.

CLOUDY BRIGHT

The sun is hidden by light clouds. The sky may be completely overcast or there may be scattered clouds. You can't see the sun's disk, but you can tell where it is by a bright area in the sky. There are no shadows.

Cloudy bright requires an exposure 2 stops greater than for bright sunlight.

HEAVY OVERCAST

The sky is filled with heavy clouds and there's no bright area to show the location of the sun. There are no extremely dark areas to indicate an approaching storm and there are no shadows.

Use 3 stops more exposure for heavy overcast lighting than for bright sunlight.

Marty Czamanske

The soft, diffused lighting from an overcast sky brings out appealing tonal qualities from the brightly colored flowers and flatters the girl's excellent complexion. Made in Stockholm, Sweden on KODACOLOR VR 100 Film.

OPEN SHADE

This is the kind of lighting you have when your subject is in the shadow of a nearby large object such as a house or a building. But you can still see a large area of open sky overhead, in front of the subject.

Open shade usually requires an exposure increase of 3 stops over that for bright sunlight.

Shot In The Dark Studios

Open shade describes the lighting conditions when your subject is in the shade of a nearby object that is not overhanging the subject and there is open sky overhead. Since there is no sunlight to cause squinting, chances are your subjects will have more pleasing expressions. Made on EKTACHROME 100 Film.

Don Maggio

When your subject is in the shade of objects blocking the sky overhead, you'll have to rely on exposure meter readings for proper exposure. The amount of light varies considerably and typically requires 1 or 2 stops more exposure than open shade.

Richard W. Brown

Sometimes the best time of day to take pictures is early or late in the day when artistic highlights and shadows are created by low sun angles when the sun is near the horizon. So don't restrict yourself to just taking pictures in the middle of the day. You'll need to increase exposure one or more stops.

BRIGHT SUNLIGHT

Most outdoor pictures are made in bright sunlight. This type of lighting offers the advantage of making colors look their brightest and snappiest. Exposure calculation is also simpler in bright sunlight because you can use the same exposure settings for most subjects. As long as you take pictures of average frontlighted subjects, you can shoot during most of the day at the same exposure settings.

A basic way to take pictures is in bright sunlight with frontlighting. The sun is behind the photographer's back or slightly off to the side. When the sun is at a slight angle to the camera axis, modeling from the highlights and the shadows on your subject's face gives it a three-dimensional quality. Made in Stockholm, Sweden, on EKTACHROME 100 Film

Marty Czamanske

79

Lee B. Bales, Jr., SKPA*
*Courtesy Scholastic/Kodak Photography Awards

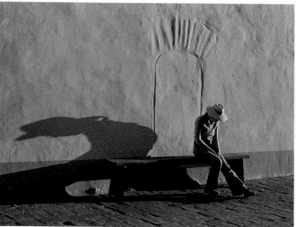

The strong sidelighting rims the man's form with highlights, enhances the texture of the wall and the bricks in the walkway, and creates interesting shadows.

Herb Jones

Sidelighting emphasizes the features of the boy's face and the texture of his clothing. For sidelighted close-ups, use 1 stop more exposure than for a frontlighted subject.

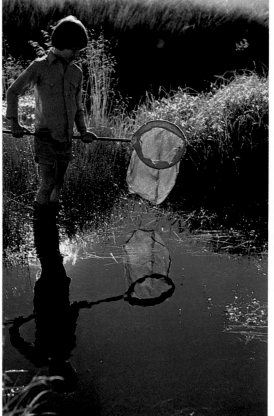

Backlighting provides separation between the girl holding the net and the background. The big advantage of backlighting is the appealing highlights that it creates.

J. Perley Fitzgerald, KINSA*
*Courtesy Kodak International Newspaper Snapshot Awards

SIDELIGHTING AND BACKLIGHTING

If you photograph all your subjects by frontlighting, you'll miss some excellent picture possibilities. Sidelighting and backlighting can help create interesting and pictorial photographs. You can use sidelighting and backlighting to produce strong separation between a subject and the background because the lighting creates a rim of light around the subject. You can use this type of lighting to emphasize the shape of the subject since sidelighting and backlighting create highlights and shadows called modeling. You can also use strong sidelighting to bring out surface textures and backlighting to capture the translucent quality of flowers and foliage. These advantages are lost when the sunlight comes over your shoulder and falls directly on the front of your subject.

When you take pictures of backlighted and sidelighted subjects, shielding your camera lens from the direct rays of the sun will help to avoid lens flare. You can use a lens hood or the shadow from your hand or a nearby object. Also be sure the sun's rays don't strike the light-sensitive cell of an automatic camera or exposure meter.

You'll usually need to use larger lens openings or slower shutter speeds for this type of lighting than for frontlighted subjects. In close-up pictures, especially of people, the shadows will probably be large and contain important details. To capture this detail, increase exposure for sidelighted subjects 1 stop over the normal exposure you'd use for frontlighted subjects, and give backlighted subjects 2 stops more exposure than normal. When you're photographing subjects at a medium distance and shadows are part of the

Herb Jones

When you're taking backlighted pictures, you should use a lens hood or shield the camera lens with your hand or another object to keep the sun from shining into the lens. It's also very important to keep your lens sparkling clean. Sunlight shining into the lens can cause reflections and flare inside the lens and camera which can spoil your pictures.

Gary Whelpley

The sunlight has produced shimmering highlights on the water in this picture which shows effective use of backlighting.

81

scene but not too prominent, increase exposure by only 1/2 stop from normal for sidelighted subjects and 1 stop for backlighted subjects. If you're photographing a distant scenic view in which shadows are relatively small and don't contain important detail, usually no exposure increase is necessary.

Backlighted close-up pictures may contain important shadow areas. To capture the detail in the shadows, give a backlighted subject 2 stops more exposure than you'd use for a frontlighted subject. Made in Sweden on KODACOLOR VR 200 Film.

Marty Czamanske

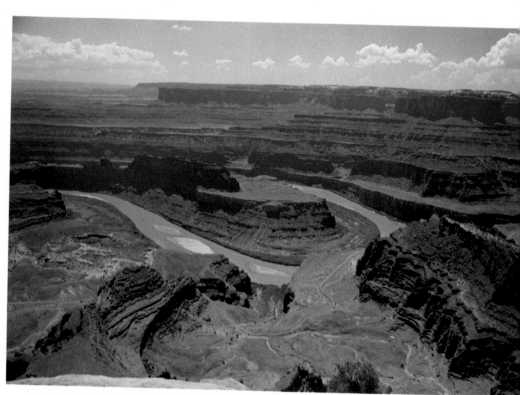

Caroline Gri

No exposure increase is usually required for sidelighting or backlighting in scenic views where the shadows are small without important detail. Dead Horse Point near Moab, Utah

Both of these are good pictures. However, the one on the top with backlighting is better because the lighting is more pleasing on the subjects' faces than the harsh frontlighting in the bottom picture caused by a high sun angle. The bright surface of the tennis court is a natural reflector which helped lighten the shadows in the backlighted picture.

Morning

It's interesting to study how the appearance and mood of a scene vary in the course of a day as the lighting changes from backlighting in the morning, to frontlighting at midday, then to sidelighting in the afternoon. Knowing how the lighting and contrast will vary in the scene from the changing position of the sun gives you control over the best time for taking the photograph.

Midday

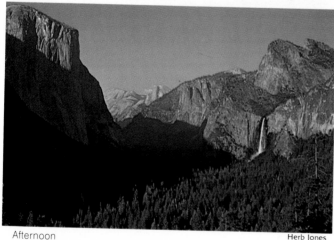

Afternoon

Herb Jones

For a completely different effect you can underexpose a backlighted subject, such as this giant Sequoia tree, to create a ponderous silhouette. Use the same exposure as for a frontlighted subject in bright sunlight. Since conditions vary also try 1 and 2 stops less exposure in order to get a dark silhouette.

Robert Kretzer

The intriguing shadows from backlighting make this a rewarding photograph. You'll get better pictures if you train your eyes to recognize opportunities for photographing backlighted subjects.

Suzanne Gayle Locke, KINSA

Shot In The Dark Studios

In the picture above, the subjects appear happy and at ease with their backs turned toward the sun. Fill-in flash brightened the shadows. Below you see the frontlighted attempt and below that the backlighted version without flash fill. Made on KODACHROME 25 Film.

REDUCING LIGHTING CONTRAST

The contrast between shadow and highlight in brightly sunlighted conditions is frequently greater than film can reproduce. The answer is to reduce the contrast by brightening the shadows of important scene elements to preserve valuable detail.

FILL-IN FLASH

Fill-in flash is especially useful for brightening the shadows in scenes with nearby people. As a bonus, you'll probably get a more relaxed expression when your subject turns away from the sun to avoid squinting.

Electronic flash is ideal for fill-in purposes, although blue flashbulbs will work well too. (Your artificial light source must be "daylight" color balance—compatible with sunlight—so that color rendition of the scene appears natural.) Use the table on page 89 to determine effective flash distances with your electronic flash unit.

If you want to get closer to your subject than the near distances in the tables, you can cut down on the amount of light from the flash by covering it with one layer of white handkerchief. Then you can divide the subject distances mentioned in the tables in half.

The tables work with any film because they're based on the ratio of flash illumination to sunlight not on film speed. The speed of the film is taken into account in determining the normal exposure for sunlight.

Similar fill-in flash tables are included in the *KODAK Master Photoguide* (AR-21), mentioned earlier, which are convenient to use when you're out taking pictures.

Neil Montanus

To avoid squinting expressions, photograph your subject with his back to the sun and fill in the shadow areas with flash.

Fill-in flash adds bright highlights to your subject's eyes.

Eastman Kodak Company

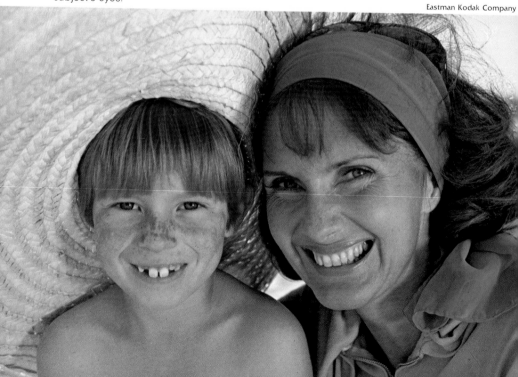

FILL-IN FLASH TABLES FOR BRIGHT SUNLIGHT

SUBJECT DISTANCES FOR FILL-IN FLASH WITH ELECTRONIC FLASH
Distance in Feet
For manual flash units and automatic flash units set on manual

Output of Unit BCPS*	Shutter Speed with X Synchronization†			
	1/30	1/60	1/125	1/250
350	1½—2—3½	2—3—4½	3—4—7	3½—5—8
500	2—3—4	2½—3½—5½	3½—5—8	4—5½—9
700	2—3—4½	2½—3½—6	4—5½—9	4½—6—10
1000	2½—3½—5½	3½—5—8	5—7—11	6—8—13
1400	3—4—7	4—5½—9	6—8—13	7—10—15
2000	3½—5—8	5—7—11	7—10—15	8—11—18
2800	4—5½—10	6—8—13	8—11—18	10—14—20
4000	5—7—11	7—10—15	10—14—20	12—17—25

*If the output of your flash unit is not given in BCPS by the flash manual, use the table on page 108 to derive BCPS from a Guide Number, which is usually provided by the manual.

†With focal-plane shutters, use the shutter speed that your camera manual recommends for electronic flash.

INSTRUCTIONS

1. Set the fastest shutter speed recommended by your camera manual for flash picture-taking to gain the greatest flexibility with exposure and subject distance.** Using a relatively low-speed film is also helpful. Set an automatic flash system on "manual," if possible. On some camera models you may have to select "X" flash synchronization or plug your flash into a socket marked "X."

2. Use the corresponding lens opening that would give you normal exposure for a frontlighted subject in sunlight—for example, 1/60 second at *f*/16 for a film with a speed of ISO (ASA) 64.

3. You'll need to know the BCPS output of your electronic flash unit to find the subject distances in the table above. If the information is not given in the flash manual, find the guide number in the manual and apply it to the chart on page 108 to find the BCPS for your unit. It is better to use BCPS (strictly a measurement of the flash output) rather than a guide number (a measurement of flash output that includes film speed). The table works with any film because your determination of the exposure (camera settings) for sunlight takes the film speed into account.

4. Read to the right in the table and locate the distance range for the shutter speed you're using. You'll get full fill, a 2:1 lighting ratio, with your subject at the near distance; average fill, a 3:1 lighting ratio, at the middle distance; and slight fill, a 6:1 lighting ratio, at the far distance.

5. Position your subject's back to the sun at the distance that will give you the amount of fill that you want, and then take the picture.

**Many automatic flash systems offer automatic exposure for fill-in flash. Differences exist among flash units and cameras, however, and the best way to learn about automatic flash fill is from your camera and flash manuals. As above, however, you're still trying to get normal daylight exposure with a little less than full flash exposure for your subject. Some cameras with automatic built-in flash cannot be adjusted to cope with both situations over a broad distance range. In this case, it's probably best to use fill-in flash anyway—the result may be better than if exposed without flash.

With the subject at the near distance shown in the table on page 89, you will get full fill—a 2:1 lighting ratio.

If you place your subject at the middle distance, the result will be average fill—a 3:1 lighting ratio.

At the far distance, your subject will receive slight fill—a 6:1 lighting ratio. Made on EKTACHROME 100 Film.

Marty Taylor

Marty Czamanske

You can reduce lighting contrast by using a reflector to bounce light into the shadow areas of a backlighted subject. Made in Sweden on EKTACHROME 100 Film.

Don Maggio

Using a reflector to fill in the shadows is an excellent technique for outdoor informal portraits because your subject doesn't have to look into the sun.

REFLECTORS

Another good way of reducing the contrast of a nearby subject on a sunny day is to use a reflector to bounce light into the shadow areas. The reflector can be almost anything that will reflect light—a large piece of white paper, crumpled aluminum foil, or even a white sheet. Don't use a colored reflector with color films because it will reflect light of its own color onto your subject.

Try to have the reflector close enough to your subject, but not *in* the picture, to bring the light level in the shadows within 1 stop of normal sunlight exposure. Expose as you would for a normal frontlighted subject.

Sometimes you'll be able to take advantage of natural reflectors in a scene to fill in the shadows. If you can photograph your subject in surroundings including bright reflective surfaces like light sand, white buildings, or snow, the light reflected from them will often fill in the shadows to produce a pleasant lighting effect.

A reflector was used
to lighten the shadows.

John Menihan, Jr.

You can use a piece of white cardboard to
reflect the sunlight into the shadows.

No reflector was used.
The shadow on the
girl is too dark.

NO DIRECT SUNLIGHT

On overcast days or for subjects in the shade, lighting contrast is very low. In these situations you simply use an exposure meter to determine exposure or follow the exposure table in the film instructions. With this very soft and shadowless type of lighting, you won't need to use fill-in flash or reflectors.

When you take color slides on overcast days or in the shade, it's a good idea to use a No. 1A, or skylight, filter over the camera lens. This filter reduces the bluishness of color slides made with this type of lighting. No exposure compensation is necessary with the skylight filter.

You're bound to encounter some unusual outdoor lighting situations, such as those found on foggy days or on the back porch during a rainstorm. In such situations, your best friend is an exposure meter or an automatic camera.

Marty Czamanske

Overcast days are ideal for taking pictures of people because the soft, shadowless lighting is very flattering. Made in Sweden on EKTACHROME 100 Film.

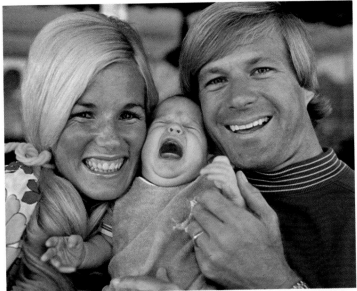

Tom McCarthy

Mom and Dad were happy with the pleasant lighting in the shade, but Baby had other ideas.

93

On overcast days it's best to choose camera angles where little or none of an uninteresting stark, white sky is included in the picture.

The soft, diffuse light from an overcast sky illuminated the porch and prevented harsh patches of sunlight and shadows from surrounding trees that would have resulted from a bright, sunny day.

Neil Montanus

Neil Mont

William C. Miller, KINSA

Some of the best pictures are taken when the lighting is dimmer than typical bright daylight conditions. So don't put your camera away just because it's late in the day; keep on shooting. Rely on your exposure meter for correct exposure settings.

The photographer took advantage of a coastal fog to capture this moody maritime scene.

You can almost feel how wet it is to deliver papers in the rain. On rainy days, keep your camera dry by shooting under the protection of an umbrella.

Sunsets are always popular subjects for pictures. Be ready with your camera because sunsets don't last very long. But when you capture a beautiful sunset on film you can view it as often as you like.

SUNSETS

Beautiful sunsets are superb subjects with rich, dramatic color and sunset pictures are easy to take. For proper exposure, just go by the meter reading of the colorful sky and clouds but do not include the sun in the metered area. Usually the exposure for KODACOLOR VR 100, and EKTACHROME 100 Film (Daylight) when the sun is partly or wholly obscured by a cloud is 1/125 second $f/8$. To have more assurance of obtaining saturated colors, it's best to bracket the estimated exposure by plus and minus 1 stop. When the sun is below the horizon, the sunset is dimmer, so try an exposure series of 1/60 second $f/5.6$, 1/60 second $f/4$, and 1/60 second $f/2.8$ with the films mentioned above. With KODACOLOR VR 200 Film use 1 stop *less* exposure than given above; with KODACHROME 64 Film (Daylight), use 1 stop *more* exposure than given above.

Your sunset pictures will be even better when you include a foreground object that will photograph as a silhouette with the sunset in the background.

Keep your lens sparkling clean because dust particles, fingerprints, or other foreign matter can cause considerable lens flare when you photograph sunsets.

Robert Kretzer

It's easy to take pictures of sunsets because exposure is not critical. Just go by your meter reading of the colorful sky area. Or during the afterglow when the sun is below the horizon try 4 to 6 stops more exposure than for a normal sunlighted scene. Usually, deep, saturated colors are preferred, so avoid overexposure.

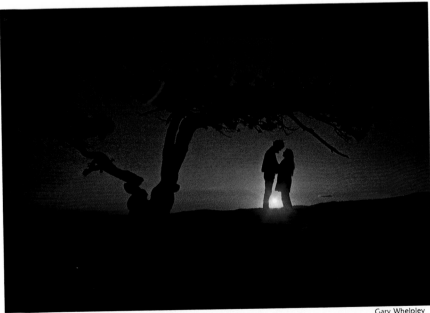

Gary Whelpley

While the setting sun is still above the horizon, use 1 or 2 stops more exposure than for a normal, sunlighted subject.

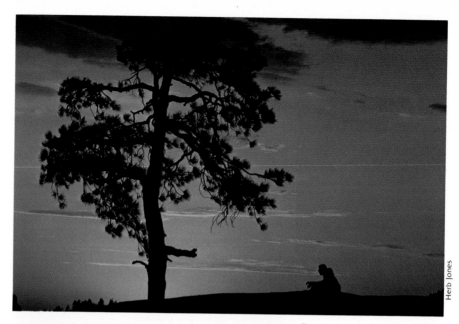

Herb Jones

Be prepared to take several pictures of the changing sunset as the sun sinks below the horizon. Your sunset pictures will be improved if you include objects in the foreground that form interesting silhouettes.

The combination of a sunset reflecting off the ocean offers great opportunities for spectacular photographs.

L. Willinger

Doris Barker

Including the silhouetted couple in a romantic pose, with an orange sky background from the setting sun, is a clever idea for an appealing picture.

Bob Clemens

Since flash is a convenient, portable light source, it's excellent for important away-from-home events. Made on EKTACHROME 100 Film.

FLASH PHOTOGRAPHY

When you move indoors for picture-taking, chances are that you'll be making many of your pictures with flash. With your 35 mm camera and a compact electronic flash unit or a flash holder and flashbulbs, you can take flash pictures about as easily as you take pictures in daylight.

ELECTRONIC FLASH

An electronic flash unit is convenient to use because you can take flash pictures without having to buy or replace burned-out flashbulbs. Electronic flash requires a larger initial investment than a flash holder, although the savings from not having to buy flashbulbs will soon pay for an electronic flash unit if you take many flash pictures. The flashtube, the light source in electronic flash units, can produce thousands of flashes. An added bonus is that the burst of light from an electronic flash is much shorter than that from a flashbulb. The short duration of the flash is ideal for stopping fast action in pictures.

There are two kinds of electronic flash: manual and automatic. With manual flash units, you determine the proper lens opening for your camera from a guide number for the unit and film you're using or from a calculator dial on the flash unit. Automatic flash units have a built-in light-sensitive cell that sees the light reflected by the subject from the flash and automatically controls the output of the flash to produce correct exposure.

BCPS—BEAM-CANDLEPOWER-SECOND—RATINGS

When you take pictures with a manual electronic flash unit or an automatic

Norm Kerr

With your camera equipped with flash, you can take indoor pictures almost as easily as you can make pictures in daylight. Flash makes it possible for you to record those spur-of-the-moment opportunities for good pictures in nearly any close-up situation, regardless of the light level in the scene.

101

unit set on manual, you can determine the correct exposure from the recommended guide number in the same way that you determine exposure for flashbulbs. For an explanation of guide numbers and how to use them, see Flash Exposure on page 106.

To select the proper guide number, you need to know the light output of your electronic flash unit. Electronic flash manufacturers usually specify the light output of a flash unit by providing a BCPS—beam-candlepower-second —rating or a guide number for a specific film or both. This information should be in the instruction manual for your electronic flash unit. If the BCPS output and guide numbers are not given, you can write to the flash manufacturer for the output value for your unit. If you supply the BCPS or any guide number you should be able to determine the correct guide number of your flash unit and the film you're using from the table on page 108.

The higher the BCPS rating or the guide number, the greater the light output. Generally, the larger portable electronic flash units have more powerful light output than the small, compact units. Flash units with more light output let you take flash pictures at greater distances or use smaller lens openings for better depth of field.

Some manufacturers publish watt-second ratings to specify light output of electronic flash. However, watt-seconds is an expression of electrical energy-storage capacity, *not a measurement of the light output* of an electronic flash unit. Two flash units with the same watt-second rating may produce significantly different amounts of light because of differences in reflector efficiency, electrical circuitry, type of flashtube, and method of triggering the flash. For this reason, don't use watt-second ratings to determine guide numbers.

Neil Mont

Outdoors, when your exposure meter indicates insufficient light for normal picture-taking, simply switch to flash. But remember to move close to the activity. Otherwise, your pictures may be too dark. Made on EKTACHROME 100 Film.

Patrick Walmsl

An electronic flash unit can be ready when you are! You won't be missing good pictures while taking the time to change flashbulbs. Made in England on EKTACHROME 100 Film.

The very brief flash duration of an electronic flash unit is ideal for stopping action or catching a fleeting expression.

FLASH DURATION

The ability of electronic flash to stop the action in photographs is one of its main advantages. A typical manual electronic flash unit has an effective flash duration of 1/1000 second. The light-sensitive cell in automatic units controls the duration of the flash to produce correct exposure. Flash duration of automatic units can range from about 1/1000 second to as little as 1/50,000 second, depending on the flash unit and the flash-to-subject distance. The closer the subject distance, the shorter the flash duration; and the farther the subject distance, the longer the flash duration.

FILTERS WITH ELECTRONIC FLASH

The color of the light from most electronic flash units is very close to the color of daylight, so you can usually use electronic flash with daylight-type color films without any filters over the camera lens. But some electronic flash units produce light that is slightly bluer than daylight, especially when the reflector is new. If your flash unit produces slides or color prints that are a little bluer than you like them, you can improve your pictures by using a No. 81B yellowish filter over the camera lens. Increase exposure by 1/3 stop to compensate for this filter. As reflectors age, they sometimes become warmer in color so that you will no longer need to use a filter.

103

FLASHBULBS

Flashbulbs vary in size, light output, color of light they produce, and synchronization characteristics. The three main considerations in selecting a flashbulb are whether you need a blue or a clear bulb, whether the flashbulb fits your flash holder, and whether the bulb is for use with your camera shutter and synchronization.

Flashbulbs are either blue or clear; flashcubes are blue only. Use blue flash with Kodak daylight color films. You can use blue or clear flash with black-and-white films; however, it's usually more convenient to buy only blue bulbs for all your flash pictures. Blue flashbulbs identified by a number have a "B" after it, for example M3B. An M3 flashbulb is clear.

Flashbulbs can be separated into three main groups. One group—26 and 26B flashbulbs—has FP synchronization characteristics for use with cameras that have focal-plane shutters. The second group—AG-1B, M2B, M3, M3B, 5B, 25, 25B, flashcubes, and HI-POWER FlashCubes—has MF or M synchronization characteristics for use with cameras that have between-the-lens shutters. Usually you can use the MF and M sync bulbs with 35 mm focal-plane shutter cameras too, although there may be limitations on the shutter speeds that you can use. The third group—magicubes, flipflash, or flashbar—is not generally used with 35 mm cameras.

To be sure you get the right flashbulb for use with your camera, check the instruction manuals for your camera and flash holder. With some flash holders you can use more than one size flashbulb. If you have an older manual that suggests flashbulbs that are no longer available, buy bulbs that have the flash synchronization characteristics necessary for your camera.

There is more on synchronization in the next section. The shutter speeds that you can use with specific flashbulbs at different synchronization settings are usually printed on the flashbulb carton and some information is provided in camera manuals.

FLASH SYNCHRONIZATION

Some cameras are designed for making flash pictures at all shutter speeds. With other cameras you should take flash pictures only at certain shutter speeds, such as 1/125, 1/60, or 1/30 second and slower. Flash synchronization and the shutter speeds you can use for flash depend on the type of shutter in your camera—either focal-plane or between-the-lens; the synchronization available on your camera—X, M, or FP; and the kind of flash you're using—electronic flash or flashbulbs. Most modern cameras have X sync only.

CAMERAS WITH FOCAL-PLANE SHUTTERS

Older cameras with this kind of shutter may have synchronization settings or flash-cord sockets for X and FP or M. (Newer cameras with focal-plane shutters with no synchronization settings accept electronic flash and flashbulbs at the shutter speeds specified in the camera manual.) The X setting or socket is a no-delay setting for electronic flash which fires the flash unit when the shutter is fully open. Cameras with focal-plane shutters will synchronize electronic flash only at shutter speeds of 1/250, 1/125, 1/90, or 1/60 second and slower *depending on the camera.*

The FP or M setting or socket (depending on the camera) is for use with flashbulbs. These synchronization settings fire the flashbulb when you press

Most single-lens reflex cameras have *focal-plane shutters*. This kind of shutter consists of fabric curtains or metal blades placed behind the lens and as close as possible to the focal, or film, plane. When the shutter is closed you can see it covering the picture area directly in front of where the film will be exposed. With the shutter closed, you cannot see the camera lens from the back of the camera. Since the focal-plane curtain is a delicate mechanism, do not touch it with your fingers. See the illustration on page 23.

If you set the shutter for a speed that's too high with a focal-plane shutter and electronic flash, the camera will not synchronize properly and you'll get only a partial picture. Most cameras with focal-plane shutters are designed to synchronize at 1/60 second, or 1/90 or 1/125 second, or slower depending on the camera. See your camera manual.

Most rangefinder cameras have *between-the-lens shutters*. This kind of shutter has leaves (blades) located between the lens elements close to the aperture. Usually, you can see the camera lens from the back of the camera when the back is open. See the illustration on page 23.

the shutter release but delay the opening of the shutter for a fraction of a second to give the flashbulb time to reach peak brightness. Use flashbulbs designed for cameras that have focal-plane shutters, such as No. 26B, at the shutter speeds recommended for your camera. Most 35 mm cameras with focal-plane shutters will synchronize with other types of flashbulbs. Since different makes of cameras vary, see your camera manual for flash synchronization and shutter speed recommendations.

CAMERAS WITH BETWEEN-THE-LENS (LEAF) SHUTTERS

Cameras with this type of shutter may have X and M settings or no synchronization setting. If there is no sync setting, it usually means that the shutter has X sync only. See your camera manual. The X setting is for use with electronic flash at any shutter speed or flashbulbs at 1/30 second and slower. If your camera has an M setting, you

can use it with an appropriate flash-bulb to take flash pictures at all shutter speeds up to the highest shutter speed on your camera, which is usually 1/500 second. Use M sync with No. 5B, 25B, M3B, and AG-1B flash-bulbs (also with the clear versions of these bulbs) and with flashcubes. If your camera has only X sync or you want to use these bulbs with the X setting at 1/30 second, you'll have higher guide numbers than with the M setting. But remember that X sync is not recommended for higher shutter speeds with flashbulbs. With M2B flashbulbs you must use only the X setting and a shutter speed of 1/30 second or slower.

With a camera that has a between-the-lens shutter, if you're ever in doubt about whether to use the X or M setting, use the X setting and a shutter speed of 1/30 second. This combination works with any flashbulb, flashcube, or electronic flash that you can use with a 35 mm camera.

FLASH EXPOSURE

The correct lens opening for a properly exposed flash picture depends on the light output of your electronic flash unit or the flashbulb you're using, the type of reflector and the shutter speed with flashbulbs, the film you are using, and your distance from the subject. Fortunately, a system of flash guide numbers lumps all these variables into one easy-to-use number for each combination of film, flash, and shutter speed. You'll find flash guide numbers in electronic flash manuals, on flashbulb cartons, and in film instructions.

Guide numbers are easy to use. Divide the correct guide number by the flash-to-subject distance in feet. The result is the lens opening to use.

$$\frac{\text{Guide Number}}{\text{Distance in Feet}} = \text{Lens Opening}$$

For example, if the guide number is 110 and the subject is 10 feet away, the correct lens opening is $f/11$. When the calculated lens opening is one that's not marked on the f-number scale of your camera, just use the nearest one that is marked or a point halfway between the two nearest f-numbers, whichever is closer to the calculation. Of course if you have a metric guide number, you would divide by the distance in metres (usually provided on the lens distance scale) to obtain the same f-number.

A really easy way to determine flash exposure settings is to use the Flash Exposure Dial in the *KODAK Master Photoguide* (AR-21).

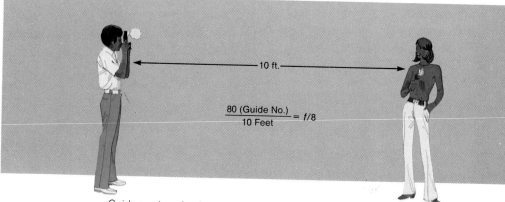

$$\frac{80 \text{ (Guide No.)}}{10 \text{ Feet}} = f/8$$

Guide numbers for determining exposure with flash are quite easy to use. To calculate the exposure, divide the guide number by the flash-to-subject distance in feet. The answer will be the correct f-number for that distance. For example, with a guide number of 80 at a distance of 10 feet, the correct camera setting would be $f/8$.

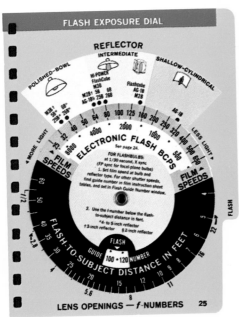

The Flash Exposure Dial in the *KODAK Master Photoguide* (AR-21) provides a convenient means for determining flash exposure for both electronic flash and flashbulbs.

Guide numbers are based on subjects of average reflectance in average-size rooms. If your subject is much lighter than average, use a lens opening 1/2-stop smaller than the guide number indicates; if the subject is darker than normal, use a lens opening 1/2-stop larger than the guide number indicates. When you're taking flash pictures in a small room with light-colored walls, use a lens opening 1 stop smaller than determined by the guide number. This kind of exposure adjustment is not necessary for an automatic electronic flash unit.

Manual Electronic Flash Units.

You determine exposure with manual electronic flash units just as you do with flashbulbs. Divide the guide number by the subject distance to find the *f*-number or use the calculator dial on the flash unit. With electronic flash, the guide number is the same for all shutter speeds. Select the guide number for your combination of electronic flash unit and film from the table on the next page or from the table on the film instructions.

To find the correct guide number in the table, you have to know the BCPS output of your flash unit. See the flash instruction manual. The instruction manual may give the output for your flash unit in the form of a guide number for a film with a certain ISO (ASA) speed. By using the electronic flash table, you can find the BCPS output for your unit as well as the guide numbers for other films.

For example, the recommended guide number in the flash instruction manual might be 70 for a film with a speed of ISO (ASA) 100. In the table find a guide number of 70 opposite an ISO (ASA) speed of 100. The guide number 70 is in the column for a flash unit with an output of 1000 BCPS, which is the output for this particular flash unit. To find the guide number for other films, just look under the 1000 BCPS column opposite the speed of the film you're using. For example, with a film that has a speed of ISO (ASA) 200, the guide number for this flash unit would be 100. You can also use the Flash Exposure Dial in the *Master Photoguide* for these purposes.

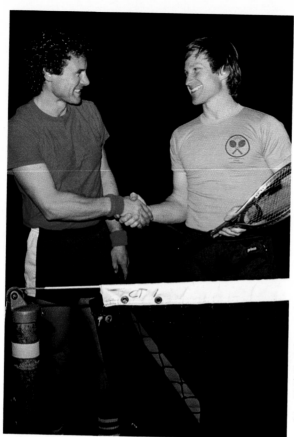

To determine the f-number with a manual electronic flash unit mounted on your camera: 1. Focus the camera. 2. Note the subject distance in feet. 3. Divide the guide number for the film that you're using by the flash-to-subject distance.

When taking vertical flash pictures, hold your camera so that the flash is above the lens, if possible. That way, shadows will appear more normal, slanting downward rather than upward. Made on EKTACHROME 100 Film.

John Menihan

GUIDE NUMBERS FOR ELECTRONIC FLASH

ISO (ASA) Film Speed for Daylight	BCPS Output of Electronic Flash Unit									
	350	500	700	1000	1400	2000	2800	4000	5600	8000
20	18	22	26	32	35	45	55	65	75	90
25	20	24	30	35	40	50	60	70	85	100
32	24	28	32	40	50	55	65	80	95	110
40	26	32	35	45	55	65	75	90	110	130
50	30	35	40	50	60	70	85	100	120	140
64	32	40	45	55	65	80	95	110	130	160
80	35	45	55	65	75	90	110	130	150	180
100	40	50	60	70	85	100	120	140	170	200
125	45	55	65	80	95	110	130	160	190	220
160	55	65	75	90	110	130	150	180	210	250
200	60	70	85	100	120	140	170	200	240	280
250	65	80	95	110	130	160	190	220	260	320
320	75	90	110	130	150	180	210	250	300	360
400	85	100	120	140	170	200	240	280	340	400
500	95	110	130	160	190	220	260	320	370	450
650	110	130	150	180	210	260	300	360	430	510
800	120	140	170	200	240	280	330	400	470	560
1000	130	160	190	220	260	320	380	450	530	630
1250	150	180	210	250	300	350	420	500	600	700
1600	170	200	240	280	340	400	480	560	670	800

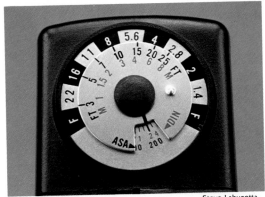

Most manual electronic flash units have a calculator dial which will indicate the correct f-number to use. After you've set the dial for the ISO (ASA) speed of the film that you're using, simply read the f-number opposite your flash-to-subject distance. Here the dial is set for an ISO (ASA) speed of 200. At a distance of 10 feet the dial indicates the correct f-number is f/8.

Steve Labuzetta

Flash pictures of groups where individuals are at different flash-to-subject distances will usually result in uneven exposure. Foreground subjects will be washed-out—overexposed—while people in the background will appear too dark—underexposed. The spread-out arrangement can also cause problems with sharpness as depth of field may not be sufficient to cover both near and far subjects.

When taking pictures of groups, it's better to have all people in the picture at approximately the same distance from the flash. It also helps to position people with lighter complexions farther from the flash, those with darker complexions closer to the flash. Made on EKTACHROME 100 Film.

John Menihan

109

A light-sensitive cell in automatic electronic flash units determines the exposure automatically. The calculator dial on the unit shows you what lens opening to set on your camera and what distance range you can use with the film you are using. Once you've set your camera for the lens opening, you don't have to change it as long as you photograph subjects within the specified distance range. Made on KODACOLOR VR 200 Film.

Automatic Electronic Flash Units.

When you use an automatic flash unit set on automatic, you won't need guide numbers. Set the lens opening on your camera for the speed of film you're using according to the calculator dial on the flash unit or the flash instruction manual. Once you have set the lens opening, an electronic sensor in the flash unit will automatically adjust the duration of the flash for the correct exposure within a specified distance range, for example from 3 to 15 feet.

With some automatic flash units you can use only one particular lens opening for each film speed while more versatile units give you a choice of two or more openings. A choice of more than one lens opening for a film lets you select the best lens opening for the conditions considering the subject distance you want to use, depth of field, and the maximum opening of your camera lens.

If your pictures taken with an automatic electronic flash unit are consistently too light—overexposed, use a lens opening 1/2- to 1-stop smaller than recommended for your flash unit

and film; if your pictures are consistently too dark—underexposed, use a lens opening 1/2- to 1-stop larger than recommended.

Automatic flash units usually have a manual setting that lets you choose the best lens opening to obtain the correct exposure for situations that might fool the automatic exposure control system. This can happen when a scene has large areas that are lighter or darker than the subject—the overall reflectance, or brightness, is lighter or darker than normal. The light sensor in the flash unit has no way of distinguishing this. It tries to make the photograph of the scene appear normal in brightness which is too dark for a normal subject with a very light background and too light for a normal subject with a very dark background. For example, a picture taken outdoors at night of a person with a dark background may be overexposed—too light—with your flash unit set on automatic. When you set the unit on manual, the automatic control system is temporarily disconnected so the flash unit is not influenced by light or dark areas in the

110

Automatic electronic flash lets you take pictures more rapidly, which helps you capture those priceless, fleeting expressions. With an automatic unit, you don't have to calculate and reset the *f*-number on the camera each time you change your subject distance.

When you take a flash picture of a nearby subject against a dark or distant background, the light sensor in an automatic flash unit may be fooled by the dark background. The sensor would try to make the overall picture appear normal in brightness even though most of the scene is dark. As a result, your subject would be too light—overexposed. For this type of scene, it's better to override the automatic feature by setting the flash on *manual* and determine your exposure manually.

When the background is very light and about the same distance as the subject, a lot of the flash will be reflected. The automatic sensor may overcompensate and cause the subject to be too dark—underexposed—in its attempt to produce a picture of normal brightness. For proper exposure of your main subject in situations like this one, switch the flash unit from automatic to *manual* and determine the exposure yourself.

111

Shooting directly into the background mirror created a glare spot from flash reflection.

Bob Harris

To avoid the reflection, the photographer moved so that he was standing at an angle to the mirror.

scene. Fortunately, most flash scenes have normal reflectance so the automatic control system works very well.

Use caution when taking flash pictures of a scene that includes a highly reflective surface such as a mirror, glass, or other shiny surface. The flash can reflect back and spoil your picture with a bright spot of light or cause a picture taken with an automatic flash unit to be underexposed. You can prevent this and get good pictures by changing the camera-to-subject angle.

Dedicated Automatic Electronic Flash. In this case "Dedicated" refers to the successful union between a camera and a flash unit which can provide precise exposure and greater lighting flexibility. A dedicated flash unit is designed and constructed to fit a particular camera or family of cameras. It is often but not always produced by the camera manufacturer. All dedicated flash equipment offers the photographer greater ease of operation by requiring fewer decisions and manual adjustments. More sophisticated equipment provides more accurate exposure sensing/setting systems, more power,

and greater flash situation adaptability.

The idea is that once you join the flash to the camera, you are ready to take flash pictures. Since systems vary in operation and complexity, we'll describe two possible dedicated systems. At the simple and relatively inexpensive end, there is the compact flash unit designed for a particular SLR. For successful operation all that's required is to slide the flash into the mounting bracket on top of the camera; select and set on the lens the aperture given on the back of the flash unit for the film in the camera; turn on the flash, and take a flash picture. Mounting the flash unit on the camera sets the camera shutter speed automatically, and the sensor in the flash unit allows good exposure over a surprisingly wide distance range at the single aperture available for that film type.

At the other end of the price spectrum you might have a camera and flash system that relies on extremely accurate sensors located at the film plane in the camera. When sufficient light reaches the film, the sensor turns off the flash. Moreover, attaching the flash sets the shutter speed and pro-

vides a display in the viewfinder that tells what aperture has been selected, when the flash is fully recycled, and sometimes whether the flash can provide enough illumination for the subject—a confidence light. The flash unit may function at several different apertures and in several power ranges. A special attachment cord is probably available for off-camera flash. Some systems provide excellent lighting and flawless exposure for close-ups.

Reading the instructions carefully for both flash and camera will provide the most reliable results. With many systems it is possible to make manual adjustments for creative license or unusual situations.

Cameras with Automatic Flash Exposure. Some cameras automatically adjust the lens opening for proper flash exposure as you focus the camera on your subject. Most cameras that have this feature also have built-in flash. For cameras without built-in flash use a manual electronic flash unit or flashbulbs; you don't need an automatic electronic flash unit. (But if you have an automatic flash unit, use it on the manual setting.) Most single-lens reflex cameras do not determine flash exposure this way. Non-single-lens reflex cameras that do determine flash exposure automatically usually have built-in flash or a guide number scale on the camera for setting the flash guide number and/or an automatic flash setting on the lens opening scale. See your camera manual. Once you've made these settings, the camera will automatically adjust for the correct flash exposure—you don't have to calculate the *f*-number.

SHUTTER SPEED FOR FLASH PICTURES

Since the duration of electronic flash is so brief, the camera shutter stays open for a period longer than the flash duration, even at high shutter speeds with a leaf-type shutter. As a result, the shutter lets all of the light from the electronic flash pass through the lens regardless of shutter speed. Consequently, changing the shutter speed with electronic flash does not affect the guide number. As explained before, most focal-plane shutters will not synchronize with electronic flash at shutter speeds higher than 1/125 or 1/250 second.

With flashbulbs, guide numbers are smaller at higher shutter speeds because the duration of the flash, which is about 1/30 second, is longer than the time the shutter is open. Therefore, at higher shutter speeds, only part of the light from the flashbulb reaches the film while the shutter is open.

Use a fast shutter speed such as 1/125 or 1/250 second or faster, if your camera will synchronize at these speeds, to minimize the possibility of registering the light present in the scene that you are photographing. Also, the existing light in the scene may be the wrong color quality for your color film. Using a faster shutter speed helps prevent these effects. If there is strong light present when you are photographing action with electronic flash, use a shutter speed fast enough to stop the action. This prevents double, or ghost, images. However, if stopping action is not a problem and the recording of remote background detail is desired, use a slower speed such as 1/30 second or slower. If you use shutter speeds slower than 1/30 second, you will need a tripod to hold your camera steady.

GUIDE NUMBER TEST

If your flash pictures are consistently too light or too dark, determine a new guide number with a photographic test. The following procedure will work for a manual electronic flash unit, an automatic unit set on manual, or flashbulbs.

1. Place your camera and flash 8 feet from a typical subject in a normal setting.

2. Load your camera with a color slide film such as KODAK EKTACHROME 100 Film (Daylight) or KODACHROME 64 Film (Daylight).

3. Set the recommended flash shutter speed and make a series of exposures at half-stop intervals with the series midpoint at the suggested guide number. (Record the lens opening used for each exposure. Allow 30 seconds for an electronic flash to recycle fully.)

4. Select the best processed slide. Multiply by 8 the lens opening used for that exposure to calculate your new guide number.

Flash-Guide-Number Test

The flash-to-subject distance was 8 feet for each of these test pictures. Because the best exposure was made at $f/6.7$, the guide number for this film and flash combination is 53.6 which can be rounded to a guide number of 55. The lens openings $f/3.4$, 4.7, 6.7, 9.5, and 13 are 1/2 stop between standard lens openings. The half-stop openings are not marked on the camera lens opening scale, but are midway between the standard lens openings. Making the exposure series at half-stop intervals gives you finer exposure increments than using only full stops.

John Menihan, Jr.

RED-EYE REFLECTIONS

Sometimes people's and pet's eyes appear red or amber in color pictures or white in black-and-white pictures. This is caused by the flash being too close to the camera lens. The flash produces reflections from the retina of the eye. This effect is especially evident in a young person who has a light complexion and blue eyes. If your subject is in dim lighting, the pupils of the eyes will be large which make the reflections from the interior of the eyes more noticeable.

There are several ways you can minimize the red reflections:

1. Move the flash away from the camera lens. If your flash pictures show the red-eye reflections when the flash is mounted on the camera accessory shoe, remove the flash and use the synchronization cord to hold the flash away from the camera lens. You can hold your camera in one hand and the flash in the other.

2. Turn on all the lights in the room or open the window drapes in the daytime to increase the light level. This causes the pupils of the subject's eyes to contract, reducing the intensity of the light reflected from inside the eyes.

3. Have your subject look directly at a room light or at a window in the daytime. This helps contract the pupils to minimize the reflections.

4. Use bounce flash. See page 119. With this method of taking flash pictures, the light from the flash is reflected from the ceiling or other reflective surface. The flash does not illuminate the subject's eyes directly near the camera-lens axis. As a result, the adverse eye reflections are not produced.

Caroline Grimes

When the flash is too close to the camera lens, red reflections are sometimes produced in your subject's eyes. To minimize this effect, move the flash away from the lens by using a synchronization cord.

VARIETY IN FLASH LIGHTING

The simplest and fastest way to take flash pictures is with the flash mounted on the camera. However, if you want to take flash pictures that appear more professional, you may want to try the special flash techniques that follow.

OFF-CAMERA FLASH

On-camera flash produces good results, but the lighting from the flash is flat front lighting. If you can use your flash off your camera, you'll get better lighting. Off-camera flash gives pleasing, more natural-looking lighting by creating interesting highlights and shadows on your subject. This produces modeling—a three-dimensional effect—which helps make faces more realistic and emphasizes surface texture, such as the texture of clothing.

The highlights and shadows produced by off-camera flash help separate tones and add a feeling of depth. You can also minimize background shadows with off-camera flash by arranging your subject a few feet in front of the background and placing the flash high to one side.

You can take off-camera flash pictures by holding the flash above and to one side of the camera with one hand while holding the camera and snapping the picture with the other hand.

In order to use your flash off the camera, you'll need to use the flash-synchronization cord. This lets you hold the flash in one hand and the camera in the other. Or you can have a helper hold the flash for you. If you need a longer sync cord, you can purchase a flash extension cord from your photo dealer.

You determine the exposure for off-camera flash the same way as for on-camera flash as long as the flash is illuminating the front of your subject. Remember to base your exposure on the distance from the flash to your subject, not on the distance from the camera to the subject. If you're using an automatic electronic flash unit, just make sure the light sensor is aimed toward the subject.

117

When you use off-camera flash, you can generally produce a pleasing, more natural-looking effect than with the flat frontal lighting produced by on-camera flash. In this picture, the flash unit was placed high and to the right, which kept the flash illumination off the background to make it go dark.

Off-camera flash improved the modeling on this baby's face and blanket. Baby skin is so fair that additional gradation of tones helps to prevent the picture from appearing overexposed and washed out. Made in England on EKTACHROME 100 Film.

BOUNCE FLASH

With this technique you aim the flash at a ceiling or wall and bounce the light back onto your subject. This produces a soft, even type of lighting similar to that found outdoors on an overcast day. With color film, aim the flash at a white or near-white ceiling or wall. Otherwise your subject may pick up some color from the reflecting surface.

Exposure depends somewhat on the size and color of the room and on the total distance the light travels from the flash to the ceiling or wall and back to the subject. As a rule of thumb, use at least 2 stops more exposure for bounce flash than for direct flash at the same distance.

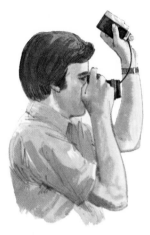

To take bounce-flash pictures, aim your flash upward. The light will bounce off the ceiling and onto your subject. For color pictures, the ceiling should be white or near-white to avoid an overall color cast.

Maria Smothers, KINSA

Bounce flash produces soft, even lighting similar to that found outdoors on an overcast day.

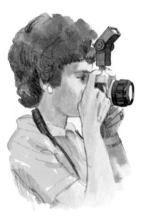

Some electronic flash units are designed so that you can also use them for bounce flash without being removed from the camera. They have a swivel flash head that you can aim upward toward the ceiling. Adjust the flash head so that the flash illuminates the ceiling between you and your subject but does not illuminate your subject directly.

119

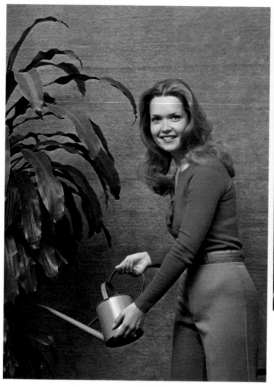

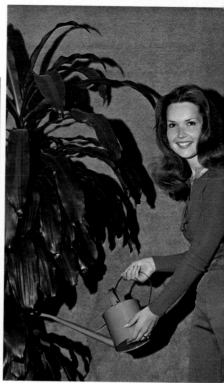

Here you can compare bounce flash on the left with direct flash on the right. Note the modeling on the face and the absence of a distracting background shadow in the bounce-flash picture.

To determine the exposure with more precision, first divide the flash guide number by the total distance from the flash to the ceiling and from the ceiling to your subject. Then use a lens opening 1 stop larger than the f-number given by the answer.

Another way you can determine exposure for bounce flash is to use the following formula:

$$f\text{-number} = 0.7 \left(\frac{\text{Guide number}}{d_1 + d_2} \right)$$

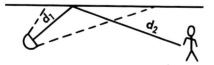

The letters d_1 and d_2 are distances in feet.

These methods of determining bounce-flash exposure are for clean, white ceilings. For off-white or light-colored ceilings, use 1/2 to 1-stop additional exposure. Be sure no direct light from the flash illuminates the subject.

When you're using an automatic electronic flash unit for bounce flash

To calculate your exposure with bounce flash, first estimate the total distance in feet that the flash must travel to reach your subject: $d_1 + d_2$. Next divide the guide number for your film/flash combination by this total flash-to-subject distance. Multiply that answer by 0.7 to find your f-number.

Bounce flash is particularly convenient to use when photographing children indoors. Your exposure can stay the same, even when your subjects move around the room.

If the walls in a room, in addition to the ceiling, are white or near-white, you can aim your flash at a point where the ceiling and a wall meet. The diffused, bounce lighting from the side as well as from overhead produced by this technique can yield a high-quality portrait.

with the flash aimed at the ceiling, the light-sensitive cell of the flash unit must be aimed at your subject for the unit to determine exposure correctly. Flash units designed for bounce flash either have a swivel flash head or a separate light sensor that you can aim toward the subject. In order to get proper exposure with bounce flash, make sure that the maximum distance of your auto flash distance range is at least 1.4 times the total flash-to-ceiling-to-subject distance.

If your flash unit has a sufficient light indicator, it will come in handy in determining if your exposure for bounce flash is okay. To use this feature, you fire the flash without taking a picture and watch the indicator to see if there is enough light from the flash. Most flash units have a button for firing the flash independently of the camera. If there's not enough light, you will have to use a larger lens opening, or move closer to your subject, or use a faster film, or use direct flash. See the instruction manual for your flash unit.

Because bounce lighting is fairly even over a large area of the room, it's a particularly effective flash technique for photographing groups.

121

Norm Kerr

Check your flash equipment in advance to see if the batteries need to be replaced or recharged so that you're not disappointed when you're ready to take flash pictures.

If your automatic electronic flash unit is not designed for bounce flash, the light sensor always points in the same direction as the flash. If you use such a unit for bounce flash, you'll have to use it on manual and determine the exposure manually because the light sensor would read the light reflected from the ceiling and give the wrong exposure.

PREVENTING FLASH FAILURE

The most frequent causes of flash failure are weak batteries and battery or equipment contacts that need cleaning. With electronic flash units, when the time required for the ready light to come on becomes excessive—about 30 seconds or longer—or it doesn't come on at all, it usually means the batteries are weak and need to be replaced or recharged, depending on the

kind of batteries. See your flash equipment manual.

Since flash holders for flashbulbs do not have a ready light, it's a good idea to have the batteries checked *at least* once every 6 months and before any especially important shooting sessions. Most camera shops will be happy to do this for you.

If there are deposits on the equipment or battery contacts, even brand-new batteries won't fire the flash. To prevent this type of flash failure, clean the battery ends and equipment contacts with a rough cloth. If the battery compartment in the flash unit is small, wrap the cloth over the end of a pencil eraser to clean the contacts. Clean the contacts even if they look clean, because some deposits are invisible.

Don McDill

To prevent flash failure, keep all electrical contacts clean. Take a rough cloth and rub the ends of your batteries and the contacts within the flash unit battery compartment.

Be sure to use the type and size of battery recommended for your flash equipment. Alkaline batteries have a long life and a short recuperation time. They are generally recommended for electronic flash units and flash holders. If you're using a flash holder for flash-bulbs that has unplated brass or copper contacts, use zinc-carbon batteries. The alkaline batteries can corrode the

contacts. Nickel-cadmium batteries are rechargeable and are recommended for use in many electronic flash units. See your flash instruction manual for the kind of battery recommended for your flash unit.

When you're not going to use your flash unit for a period of time, remove the batteries to prevent possible corrosion of the contacts in the unit.

Check the fittings between the flash and the camera to see that they remain tight. If your flash connects to your camera with a flash cord, make sure any press-on adapters are tight. Also, a break in the cord will prevent the flash from firing. You can often detect an internal break in the cord by wiggling the cord. When momentary contact is made, the flash will fire. When you detect such a break, replace the cord.

CAUSES OF LIGHT LOSS WITH ELECTRONIC FLASH

RECYCLING TIME

After you have fired an electronic flash unit, it takes several seconds for the condensers in the unit to recharge. Most electronic flash units have a ready light that comes on after about 10 seconds, depending on the unit, to indicate that the unit is ready to flash. But at this point you may get only about 65 percent of the total light output because the ready light does not necessarily indicate when the condensers in the unit are *fully* charged. Recycling time for full light output varies in practice and depends on the electronic components in the unit, type and condition of batteries, and other factors. An automatic flash unit with an energy-saving circuit, called a thyristor circuit, will recharge more quickly on automatic than a unit without this circuit. An ac-powered unit may recharge faster than a battery-powered unit.

You will get more consistent photographic results if you wait until your flash unit has recycled completely before taking the next picture. After the ready light comes on, wait a few seconds before firing the flash. Or to be on the safe side, allow at least 30 seconds between flashes, because it may take that long for the condensers in some units to recharge fully. If necessary, you can take pictures more rapidly than this, but you may not get full light output from your flash unit. This can cause underexposed pictures, depending on the exposure latitude of the film you are using.

WEAK BATTERIES

As the batteries in your flash unit lose power with use and age, the recycling time increases. When the battery power drops below the required level, the unit will lose light output even though it may still flash. Replace or recharge the batteries whenever the recycling time becomes excessive. Also, remember that it's important to keep the battery and flash contacts clean by wiping them with a rough cloth.

DE-FORMING OF CONDENSERS

Another factor which can weaken batteries and cause a loss of light output is the tendency of the condensers in an electronic flash unit to de-form after a month or so of inactivity. When this happens it will take an extra-long time to re-form the condensers and bring them back up to a full charge. This re-forming puts a considerable drain on the batteries. If you can use regular house current (ac) to power your unit, re-form the condensers by letting them recharge from the power line for an hour or so—and fire the flash a half dozen times—whenever the unit has been out of use for a few weeks. This helps your flash unit produce full light output.

Caroline

A normal-focal-length lens is a good lens for general picture-taking.
It will give you a normal image size and a normal angle of view.

LENSES

The ability of many 35 mm cameras to accept interchangeable lenses is one of the features that makes these cameras so versatile. Since the lens plays a vital role in determining what the camera can do for you, knowing how to take full advantage of the various lenses for your camera pays dividends in terms of better, more exciting pictures.

NORMAL LENS

The focal length of a camera lens is the distance from the film plane of the camera to approximately the center of the lens when the lens is focused on infinity. The normal-focal-length lens for your camera is the one that you'll probably use for most of your picture-taking because it's designed to fill most of your picture-taking requirements. It's called the normal lens for your camera because it provides natural perspective and an angle of view similar to the *central* vision of the eye. In addition, the angle of view is practical for most pictures. The focal length of the normal lens for most 35 mm cameras falls in the range of about 40 mm to 58 mm.

When you want to photograph people involved in activities, a normal-focal-length lens is a wise choice. With a normal lens, which requires a minimum of fuss, there's usually no problem in getting sharp pictures with a handheld camera, depth of field is usually adequate, and distortion is at a minimum.

The normal lenses on 35 mm cameras are usually quite fast—at least $f/2.8$—and lenses with even larger maximum apertures are common. You might compare an extremely fast lens to a high-horsepower automobile engine. A high-quality lens with a very large maximum aperture carries a premium price tag, but its extra capabilities save the day when you really need them. A fast lens lets you take pictures with a handheld camera under poor lighting conditions. This gives you more freedom of movement and makes it easier to capture candid expressions than when you have to use a camera support, such as a tripod. A fast lens is helpful when you're photographing action, too, because you can use higher shutter speeds under adverse conditions—for example, when you're using a slow- or medium-speed film in lighting conditions that are less than optimum. You'll find more about the benefits of a fast lens on pages 207 through 230.

Although you can get good pictures of most subjects with a normal lens, there are other lenses that can give you the versatility you may need for certain picture-taking situations.

This photo was taken with a 28 mm wide-angle lens, which lets you include more of the surroundings when you want to show the location. This is a big help when it's inconvenient or impossible to back up far enough to take in the scene.

This picture was taken with a 50 mm lens which is the normal lens for a 35 mm camera.

This series of pictures was taken from the same subject distance to show the effect of using different focal-length lenses. Note how the subject appears larger and closer as the focal length increases.

28 mm wide-angle lens

50 mm normal lens

These pictures show how lens perspective changes with the focal length when the subject distance is adjusted to maintain the same image size. Notice how the distance between the subject and the background appears to decrease as the focal length increases.

This shot was taken with a 105 mm telephoto lens which is a good focal length for casual portraits. This focal length gives pleasing perspective and a good image size at convenient, medium subject distances.

This picture was taken with a 200 mm telephoto lens which lets you get a close-up of your subject from a distance.

Don Maggio

105 mm telephoto lens

200 mm telephoto lens

Don Maggio

With a wide-angle lens, you can capture a scenic vista and get it all in, which isn't always possible with a normal lens.

WIDE-ANGLE LENS

A wide-angle lens has a shorter focal length than the normal lens for the camera. A wide-angle lens takes in a greater angle of view than the normal lens. From any given spot a picture made with a wide-angle lens includes more than a picture made with the normal lens.

When do you use a wide-angle lens? Some of its uses are rather obvious. A wide-angle lens is helpful for taking pictures in places where space is limited. Without enough space, you just can't move back far enough to include everything you want with the normal lens. When you're photographing such subjects as all the in-laws around the Christmas tree at home or a brand-new sports car on display at a crowded auto show, a wide-angle lens is a very handy item to have.

A wide-angle lens is often a good friend to have outdoors, too. When you take pictures in narrow city streets or crowded public markets or photograph sweeping scenic vistas, a wide-angle lens will let you get it all in when this isn't possible with the normal lens.

Another situation where a wide-angle lens may help you is in public places when people or other objects are between you and your subject. You may be able to eliminate them from the picture by using a wide-angle lens which allows you to move closer to your subject and frame the picture the way you want it.

128

You can make a picture more interesting by including objects in the picture around the borders to frame the main subject. This is often easier to do with the wider field of view produced by a wide-angle lens on your camera.

Bill Douglass

Caroline Grimes

A wide-angle lens comes closer to simulating the angle of vision of your eyes than a normal-focal-length lens. A 28 mm wide-angle lens included the silhouetted tree limbs to enhance the picture.

129

Norm Kerr

At home there's often not enough space in cramped rooms to move back far enough to include what you want in the picture. This is where a wide-angle lens will help you get more in the picture.

Neil Montanus

An extreme wide-angle lens gives you a very wide angle of view but also produces distortion by making straight lines appear curved. You can make this work to your advantage for a different, artistic viewpoint. A 16 mm semifisheye lens was used here.

A wide-angle lens exaggerates space relationships by expanding the apparent distance between nearby and distant objects.

PERSPECTIVE CONTROL

Perspective is determined by camera-to-subject distance. Whether you have a normal, wide-angle, or telephoto lens, perspective is the same for all of them if the camera-to-subject distance remains the same. When you get close to a subject, as you might with a wide-angle lens, nearby objects look unusually large, and distant objects in the same picture look small and far away. This is because the distance between the near and far subjects is great compared to the distance from the camera to the near subject. The wide-angle lens exaggerates space relationships by expanding the apparent distance between nearby and distant objects. You'll increase the feeling of vastness in scenic pictures by using a wide-angle lens and including a nearby foreground object, such as a person, tree, or automobile, for size comparison.

For the same reason—exaggerated perspective—a close-up picture of a person's face made with a wide-angle lens gives the features a distorted appearance. The nose, since it is closer to the camera, looks bulbous, while the more distant ears look exceptionally small. If you use a wide-angle lens to take a picture of an automobile from a front angle, it will look especially long and sleek. A welcoming hand stretched toward a wide-angle lens looks as large as or larger than the head of the person offering the greeting.

When you use a wide-angle lens to photograph entire buildings or similar subjects with prominent parallel vertical lines, try not to tilt the camera up or down. If you do, the vertical lines will converge, or keystone, in your picture. While keystoning is usually undesirable, there may be times when you want to create this effect—to make a building look taller, for example, or to exaggerate perspective for creative composition.

131

You can photograph the vastness of panoramic landscapes most effectively with a wide-angle lens. These lenses enhance the spaciousness between foreground subjects and the distant view.

A wide-angle lens lets the photographer stand very close to the car and still photograph the entire car. The result is an exaggerated perspective that makes the car appear to be longer than it really is. (A filter that gives a star effect was also used. See page 246.)

Neil Montanus

If you use a wide-angle lens for close-up pictures of people, parts of the subjects may be distorted like the enlarged size of the legs and feet in this picture. Sometimes you can use this effect to produce a picture with more impact. In this case the distortion seems to extend the idea and feeling of leisure for this relaxed yachtsman. Made in the Bahamas on KODACOLOR VR 200 Film.

Herb Jones

When you use a wide-angle lens to photograph tall subjects, try to avoid tilting your camera upward. If you do tilt the camera up, you'll get converging lines called keystoning.

133

Using a wide-angle lens lets you stand close to the building and still photograph the entire building. The result is a distorted perspective that makes the building appear to be taller than it really is and squeezed together at the top.

Herb Jones

The converging lines from a wide-angle lens appear quite natural in this rendition of Marina City in Chicago photographed at dusk. When you are close to a building and look up, you see a similar effect because parallel lines appear to recede with distance. In pictures this effect appears normal as long as it's not overdone.

Caroline Grimes

One of the benefits of using a wide-angle lens is the increased depth of field you obtain compared with that from longer focal-length lenses. The extreme sharpness helps make this a superb scenic photograph. Monument Valley, Arizona

Gary Whelpley

The distant view and the structure framing it are both in sharp focus. A wide-angle lens and a small lens opening provided the necessary depth of field. Made in Sweden on KODACHROME 64 Film.

Marty Czamanske

DEPTH OF FIELD

Photography with a wide-angle lens offers the bonus of increased depth of field. For example, with a 28 mm wide-angle lens on a 35 mm camera, if the lens is set at $f/11$ and is focused on a subject 10 feet away, everything from about 4½ feet to infinity will be in focus. In the same situation with a 50 mm lens, the depth of field would extend from about 7 feet to 17 feet.

Depth of field is actually the same for all lenses, no matter what their focal length, if you adjust the subject distance to give the same image size. For a particular camera and particular subject distance, however, we can say that depth of field increases as focal length decreases.

135

Jack Zehr

It's easier to stop action in pictures when you use a wide-angle lens because the moving subject appears smaller and farther away.

CAMERA AND SUBJECT MOVEMENT

A wide-angle lens is a forgiving lens as it tends to minimize the effects of camera movement. A wide-angle lens makes everything in the picture appear smaller than a normal lens does at the same subject distance—people, buildings, mountains, *and evidence of camera movement.* This means that when necessary, you can get away with slower shutter speeds than those you need for taking pictures with lenses of longer focal lengths.

A wide-angle lens reduces the effect of subject movement as well. Since the subject appears farther away and relatively smaller in the picture, subject movement will be less obvious.

See more about subject movement in the section on stopping action on page 192.

In summary, you may want to use a wide-angle lens—

- to get it all in when this is not possible with the normal lens.
- to exaggerate space relationships.
- to eliminate distracting objects by letting you move closer to your subject.
- to get great depth of field.
- when you must use a slow shutter speed.
- when camera steadiness is hard to achieve—on a moving train, for example.
- to photograph nearby action.

TELEPHOTO LENS

A telephoto lens has a longer focal length than the normal camera lens. Technically, the term telephoto refers to a particular kind of optical arrangement that has a positive front element and a negative rear element. This allows the physical length of some telephoto lenses to be shorter than the focal length. However, it has become common practice to call any lens with a focal length that is longer than normal a telephoto lens, so that's what we do in this book.

Telephoto lenses do just the opposite of what wide-angle lenses do. They include a narrower angle of view than the normal lens, so they take in a smaller area of the scene. Consequently, distant subjects photographed through a telephoto lens appear closer than they do when photographed through a normal lens. A telephoto lens magnifies the image similarly to the view you see through binoculars or a telescope.

A telephoto lens gives you a large image size when you can't get close to your subject.

Alan Hoel

A close view made with a telephoto lens is sometimes more appealing photographically than a tiny image of a sailboat off in the distance.

John Menihan, Jr.

137

A telephoto lens lets you effectively crop your picture in the viewfinder as you take the picture. This is especially important when you're using color-slide film which usually is not cropped for projection.

Jean-Yves Crispa, KINSA

Objects in the sky often photograph much too small. A telephoto lens magnifies the image to make a good picture.

Daniel J. Risk, KINSA

138

When do you use a telephoto lens? As a rule, you use a telephoto lens when you can't get as close to your subject as you'd like—for example, when you're photographing a baseball game, an alligator in Okefenokee Swamp, or a chalet perched on a distant hillside. You can't climb into a cage at the zoo to get a close-up of a lion or stand in the middle of the Hudson River to get a close-up of a luxury yacht, but a telephoto lens can produce a big image of such subjects by bringing them closer to you optically.

PERSPECTIVE AND COMPOSITION CONTROL

Like wide-angle lenses, telephoto lenses offer advantages that aren't so obvious, as well. For example, lenses in the 75 mm to 105 mm focal-length range are great for making head-and-shoulder portraits of people. You can be 6 or more feet from your subject and still get a nice-size head-and-shoulder image on the film with a moderate telephoto lens. This means that the nose-to-ears distance is very small in relation to the total subject distance, so the exaggerated perspective we mentioned in the section on wide-angle lenses doesn't exist. Being 6 or more feet from your subject also makes it easier to take pictures of people. You can move around your camera when it's on a tripod and your subject without stumbling over them.

We mentioned that wide-angle lenses expand distances. As you might suppose, telephoto lenses have the opposite effect—they compress distances. Distant objects look closer to each other than they actually are. You've probably seen extreme telephoto pictures of a large city or rows of buildings on a distant hillside. In such pictures, the distant subjects appear squashed together. This effect is caused by the very narrow angle of view, which eliminates from the picture

R. Scott Boyd, KINSA

Moderate telephoto lenses of about 75 mm to 105 mm focal length are ideal for making head-and-shoulder portraits of people. These lenses produce pleasing perspective because you can get a good image size at 6 or more feet from your subject. You don't have to get right in the subject's face with your camera to take the picture.

all the nearby objects that help us judge distances.

Because a telephoto lens has a narrow angle of view, it can help eliminate distracting elements in the composition of a picture. If there is a water tower next to a picturesque country church, you can crop the tower out of the picture by using a telephoto lens with its narrower angle of view. The lens sees the church, but not the tower. In the same way, you can photograph between the heads of spectators at a sports event or parade.

139

Jim Dennis

Using a telephoto lens and a large lens opening for informal portraits lets the photographer throw the background out of focus to produce a blur of color flattering to the subject.

You can isolate your subject from distracting surroundings with a telephoto lens. This concentrates the viewer's attention on the person in the photograph.

Jim Dennis

Telephoto lenses compress apparent distances; they make objects look closer to each other than they really are.

Paul Yarrows

The repetition of the school buses produced an eye-catching design with the help of a telephoto lens to make them appear closer together.

Robert Kretzer

An ordinary street scene is transformed into a stimulating view by a telephoto lens which compressed the houses together in the photograph.

Norm Kerr

A telephoto lens gives a narrow angle of view which helps eliminate distractions. The photographer used this technique to photograph the row of soldiers between the shoulders of two others to capture this colorful scene.

Neil Montanus

DEPTH OF FIELD

Telephoto lenses have shallow depth of field. The longer the focal length of the lens, the more shallow the depth of field. This means that accurate focusing is much more important with telephoto lenses than with normal and wide-angle lenses.

As mentioned earlier, you can use shallow depth of field as a creative tool for throwing a distracting background out of focus or for de-emphasizing foreground objects, both of which help concentrate interest on the main subject.

Thomas Biskup, KINSA

Accurate focusing is a must for sharp pictures with telephoto lenses because depth of field is shallow. When you use long-focal-length telephoto lenses, which often have relatively small maximum lens openings, half the split-image rangefinder and the microprism area in your viewfinder usually will be black. As a result, these focusing aids become useless at lens openings of about f/5.6 and smaller. Use the ground-glass portion of your viewfinder for focusing these lenses.

Don Maggio

You can take excellent candid pictures with telephoto lenses because you don't have to be up close to get a good image size. Your subjects may not be aware they're being photographed. Learn to focus quickly and accurately when you use a telephoto lens for candid photography. The depth of field in this picture extends for only a short distance behind the subjects.

CAMERA STEADINESS AND SUBJECT MOVEMENT

While a wide-angle lens is forgiving, the telephoto lens is demanding. In addition to focusing very carefully, you must hold your camera extremely steady to get pictures that are free of blur. This is because a telephoto lens magnifies camera movement as well as image size. Consequently, it's a good idea to use a tripod and a cable release with a telephoto lens. As a general rule, don't try to handhold the camera when you're taking pictures with a lens that has a focal length longer than about 400 mm.

To minimize the effects of camera motion, it's essential to use a high shutter speed. A good rule to follow is to use a shutter speed approximately equal to: 1/Focal Length in Millimetres second. For example, with a 200 mm lens, you should use 1/200 second or higher. Since 1/200 second is not available on your camera, use the next higher shutter speed setting of 1/250 second. If you still have difficulty getting sharp pictures, use a shutter speed twice as fast—in this case 1/500 second. Be especially watchful with automatic cameras that determine the shutter speed. If the shutter speed indicated by the camera drops to a speed that's too slow for sharp pictures, use a larger lens opening so the camera will adjust for a sufficiently high shutter speed.

A telephoto lens increases the effect of subject movement, too. Since the subject appears to be nearby and relatively large in the picture, any movement of the subject will be quite noticeable. This means that when you photograph action with a telephoto lens, you should use higher shutter speeds than you would to photograph the same action with a normal lens. See Action Shots with Telephoto Lenses on page 204.

Martin Brock, K

Since telephoto lenses magnify the image to make it larger, they will also magnify any unsharpness caused by camera motion. Many such pictures taken with telephoto lenses are spoiled this way. When handholding your camera, you should use a high shutter speed to minimize the effects of camera motion. The photographer held his camera steady to obtain excellent sharpness as well as an extraordinary expression in this zoo picture.

So, you may want to use a telephoto lens—

- to produce a large image of a distant subject by bringing it closer to the camera optically.
- to make portraits.
- to compress distances.
- to eliminate distracting elements from a picture.
- to get shallow depth of field.

144

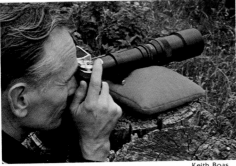

Roger Smith

A tripod is an important aid to help you get sharp, crisp pictures by providing a firm support for your camera when you use a telephoto lens.

Keith Boas

A beanbag is a handy item to have along in your camera bag. The beanbag provides a flexible cushion which conforms to your telephoto lens while supporting it on a firm object for steadiness.

TELECONVERTERS

A teleconverter, sometimes called a teleextender, is an inexpensive way to increase the focal length of a telephoto lens. A teleconverter will also work with a normal-focal-length lens to produce the effects of a telephoto lens. These converters fit between the camera body and the lens. They extend or multiply the focal length of the lens by 2 or 3 times depending on the power of the converter. A 2X teleconverter converts a 100 mm-focal-length lens to 200 mm focal length, and a 3X teleconverter will convert the same lens to 300 mm focal length.

Another advantage of a converter is that it will give you a larger image for close-up photography. You get a larger image because of the increased focal length of the lens with the converter and because you can focus at the same close focusing distance as the original lens when it's used without the converter.

However, there are some disadvantages in using a teleconverter. A converter makes the effective lens opening smaller—a 2X teleconverter reduces the effective lens opening by 2 stops; a 3X teleconverter by 3 stops. For example, if your lens is set at $f/5.6$, the effective lens opening with a 2X converter is $f/11$; with a 3X converter it is $f/16$. Through-the-lens exposure meters in cameras will automatically compensate for the reduced effective lens opening. With a separate exposure meter or for flash pictures you will have to determine the exposure based on the smaller effective lens openings.

The reduced lens openings make the viewfinder dimmer for viewing. Also you may have difficulty using a high enough shutter speed or getting enough exposure under dimmer lighting conditions. In addition, with a converter it's generally better to use a

By using a teleconverter with a telephoto lens, you can double or triple the effective focal length. The picture on the top was taken through a 200 mm lens; the one on the bottom was taken with the same lens plus a 2X teleconverter lens to extend the focal length to 400 mm.

Herb Jones

Jerry Antos

Typical teleconverters—The left one extends the focal length by 3 times; the right one by 2 times.

smaller lens opening to increase the image quality.

You may notice some darkness and a loss of the image around the corners and top edge of your viewfinder when you use a teleconverter. This happens because the mirror in a single-lens reflex camera is not designed to reflect all the light from lenses when teleconverters are used with them. However, this affects only the viewfinder. The film should receive a complete image with no darkness around the edges when you take the picture.

In selecting a teleconverter, make sure that the mechanical linkage between the camera body and the lens will still work properly.

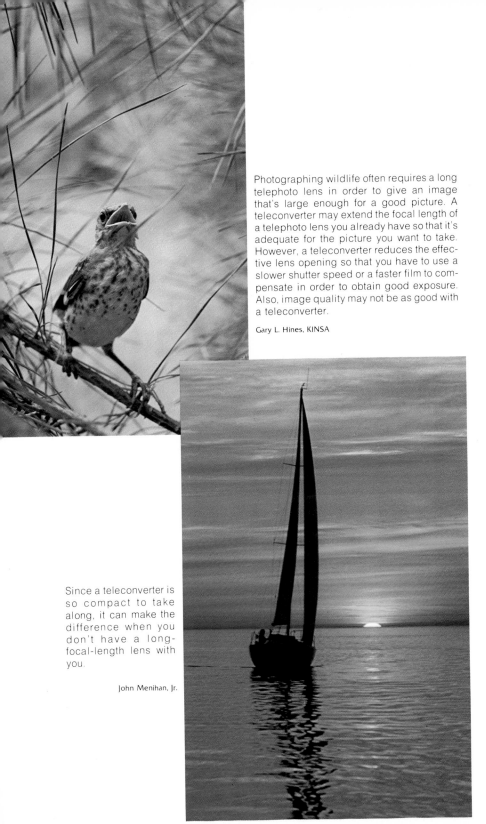

Photographing wildlife often requires a long telephoto lens in order to give an image that's large enough for a good picture. A teleconverter may extend the focal length of a telephoto lens you already have so that it's adequate for the picture you want to take. However, a teleconverter reduces the effective lens opening so that you have to use a slower shutter speed or a faster film to compensate in order to obtain good exposure. Also, image quality may not be as good with a teleconverter.

Gary L. Hines, KINSA

Since a teleconverter is so compact to take along, it can make the difference when you don't have a long-focal-length lens with you.

John Menihan, Jr.

147

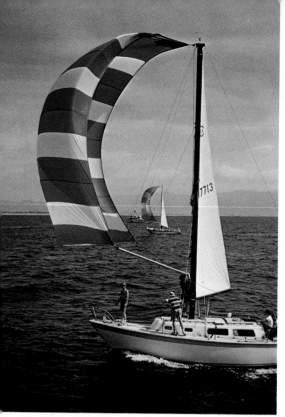

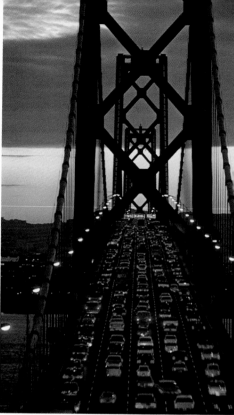

Peter Gales

Zoom lenses are very popular because they can take the place of several lenses of equivalent focal lengths. You can quickly change from one focal length to another to compose the picture the way you want it without changing your position.

Tom T[

When you focus a zoom lens, you can more easily determine the best focus setting if you focus the lens at its longest focal length. Then change the zoom setting to where you want it for taking the picture. This technique is good only for lenses that don't change focus with the zoom setting. Refer to the instruction manual for your zoom lens.

ZOOM LENS

Zoom lenses, available for some cameras, have a variable focal length. For example, you might buy a zoom lens with a focal length that varies from 35 mm to 85 mm or one that varies from 85 mm to 210 mm. You simply set the lens for the focal length that best fills your need. A zoom lens has the advantage of offering an infinite selection of focal lengths within its zoom range, thereby reducing a photographer's need for many different lenses. With a zoom lens it's easier to get precise framing for the picture you want without changing lenses so often. However, you will probably have to pay a price near the upper end of the price range for a zoom lens that maintains sharpness throughout its zoom range comparable to that of a fixed-focal-length lens.

The information we've discussd for wide-angle and telephoto lenses also applies to zoom lenses that have wide-angle or telephoto focal lengths. To avoid getting blurred pictures with a zoom lens in the telephoto position while handholding your camera, remember to use a high shutter speed to minimize the effects of camera motion.

148

Another precaution you should be aware of when using a zoom lens is the tendency for such lenses to produce flare—less image contrast—or ghost images. These effects are caused by the sun or a bright light source shining into the lens. Zoom lenses are more prone to this than most other lenses because zoom lenses have complex lens systems consisting of many lens elements which increase the possibility of internal reflections. To minimize flare and ghost images, use a lens hood to help keep extraneous light from shining into the lens; use the smallest lens opening possible; and use camera angles where the sun or bright lights are not included in the picture.

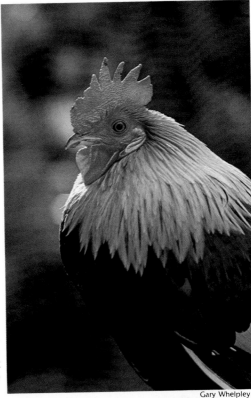

Some zoom lenses have a close-focusing feature which you can use to take close-ups. KODAK EKTACHROME 400 Film (Daylight)

Gary Whelpley

Neil Montanus

If you move the zoom control during a slow exposure, you can produce a blurred effect like this. The picture was taken with an 80—210 mm zoom lens by moving the zoom setting from the small image setting to the large one during a 1/8-second exposure. Remember to use a tripod when you use slow shutter speeds.

Robert Kretzer

COMPOSITION

Most good pictures are not the result of a fortunate accident! The photographs you admire in exhibits may look like chance shots. But most often they have been created by the photographer. How do you create a picture? First you learn the rules of good composition given here. After you learn these rules, you'll realize that most pictures with good composition are the result of careful planning, patient waiting, or a quick sensing of the best moment to take the picture. But it's easier than it sounds. You'll find that the rules of composition will become part of your thinking when you are looking for pictures, and soon they will become second nature to you.

Photographic composition is simply the selection and arrangement of subjects within the picture area. Some arrangements are made by placing figures or objects in certain positions. Others are made by choosing a point of view. Just moving your camera to a different position can drastically alter the composition. For moving subjects you select the best camera position and wait for the opportune moment to snap the picture when the subject is in the best location for composition.

While the rules for good pictures are not fixed and unalterable, certain principles of composition will help you prevent making serious mistakes in subject arrangement and presentation.

Peter Gales

Sometimes you can include a secondary subject in the picture to complement the main subject and to create a pleasing, balanced composition. When secondary subjects are included, position them in the viewfinder so that they do not detract from the main subject. If each of these two balloons appeared as the same size, the composition would be static and uninteresting.

nposition is simply the pleasing ar-
gement of the subject within the picture.
en the arrangement is more effective
en you place the subject away from the
ter of the picture.

Don Maggio

A bright-colored subject naturally attracts the eye, adding strength to the center of interest.

Herb Jor

Consider the power that color has when choosing and composing your pictures. To draw your viewer's attention to your subject, it helps to have that subject be the brightest element in the scene. Warm colors, such as reds, oranges, and yellows, usually work best for attracting interest.

HAVE A STRONG CENTER OF INTEREST

It is usually best to have one main point of interest because a picture can tell only one story successfully. The principal subject may be one object or several. For instance, you may want to include a secondary subject, but make sure that it doesn't detract from your main subject. Whatever the main subject is, always give it sufficient prominence in the photo to make all other elements subordinate to it.

Avoid putting your center of interest in the center of your picture. Usually, if the main subject is in the middle of the picture, it looks static and uninteresting. You can often make excellent picture arrangements that have pleasing composition by placing your center of interest in certain positions according to the rule of thirds. When you divide a scene into thirds both vertically and horizontally, the dividing lines intersect in four places. Any of these four intersections provides a pleasing position for your center of interest.

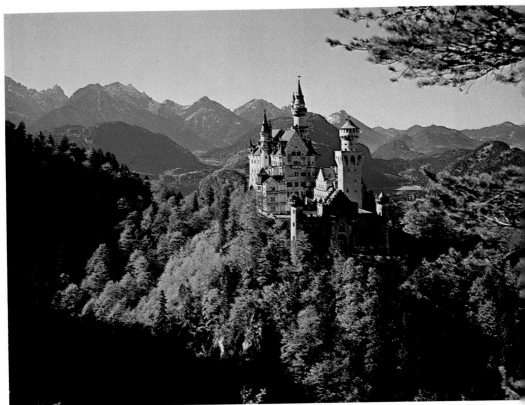

To understand the rule of thirds, imagine two horizontal lines cutting the picture into thirds. Then imagine two vertical lines cutting the same picture into thirds vertically. The intersections of these imaginary lines suggest four possible options for placing the center of interest for a pleasing composition. Neuschwanstein Castle, West Germany

Robert Kretzer

This picture demonstrates good composition. The subject was placed in the upper right position according to the rule of thirds so that the girl would face into the picture. Notice, too, how the reflection in the water helps to balance the subject.

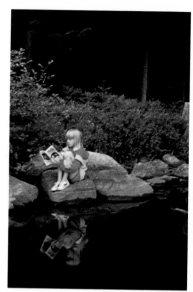

Poor composition results when the subject is placed in the middle—top to bottom, splitting the picture in half. The space to the right of the girl also appears excessive because she is facing away from it.

Here the composition is better but perhaps not quite as good as the arrangement in the larger photo above. In this horizontal format, there is excessive space on the left side of the picture.

When the subject appears in the middle of the picture, the composition becomes rather passive and unimaginative. This arrangement is not as dynamic or pleasing as the off-center treatment in the large picture above.

154

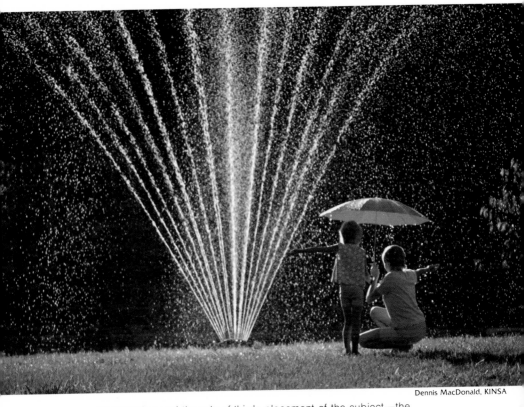

Backlighting and the rule-of-thirds placement of the subject—the girls and umbrella—make this a pleasing photograph.

In photographing this hang glider—dwarfed by the sheer face of a mountain in Yosemite National Park—the photographer used the rule of thirds to make an effective composition.

Gary Whelpley

The window mullions frame the inquisitive expression of the cat, whose face falls nicely into the upper left third of the picture. For a pleasing composition, think in terms of thirds as you compose in the viewfinder.

Michael Powell Taylor, KINSA

When photographing multiple subjects, such as a group, you can pull together all the elements into a unified picture by directing everyone to look in the same direction.

Here the entire family was asked to look at the child's book—a simple technique for producing candid harmony in this late afternoon scene. Made on KODACOLOR VR 1000 Film.

When your subjects are looking to one side or moving in a direction that will take them out of the picture, allow extra space on the side they are facing to balance the composition.

In composing your picture when photographing a moving subject, you should allow space in front of the subject so there is room for it to move. A striking, well-balanced composition has resulted from the glider in a rule-of-thirds position with the strong, leading lines of the Golden Gate Bridge in the background.

Explore different camera angles to determine the best composition and the most creative approach. In this example, a high camera angle with the camera pointed down emphasizes the woman and the bench by simplifying the background.

Rhoda Pollack, KINSA

USE THE BEST CAMERA ANGLE

Good pictures usually depend on selecting the proper point of view. You may need to move your camera only a few inches or a few feet to change the composition decidedly. When you want to photograph a subject, don't just walk up to it and snap the shutter. Walk around and look at it from all angles; then select the best camera angle for the picture.

Outdoors, shooting from a low camera angle provides an uncluttered sky background. However, when the sky is overcast with cloud cover you'll want to shoot from a high angle and keep most or all of the sky out of the picture. Overcast skies look bleak and unappealing in pictures.

Always consider the horizon line. Avoid cutting your picture in half by having the horizon in the middle of the picture. When you want to accent spaciousness, keep the horizon low in the picture. This is especially appropriate when you have some white, fluffy clouds against a blue sky. When you want to suggest closeness, position the horizon high in your picture. Another important point, easily overlooked, is to see that the horizon is level in the viewfinder before you press the shutter release.

The high camera angle selected for this picture helped to isolate the children and raft and better display the pattern of ripples in the water.

The photographer pointed the camera down from a high vantage point in a nearby building to capture this unusual design of cars and pavement.

Photographing the little boy from this high viewpoint strengthened the picture as the statue's features appear more foreboding and overpowering.

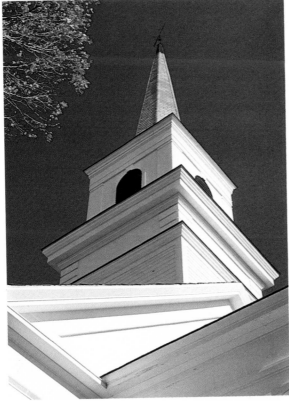

A low camera angle has produced an interesting study of clean, architectural lines against a deep-blue sky.

For a center of interest with plenty of impact, the photographer chose a low camera angle from nearly ground level. Taking the picture from this viewpoint helps to involve you in the fun the girl is having on the play gym.

Neil Montanus

Picturing a child from a point of view at his or her eye level helps convey a feeling of intimacy with the child's world of activities.

Roger C. Luce, KINSA

A water-level camera angle in this case helps suggest the feeling that you're right in the water with the swimmer, sensing the power of his competitive stroke.

On overcast days, you can avoid a cloudy, gray, uninteresting sky in your pictures by choosing a high camera angle. Made in England on EKTACHROME 100 Film.

Another way you avoid including overcast skies in your photos is to select backgrounds or photograph scenes that don't include any sky.

Arthur Whitty

Make sure that you keep the horizon line level in your pictures. When the horizon is straight and level in the scene, it should be parallel to the top and bottom of the picture. Postcard photographers often use a bubble level on their cameras to aid them in keeping the camera aligned with the horizon.

Besides being level, a horizon which is low in the picture area will usually enhance the vastness of the sky and, in the case of this rural scene, suggest wide open spaces.

Bronette Ehrlich. KINSA

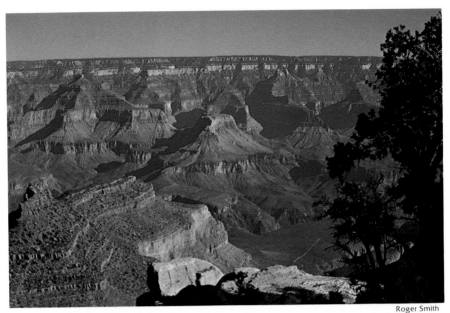

When you position the horizon high in the picture, you can communicate the feeling of being closer to the scene. Grand Canyon

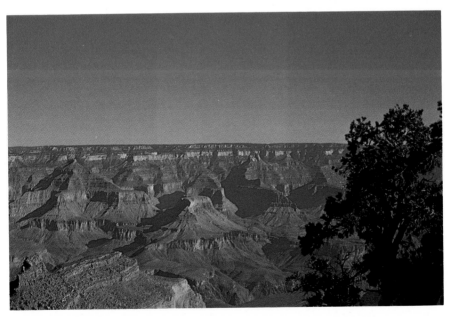

It's nearly always best not to have the horizon in the middle of the picture because it has the effect of splitting the picture in half.

Move close to your subjects for dynamic photos with impact.

MOVE IN CLOSE

One rule of composition you should always keep in mind is whether the picture you're about to take would be better if you move in closer to your subject. Close-ups convey a feeling of intimacy to the viewer while long shots provide a sense of distance and depth. A close-up picture focuses your attention on the main subject and shows details that you could otherwise overlook or defines details that are too small in more distant views.

Some amateur photographers look through the viewfinder when they're taking pictures and start backing away from the subject. This is not only bad from a safety standpoint, but it can also be bad for composition. This can have the effect of making the subject too small in the photograph and encompassing too many elements that are not part of the picture. Including

too much in the picture can be confusing and distracting to the viewer.

When you look through your viewfinder, move toward your subject until you have eliminated everything that does not add to the picture. Even though you can crop your picture later if you plan to enlarge it, it's usually better to crop carefully when you take the picture. Carefully composing the picture in the viewfinder is essential for taking color slides because cropping techniques are not generally used with slides. In addition, because the frame size of a 35 mm camera is not large, you'll obtain the highest quality when you utilize all of the picture area. The larger the image size on the film and the less enlarging that's necessary, the higher the image quality. A good rule to remember is to fill the frame.

Art Robb, KINSA

Moving in close to your subject to take the picture gives the viewer the sense of being there.

You can show interesting detail by taking close-up pictures.

Herb Jones

Close-ups focus your attention on unusual subjects that can otherwise go easily unnoticed.

Whether you crop in the viewfinder before taking the picture or later on when prints are made, it's best for people subjects, when you're not going to include the full-length figure, to crop between joints on arms or legs as indicated by the middle line. Cropping at a joint, such as a knee or an ankle —top and bottom lines, is unflattering because it looks as though the rest of the limb has been cut off.

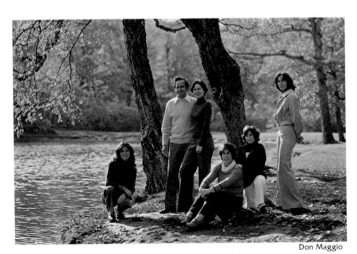

Don Maggio

Crop carefully when you take the picture. By moving toward your subject (or zooming in with a zoom lens) until you have eliminated all unnecessary elements, you'll strengthen the composition in the resulting photograph.

Look for unique points of view and crop in the viewfinder if possible when you take the picture. Keep in mind that it's a necessity for color slides as they are usually not cropped for projection. Also, when you want large prints, you'll get better quality if most of the cropping is done in the viewfinder because your original film won't have to be enlarged as much to get the desired image size.

Leading lines may be many different elements within the picture area, from pathways and streams to lightbeams and shadows.

USE LINES FOR INTEREST AND UNITY

Use leading lines to direct attention into your pictures. Select a camera angle where the natural or predominant lines of the scene will lead your eyes into the picture and toward your main center of interest. You can find a line such as a road or a shadow in almost anything. The road will always be there, so it's just a matter of choosing the right camera angle to make it run into the picture. A shadow, however, is an ever-changing element in the scene. There may be only one time in the day when it's just right. So you should patiently wait for the best composition.

A leading line is usually the most obvious way to direct attention to the center of interest. In this case, the road leads the viewer's attention to the distant house—the center of interest.

Tom Tracy

B. B. Caron, KINSA

Here the bright mooring lines in the foreground and the diagonal line formed by the reflections in the background direct the viewer's eye to the two small boats.

In this case, the two long necks and outstretched chin lead your eye to the head of the dominant giraffe on the right. Look for leading lines in whatever you choose to photograph.

The dominating S cur formed by train and track this arrangement succes fully leads you into a through the picture. curves make ideal leadi lines for helping achie good composition.

Margaret Fava, KIN

B. Greiser

The modified S curve formed by the road combines well with the rule-of-thirds placement of the pedestrians. The resulting arrangement is a pleasing blend of scenic elements.

Barbara Jean

The V formations of multiple tree trunks perform the dual functions of framing the subject and leading your eyes to the child.

The radial arrangement of this family group draws attention to the pet in the center. Having family members look at each other and at the dog (but definitely not at the camera), develops a fine feeling of natural spontaneity. Made on EKTACHROME 100 Film.

Bob Clemens

In this composition, the triangular arrangement of the mission bells calls attention to the cross by directing the viewer's eye upward.

Herb Jones

Notice how the grouping of these four people form a pleasing arc for a comfortable, informal arrangement.

Peter Gales

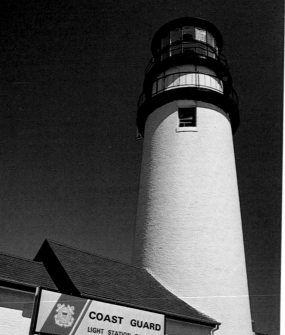

COAST GUARD
LIGHT STATION CAPE COD

The camera angle selected for this pictorial photo places the two structures in an L-shaped arrangement —a good example of leading lines and the rule of thirds working together for a pleasing composition.

Herb Jones

You can often use more obvious geometric patterns to produce striking compositional arrangements.

WATCH THE BACKGROUND

The background can make or break a picture. It can add to the composition and help set the mood of a picture, or it can detract from the subject if it is cluttered. Watch out for backgrounds that are more compelling than the subject. Cluttered, distracting backgrounds often spoil otherwise good pictures. Before you snap the shutter, stop for a minute and look at the background. Is there some obtrusive object or action in the background that does not relate directly to your subject which would divert the viewer's attention? For example, is there a telephone pole growing out of your subject's head? Beware of an uncovered trellis or the side of a shingled house when you take informal portraits or group shots, because prominent horizontal or vertical lines detract from your subject. Foliage makes a better background. A blue sky is an excellent background, particularly in color pictures. Remember to look beyond your subject because your camera will!

Patrick Walmsley

A cluttered background with trees or other unwanted elements sprouting out of your subject's head usually makes a confusing and distracting picture. Also, people may not appear at their best when photographed head-on with their bodies perpendicular to the axis of the camera.

Moving the offending tree to the right in this comparison shot improved the overall arrangement, and having the subject take a relaxed position at a slight angle to the camera helped create a more pleasing informal atmosphere. Made in England on EKTACHROME 100 Film.

or better pictures, be constantly on the okout for strong lines and patterns as aids creating interesting compositions.

lliam Utech, Jr., KINSA

Watch the background in your picture because busy backgrounds can steal attention from your subject. A plain blue sky makes a good background for many subjects.

Peter Gales

Plain backgrounds help concentrate attention on your subject. Made on KODACOLOR VR 400 Film.

Don McDill

When you have a background with many elements in it that could easily be distracting, select a camera angle that will place these elements in harmony with your subject. For example, the red sailboat looks better off to the right, rather than merging with the girl's head.

Neil Montanus

180

Add a natural frame to your scenics by including foreground objects such as trees. A foreground frame can help add the feeling of depth to a picture.

TAKE PICTURES THROUGH FRAMES

Frame your pictures when you take them with an interesting foreground, such as a tree, a branch, an archway, a window, or another appropriate opening. A frame creates a sensation of depth and directs your attention to the center of interest. Watch the depth of field of your lens so that both the foreground and the other details in the scene will be in focus. It's very distracting to have an out-of-focus foreground in scenic views. In other kinds of shots, such as informal portraits, you may want an unsharp foreground frame to help direct the viewer's eyes toward the subject.

In scenic photographs, it is often a help rather than a hindrance to include people who may be in the field of view. They add interest, scale, and depth to the scene. People in the picture should stay about 25 feet away from the camera and they should look at the scene—not at the camera. For color pictures, have your foreground figures wear colorful clothing, preferably red or yellow, to add color and interest.

After you've followed the rules of composition for a while, you'll no longer need to spend much time trying to determine the best arrangement of the picture you're taking. As we all have some artistic ability, soon the recognition of pleasing composition will become almost automatic. You'll be aware that it is important to place figures or objects in certain positions. Figures should look into not out of the picture. Fast-moving objects should have plenty of space in front of them to give the appearance of having somewhere to go. And remember that since bright tones or colors attract attention of the eye, the most important elements of the picture should be the lightest or brightest or most colorful.

To remind you again: composition is simply the effective selection and arrangement of your subject matter within the picture area. If you follow the suggestions given here, experience will teach you a great deal about this subject. When you look through the viewfinder, concentrate on how you want the final picture to appear.

Arches and doorways make interesting, storytelling frames and add dramatic impact to the scene. San Xavier Mission located near Tucson, Arizona

Without the foreground frame, the picture has less pictorial appeal.

For this interpretation, the photographer walked around to picture the mission with a different foreground frame. A wide-angle lens was used to include the entire height of the archway and to make it more prominent relative to the church.

Herb Jones

Caroline Grimes

Overhanging branches are usually available and, consequently, popular as elements for foreground framing. Here in this scene, they provide added dimension to Thomas Jefferson's Monticello, near Charlottesville, Virginia.

183

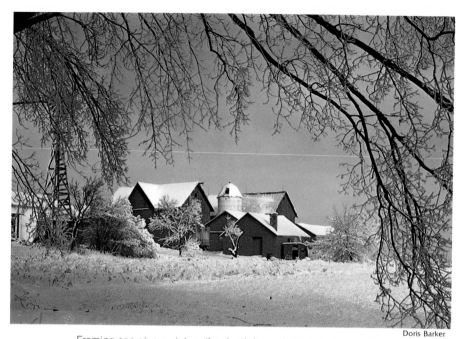

Framing can give a picture the depth it needs to make it more than just another snapshot. In this picture, the photographer used tree branches both as a frame and as a device to add interest to a rather bland sky.

You can usually improve a sunset scenic by using silhouetted objects in the foreground as a compositional frame.

Don Maggio

Informal portraits outdoors are often better when you use framing to set the scene and focus attention on your models.

Lee Howick

Don't limit your selection of foreground frames to trees and architecture. Keep an eye out for fresh approaches to make more of your pictures have lasting appeal.

Sometimes you can use a colorful foreground like pretty flowers to frame your subject.

An interesting foreground can help improve your pictures of people. Notice how the dead tree branches direct your attention toward the subjects.

A field of flowers provides a carpet of color for environmental portraits. While just the flowers would make a good picture, including the little girl makes it even better.

John Fish

Include people in the fore-ground of scenic pictures to provide color and scale. The picture above is more effective than the one below because the people have provided foreground interest. By includ-ing your companions in your scenic views, you'll also be personalizing your pictures —an added bonus that says *you were there*. Sand Beach, Mt. Desert Island, Maine

Paul Kuz

Adding the person in the picture has introduced a colorful center of interest to attract the eye.

188

You can use people effectively in pictures to give scale to the rest of the subject matter. The presence of a person in this photo helps us appreciate the great size of the redwood tree.

Yosemite Falls in Yosemite National Park, California, takes on added height with the inclusion of people for scale in the lower left corner.

It would be difficult to visualize how large the stone arch is without people near it to give it scale. Arches National Park, Utah

By picturing people on the trail in Bryce Canyon National Park in Utah, the photographer helps you imagine that you're on the trail with them, enjoying the view.

Let the subjects within your composition tell a story. For an entertaining effect, look for humorous situations, such as that created by this wall mural.

Always be ready with your camera. You never know when you'll have an opportunity to photograph those candid, often amusing events that come and go so quickly.

191

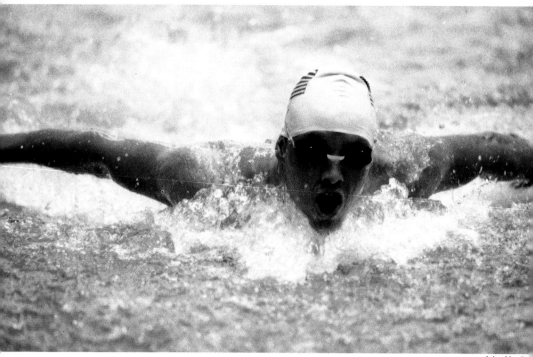

Stopping action in pictures is thrilling because it lets you freeze an exciting, fleeting image, which lasts only a moment, so you can view the action again and again for as long as you like. Made on KODACOLOR VR 1000 Film.

ACTION PICTURES

Pictures of subjects in action usually convey a feeling of excitement, so the technique you use to photograph the action will have a great deal to do with the quality and mood of your pictures.

STOPPING THE ACTION

The most common technique for stopping the action in a photograph is, of course, to use a high shutter speed. For most action pictures you'll probably want to use as high a shutter speed as lighting conditions allow. But it's useful to know when you must use the highest shutter speed and when you can stop the action with slower speeds.

Action moving at right angles to the camera is more difficult to stop than action moving diagonally, and action moving directly toward or away from the camera is the easiest to stop. Also, distant action is easier to stop than action close to the camera.

For example, suppose you were photographing the Grand Prix. You would have to use your highest shutter speed to try to stop the action if you were photographing the cars from the side as they raced across the finish line. If you were near a bend in the track and could photograph the cars coming toward you, you could get away with a slower shutter speed. Also, you could stop the action with a slower speed if you were in the last row of the bleachers rather than in the pits.

Certain types of action have a peak—a split second when the action

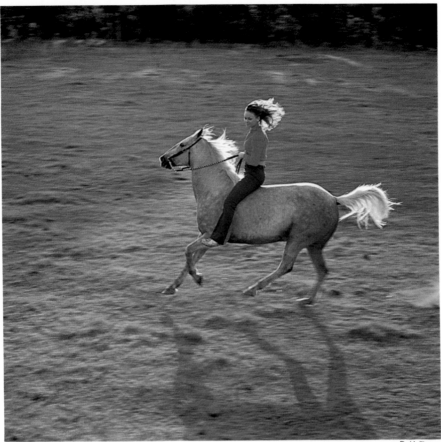

Picturing the moving horse and rider, mane and hair flying, ground blurred, conveys the fun of riding better than posing such dynamic subjects standing still. A 1/500-second exposure would stop this action. Backlighting makes the photo even better.

almost stops. If you anticipate the peak of the action and begin pressing the shutter release so that the shutter clicks right at the peak, the action is easier to stop. A pole-vaulter at the top of his jump, a golfer at the end of his follow-through, and a tennis player at the peak of his backswing are all examples of good times to shoot to stop the action.

Another good way to arrest the action is to pan with the moving subject. If you move the camera to keep the moving subject centered in the viewfinder as you squeeze the shutter release, the subject will be sharp and the background blurred. The slower the shutter speed, the more blurred the background will be. This technique is useful for creating a feeling of speed in a photograph. A picture of a trotter made at 1/500 second may show the action frozen in a rather static-looking photograph. But if the shutter speed were reduced to 1/125 second and the camera panned with the action, the result could be a very exciting photograph filled with the feeling of motion. The body of the horse would be sharp, with perhaps some motion in the legs, and the background would be a blur of movement.

For additional guidelines on selecting the shutter speed to stop action, see the table on page 29.

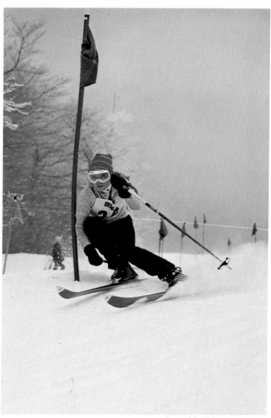

The excitement of a downhill slalom race is effectively captured in this memorable action shot. For rapid action close to your camera, use the highest shutter speed that you can. To stop the action in this picture would require 1/1000 second.

Richard E. Weber, Jr., KINSA

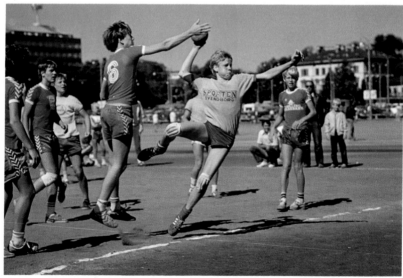

Marty Czamanske

Sports are a natural for action photography. The main concern is to watch for the most opportune moment to snap the shutter as the action takes place. This is where an autowinder or motor drive comes in handy because you can take pictures rapidly. Made in Sweden on EKTACHROME 100 Film.

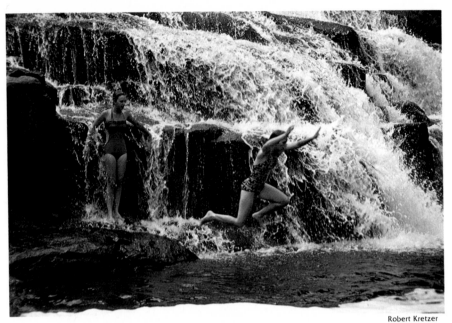

Using a moderately high shutter speed of 1/250 second stopped the girl jumping in midair and the water cascading over the falls.

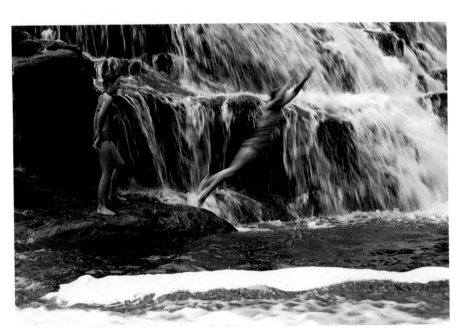

A slow shutter speed of 1/30 second caused the girl jumper and the waterfall to be blurred. Blurred subjects in motion can make good action pictures, too, because this effect conveys a sense of action.

195

Pete Culross

Action moving directly toward
or away from the camera is the
easiest to stop.

When action is moving across
your field of view at right an-
gles to the camera, the action
is harder to stop. You'll need to
use a higher shutter speed
than when the action is moving
in other directions.

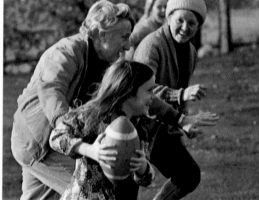

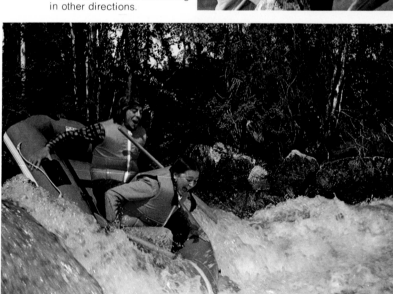

David K. Robertson, KINSA

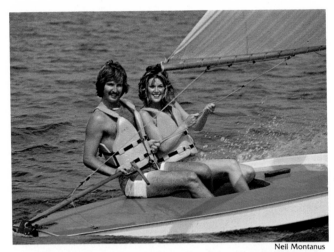

This sailboat wasn't moving very fast so 1/250 second would stop the action.

Neil Montanus

Subjects moving diagonally to the camera are easier to stop than those moving at right angles. A shutter speed of 1/500 second was enough to stop this airplane at an air show.

Bob Clemens

This catamaran was moving diagonally as well as away from the camera. A shutter speed of 1/250 second was adequate to stop the motion.

Don McDill

197

A shutter speed of 1/250 second stopped these girls jogging at a moderate pace at right angles to the camera.

In a fast hurdle race, 1/500 second was necessary to stop the runners moving across the camera field of view.

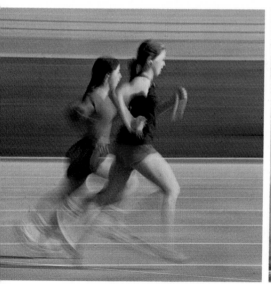

To record blurred motion, the photographer used 1/15 second and panned his camera with the runners.

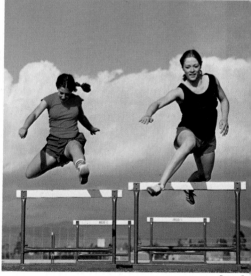

Peter Ga

The fast moving hurdlers are easier to stop running toward the camera. A shutter speed of 1/250 second would stop the forward motion of the runners. But the photographer used 1/500 second which also stopped the rapidly moving arms and legs as well. Use the highest shutter speed that you can to stop the action sharply in the picture.

The farther the action is from your camera the easier it is to stop. To stop this skier, 1/500 second would be more than adequate.

This little girl running toward the camera is far enough away so that 1/125 second was fast enough to stop the action. The afternoon sunlight filtering through the woods makes this photograph one to be proud of.

Be ready to catch the action at its peak—that split second when the action almost stops.

Here the photographer snapped the picture at the precise moment when the motorcycle was at the peak of its jump. It's easier to stop motion this way.

Lawrence Grella, KINSA

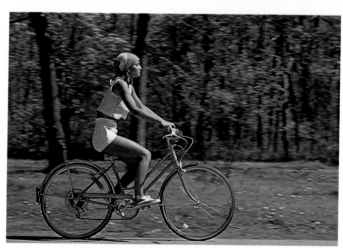

You can pan with the action to keep a moving subject centered in the viewfinder as you squeeze the shutter release. When you do this, the subject will be sharp, but the background will be blurred.

Don Maggio

In this picture, panning wasn't used so the background is sharp. But a higher shutter speed is necessary when you don't pan your camera with the moving subject. Compare this photo with the one above.

Murry Koblin, KINSA*

*Courtesy Kodak
International Newspaper
Snapshot Awards

Andrew Greene

Panning is a big help to get sharp pictures of fast-moving subjects when you're photographing them close to your camera or with a telephoto lens.

Don Buck

Panning the camera with this skateboarder gives a realistic impression of speed.

Linda Sue Alexander, KINSA

People walking at a distance from the camera can be easily stopped in your pictures using 1/125 second. This is a good shutter speed to use for general handheld picture-taking with normal or wide-angle lenses. The speed is fast enough to produce sharp pictures with a handheld camera and fast enough to stop moderate action. Note how the woman's moving hands and feet are sharp, as are the breaking waves in the background. Made on KODACOLOR VR 200 Film.

Howard E. Marlin, KINSA

The children have momentarily halted their rapid action to be ready to hit the ball, so 1/250 second is fast enough to stop the action. If they were swinging their rackets, 1/500 second would be needed at the distance this picture was taken.

Since a telephoto lens magnifies the image and brings the action closer optically, you need to use higher shutter speeds than with normal or wide-angle lenses.

F. P. Foltz

ACTION SHOTS WITH TELEPHOTO LENS

Sometimes you'll want to photograph action that you can't get as close to as you'd like, so you may use a telephoto lens to bring the action closer to you. Remember that a telephoto lens not only increases image size but also increases the effect of subject movement. When the subject distance remains the same, the effect of subject movement increases in direct proportion to the focal length of the lens. For example, if you need a shutter speed of 1/250 second to stop the action with a 50 mm lens, you'll have to use a shutter speed that's twice as fast or 1/500 second with a 100 mm lens. The longer the focal length, the faster the shutter speed needs to be.

Lee He

A close-up action photo of auto racing is usually possible only when you use a telephoto lens. The car moving diagonally by the camera helped the photographer get a sharp picture. It would be best to use 1/1000 second for this kind of picture.

Marty Czamanske

It's often easier to take good telephoto pictures with a high- or very high-speed film such as KODAK EKTACHROME 400, EKTACHROME P800/1600 Professional, KODACOLOR VR 400, KODACOLOR VR 1000, or KODAK TRI-X PAN Film. These films will let you use a smaller lens opening for improved depth of field with the very high shutter speeds required to stop action when you're using a telephoto lens. Made in Sweden on KODACOLOR VR 1000 Film.

Because it's difficult to get close enough to subjects in the water, a telephoto lens is a great asset in getting a good image size to show the action. Shutter speeds of 1/500 or 1/1000 second are necessary to stop the motion.

Not all action pictures should show completely stopped action. The blurred wings of these beautiful snowy egrets photographed at the best possible moment have created a breathtaking nature photograph. A shutter speed of 1/125 second recorded just the right amount of blur in the wings. The photographer used a 300 mm telephoto lens and panned his camera with the birds' flight path.

The blurred action effectively shows the great speed of the skater. The camera was panned to follow the skater while the exposure was made at 1/8 second. Good shutter speeds to try for blurred action are 1/30 to 1/4 second depending on the speed of your subject and the amount of blur you want in the picture. A low-speed film—less than ISO (ASA) 50—will allow the slow shutter speed necessary to get an attractive blur.

A slow shutter speed of 1/8 second, used while panning the camera, reproduced the fast-moving pace of a bicycle race as a blur of motion.

EXISTING-LIGHT PHOTOGRAPHY

Existing-light pictures have a natural appearance because they're made by the natural lighting on the subjects. Made with a combination of existing natural window and artificial tungsten light on KODACOLOR VR 400 Film.

Dick Boden

Existing light, sometimes called available light, includes artificial light which naturally exists in the scene, daylight indoors, and twilight outdoors. It's the light that happens to be on the scene. Technically, sunlight and other daylight conditions outdoors are existing light. But in defining existing light for photography, we are referring to lighting conditions that are characterized by lower light levels than you would encounter in daylight outdoors.

Existing-light pictures have a natural appearance because they're made by the natural lighting on the subject. Existing-light photography is also sometimes more convenient than picturetaking with flash or photolamps because you don't have to use extra lighting equipment or concern yourself about the light source-to-subject distance.

An added bonus of taking pictures by existing light is that it's less expensive than using flashbulbs.

Existing-light photography really isn't as new as we sometimes think. Photographers have been taking existing-light pictures for over 50 years. But their exposures often lasted several minutes. The big advantage of today's fast lenses and fast films is that they make it possible to take existing-light pictures with much shorter exposure times. Often the exposure times are short enough to allow you to handhold your camera.

Since most existing lighting is comparatively dim, you need an $f/2.8$ or faster lens and a high- or very high-speed film for handheld picture-taking. An $f/2.8$ lens is sufficient for many existing-light scenes. But if you have

an even faster lens such as $f/2$ or faster and use a high- or very high-speed film—ISO (ASA) 400 to ISO (ASA) 1600—you'll have more versatility. The combination of an $f/2$ or faster lens and a 400-speed or faster film lets you take pictures in dimmer lighting conditions while handholding your camera. A fast lens and a high- or very high-speed film also let you use higher shutter speeds for stopping action when the existing lighting is somewhat brighter. Another advantage is that you can use a smaller lens opening for greater depth of field under brighter existing-light conditions.

Handholding your camera is suitable for shutter speeds as slow as 1/30 second with a normal-focal-length lens. For sharp pictures it helps to practice the steady-camera routine described on page 20. At slower shutter speeds, put your camera on a tripod or other firm support. It's also good to use a cable release so that you don't jiggle the camera as you trip the shutter.

If you don't have a tripod handy and you want to make a relatively long exposure, try bracing the bottom of your camera tightly against a wall or post while you take the picture. A rubber mason-jar ring between the bottom of the camera and the wall or post makes a good nonskid device. If your camera has a delayed-action timer, you can set the camera for delayed action and an exposure time of 1/2 second, for example. Press the camera against its support, push the shutter release, and let the shutter trip itself. This way there is less chance of jiggling the camera as the timer makes the exposure with a slow shutter speed.

Most of your existing-light pictures will be shot at large lens openings, so depth of field will be shallow. This means that accurate focusing is a must.

Ann Marchese, SKPA

Taking the picture by the existing lighting lets you capture the realism of beautiful interiors you see in your travels.

Night scenes are natural subjects for your existing-light photography. The colorful and dramatic lighting patterns let you create pictures with a totally different appearance from that of conventional pictures taken in the daytime. Las Vegas, Nevada, KODAK EKTACHROME 160 Film (Tungsten), 1/30 second f/4

The lighting in museums is arranged to produce the most effective illumination for the objects on display. You can take advantage of this lighting when you take your pictures by existing light. The Imperial Calcasieu Museum, Inc., Lake Charles, Louisiana

Compare this picture taken with flash with the one on the left. When you use flash, your camera does not record the pleasing appearance of the museum lighting on the display.

John Menihan

Night sports present an exciting challenge to the existing-light photographer. A telephoto lens which gives close-up views of the athletes is somewhat difficult to use in existing light because most long-focal-length lenses have rather small maximum apertures. This, combined with fast shutter speeds for capturing action, means using very high speed films and precise techniques. Try to find convenient extra support for your camera, such as a fence post or railing. Made on KODACOLOR VR 1000 Film.

Shot In The Dark Studios

Focus carefully when you take existing-light pictures because depth of field is shallow due to the large lens openings that are required for the relatively dim lighting. Made on EKTACHROME P800/1600 Professional Film (Daylight) exposed at EI 1600, 1/30 second, f/2.8.

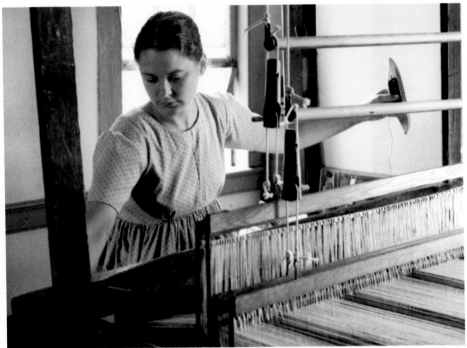

Versatile KODACOLOR VR 400 Film combines outstanding image characteristics with the high speed necessary for many existing-light situations. This indoor scene was lighted by existing window light and balanced by a reflector card to brighten the shadow side of the woman's face.

FILMS

When you want color prints, KODACOLOR VR 400 and 1000 Films (ISO 400 and 1000 respectively) are exciting films, and excellent for existing-light photography. They are especially suited for this kind of picture-taking because of their speed and their versatility. You can take pictures in various kinds of existing light—daylight indoors, tungsten, and fluorescent illumination—without using filters. These films produce more natural color rendition under a wide range of lighting conditions because they have special sensitizing characteristics that minimize the differences between various light sources. Also, color rendition can be partially controlled during the printing process.

KODAK EKTACHROME P800/1600 Professional Film (Daylight), EI 800 or 1600 (depending on exposure index and processing); EKTACHROME 400 Film (Daylight), ISO (ASA) 400; EKTACHROME 200 Film (Daylight), ISO (ASA) 200; and EKTACHROME 160 Film (Tungsten), ISO (ASA) 160, are great for making color slides by existing light. EKTACHROME P800/1600 and EKTACHROME 400 Films are real boons for the existing-light photographer who wants color slides because they offer the advantages of high film speeds. If you don't need that much speed, you may want to use EKTACHROME 200 Film or 160 Tungsten Film which offer the advantage of very fine grain. When you need more film speed, you can double the speed of most 35 mm EKTACHROME Films by taking advantage of a special processing service offered by Kodak or by processing the

You need a high-speed film for action pictures in existing light because a high shutter speed is necessary to stop the action and a large lens opening is required for proper exposure. Existing light is not very bright compared with bright outdoor lighting conditions in the daytime. KODAK EKTACHROME 400 Film (Daylight)

Don Maggio

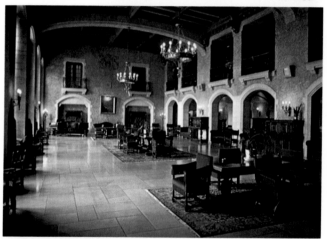

KODAK EKTACHROME 200 Film (Daylight) is a good choice when you plan to take both existing-light pictures and daylight pictures outdoors on the same roll of film. Its speed of ISO (ASA) 200 is adequate for many existing-light scenes if your camera has an f/2.8 or faster lens.

Gary Whelpley

For scenes with tungsten existing light—regular light bulbs—KODAK EKTACHROME 160 Film (Tungsten) produces pleasing slides with good color balance.

Gary Whelpley

Bob Clemens

KODACOLOR VR 1000 Film has a very high film speed which is so desirable for existing-light picture-taking when you want color prints. The ISO 1000 speed lets you handhold your camera in dim lighting, use a smaller lens opening for better depth of field, or use a higher shutter speed for stopping action.

film yourself. See page 57 for details.

Whether you choose daylight-type color-slide film or color-slide film designed for use with tungsten light—regular light bulbs—for your existing-light pictures is often a matter of personal taste. With existing tungsten light, you'll get the truest color rendition when you use film balanced for tungsten light. With daylight film the colors will appear warmer, or more orange. However, many people like this added warmth in their existing-light pictures. With fluorescent lamps, daylight film is the better choice, but the colors are still likely to have a cold greenish or bluish cast. When daylight from windows or a skylight illuminates your subject, use daylight film.

For taking existing-light pictures in black-and-white, KODAK TRI-X Pan Film, ISO (ASA) 400, is an excellent choice. This film with its high quality is a favorite for low-light photography. When you photograph your subjects with black-and-white film, you don't have to be concerned with the color quality of the light or the type of lamps illuminating the scene.

The combination of a very high film speed and superb quality makes EKTACHROME P800/1600 Professional Film (Daylight) a really great film to use for taking color slides by existing light. Exposed at EI 800.

Shot In The Dark Studios

213

Tom McCarthy

For activities outdoors at night you need a lot of film speed. The 1-stop increase in film speed you get by using the KODAK Special Processing Envelope, ESP-1, gives you the extra speed you need. KODAK EKTACHROME 160 Film (Tungsten)

A high or very high film speed is a tremendous help when you want color slides of action in existing light. The speed of KODAK EKTACHROME 400 Film (Daylight) was increased to ISO (ASA) 800 by ESP-1 Processing. Damascus Temple Shrine Circus. 1/250 second f/2.8

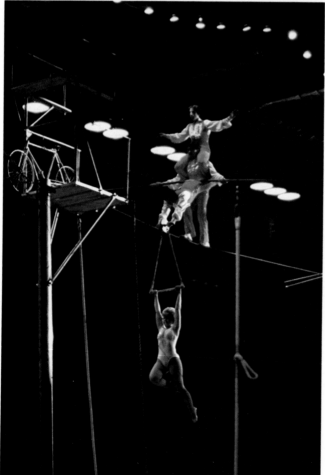

Caroline Grimes

214

KODAK EKTACHROME 160 Film (Tungsten), ESP-1 Processing

KODAK EKTACHROME 200 Film (Daylight), ESP-1 Processing

Jim Dennis

For taking color slides in tungsten lighting, tungsten film gives color rendition that appears natural as shown by the photo on the top. The one on the bottom, which has an orange-red color cast, was made on daylight film. Although the bottom photo has a warm color balance, many people like the color in slides made this way. Damascus Temple Shrine Circus

Patrick Walmsley

You can use either tungsten or daylight film for color slides of night scenes. Slides made on tungsten film have a bluer, perhaps more realistic appearance than slides made on daylight film which have an orange-red color balance. Both kinds of film produce good results. The one you select is a matter of personal preference. Made in England on KODAK EKTACHROME 160 Film (Tungsten).

For subjects in fluorescent illumination, you should use daylight film for color slides. The slides may have a slight greenish cast, but many people find the pictures acceptable. This picture was made on KODAK EKTACHROME 400 Film (Daylight).

Bob Clemens

Film for color prints, such as KODACOLOR VR 400 Film and KODACOLOR VR 1000 Film, usually produces acceptable pictures in fluorescent lighting because color rendition can usually be improved when the prints are made. However, the pictures may still have a greenish cast depending on the kind of fluorescent lamps. Made on KODACOLOR VR 1000 Film.

Bob Clemens

KODAK TRI-X Pan Film offers the ideal combination of a high film speed—ISO (ASA) 400, fine grain, and excellent overall quality for producing black-and-white existing-light pictures you'll be proud of. Exposed 1/60 second f/2.8

Judy Mott, KINSA

Lucy H. Kirshner, KINSA

It's easy to get good black-and-white pictures in existing light because you don't have to think about the color of the light source. The main concerns for black-and-white are to choose a camera angle where the lighting on your subjects is pleasing, determine the correct exposure, focus sharply, and hold your camera steady. KODAK TRI-X Pan Film

In the existing lighting at home, position your subject or select a camera angle where the light source is illuminating the front or side of the face so it's not in heavy shadow.

Home lighting is dim at best, so it's best to use a film in the 320- to 1600-speed range and a fast lens of $f/2.8$ or faster for handholding your camera. Made on EKTACHROME 160 Film (Tungsten) exposed at ISO (ASA) 320.

EXISTING-LIGHT PICTURES INDOORS

You'll find lots of possibilities for existing-light pictures indoors. Around home you can make unposed pictures of your family just being themselves and can record special holidays and occasions. Away from home you can make pictures of such subjects as ice shows, stage plays, museum displays, auto shows, and graduation ceremonies.

An exposure meter is a great help in determining indoor existing-light exposures in situations where the lighting is even or when you can move in close to your subject. However, when your subject includes both very bright and very dark areas and you can't take a close-up reading—for example, at indoor ice shows and in other places where spotlights are used—an exposure meter isn't much help unless you have a spot meter. The meter sees the large dark area surrounding the small bright area and indicates that there isn't enough light for picture-taking. Actually, there is plenty of light on the spotlighted subject. With spotlighted subjects, try an exposure of 1/250 second at $f/2.8$ with EKTACHROME 400 Film (Daylight) or KODACOLOR VR 400 Film. With the carbon-arc spotlights used in most theaters and auditoriums, you'll get best results by using daylight film when you want color slides.

If the lamp is behind your subjects, their faces will be too dark because of dark shadows.

Don Maggio

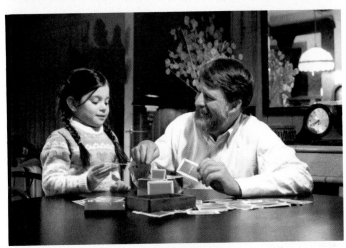

At night it helps to turn on all the lamps in the room to lighten the shadows on the subject. More lamps also help provide enough light so you can handhold your camera when you use a high-speed film. Made on KODACOLOR VR 1000 Film.

John Menihan

The soft, diffuse light from existing daylight is excellent for photographing subjects indoors. Compare the lighting in this photo with the tungsten household lighting used for the photo above. Notice how reflected light from the sheet music brightens the shadowed face? Made on KODACOLOR VR 400 Film, 1/60 second f/5.6.

Patrick Walmsley

Tom McCarthy

Norm Kerr

When window light is providing the existing lighting, take the picture from a position where the window is in back of you or at the side so that the daylight is illuminating the front or side of your subject.

Here the photographer had the subject turn toward the window to improve the lighting on the face. Made on KODACOLOR VR 200 Film, 1/30 second f/4.

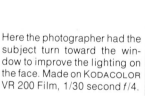

Patrick Walmsley

Try to avoid having a window behind your subjects in the daytime unless you want a semisilhouette effect. To keep their faces from going too dark in the picture, make a close-up meter reading of your subjects. Made on EKTACHROME 100 Film.

Patrick Walmsley

Museums have fascinating displays which offer superb opportunities for existing-light photographs. When the scene and displayed objects are lighted evenly, expose according to an overall meter reading. Otherwise get as close as possible to the subject to make your reading. Made on KODACOLOR VR 1000 Film.

Bob Clemens

Life-sized dioramas yield pictures that are almost like those taken of a real-life scene. If there is a framework surrounding the diorama, it's frequently darker than the objects on display so move close enough so your exposure meter measures only the diorama in order to obtain the proper exposure.

John Fish

When windows are part of the picture, either make a close-up meter reading of the subject if you can or aim your meter or camera with built-in meter to the side away from the window toward a similarly lighted subject to take the meter reading. Set the exposure on your camera, recompose the picture in the viewfinder, and take the picture. KODAK EKTACHROME 200 Film (Daylight)

Barbara Jean

221

an often improve existing daylight pic-
by using a reflector to fill in the shadow
of the face similarly to using a reflector
oors. This rewarding informal portrait
s how sidelighting from the window
ghts the right side of the subjects with
hadows lightened by the reflector.
K EKTACHROME 400 Film (Daylight)

helpley

If no reflector is used, the shadow on the face
is quite dark. The reflector was turned to
show its surface. It's not reflecting light on
the subjects in this picture.

This shows the position of the reflector and
window for the picture on the left. The reflec-
tor should be close enough to the subjects to
fill in the shadows. Keep the reflector out-
side the picture area.

For the reflector you can use crumpled
or textured aluminum foil or a large white
card. Here aluminum foil was wrapped over
a piece of plywood. The plywood was
mounted on a light stand with a ball-joint
adapter, both of which are sold by photo
dealers. You can also mount the reflector on
the tilting head of your tripod or you can have
a helper hold the reflector in the proper po-
sition.

You can use either gold or silver aluminum
foil for the reflector surface. Gold foil was
used for this setup to add a little yellow or
warmth to the bluish light from a winter day.
Silver and gold foils are available from art or
display supplies stores. You can also use
silver aluminum foil sold in food stores.

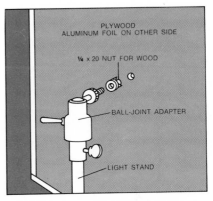

A ¼ x 20 threaded T-nut for pounding into
wood was used on the back of the plywood to
attach to the threaded bolt of the ball-joint
adapter. This kind of nut for use in wood is
sold by hardware stores.

Neil Montanus

R. J. Boden

Indoor sporting events are usually evenly lighted so exposure meter readings of the action area will indicate correct exposure. If your seat is far away, try to make an exposure meter reading up close before the contest begins. Made on KODACOLOR VR 1000 Film.

The background and surroundings for performers in stage shows are often dark. Since an exposure meter would measure the dark surroundings, the pictures would be overexposed. Make a close-up meter reading if you can or try the exposure given in the existing-light exposure table in this book. KODACOLOR VR 1000 Film.

John Menihan, Jr.

John Menihan,

KODAK EKTACHROME 200 Film (Daylight),
ESP-1 Processing, 1/250 second f/2.8

Since the lighting changes rapidly at ice shows and often includes large areas of darkness, it's not practical to make exposure meter readings of some acts. Suggested exposures for ice shows are given on page 230. Because conditions vary, it's good to bracket your exposures as described in the chapter on exposure, page 72. Ice Follies

The only way to photograph the intricate lighting in night scenes is by existing light. For handheld picture-taking it helps to have a high-speed film and an f/2.8 or faster lens. The best time to shoot outdoor pictures at night is just before complete darkness while there's still some rich color in the sky. Parliament Building, Victoria, British Columbia, KODAK EKTACHROME 200 Film (Daylight)

EXISTING-LIGHT PICTURES OUTDOORS AT NIGHT

Brightly illuminated street scenes, amusement parks, campfires, interesting store windows, and floodlighted buildings and fountains all offer good nighttime picture-taking possibilities. The best time to shoot outdoor pictures at night is just before complete darkness when there's still some rich blue left in the sky. The deep colors of the sky at dusk make excellent backgrounds for your pictures.

Outdoor photography at night is easy, primarily because of the pleasing results you can get over a wide range of exposures. The subject usually consists of large dark areas surrounding smaller light areas. Short exposures leave the shadows dark and preserve the color in the bright areas, such as illuminated signs. Longer exposures tend to wash out the brightest areas, but produce more detail in the shadows.

When your subject is evenly illuminated, try to get close enough to take an exposure-meter reading. Many floodlighted buildings and store windows fall into this category. Night sporting events also are usually illuminated evenly. Before you take your seat at the event, make an exposure-meter reading from a position close to the spot where the action will take place, and set your camera accordingly. When you can't take a meter reading of your subject, use the exposure suggestions in the table on page 230 as a guide. If the idea of existing-light photography really catches your fancy, you may want to read the KODAK Workshop Book *Existing-Light Photography* (KW-17), available from photo dealers.

The photographer made the exposure at the right moment to record the moon peeking through the clouds above the Jefferson Memorial, Washington, D. C. Including the moon in your night pictures adds interest to a black sky. KODAK EKTACHROME 400 Film (Daylight), 1/30 second at f/2

John Fish

You can start taking pictures of bright lights outdoors as soon as it begins to get dark. Many outdoor scenes, incidentally, may be more interesting if the sky is not entirely black, but the deep blue of twilight. Made in England on KODACOLOR VR 400 Film, 1/60 second f/5.6.

Patrick Walmsley

If you put your camera away at night when you're on vacation, you'll miss a lot of good pictures which help you relive your trip and provide a means to show your experiences to your relatives and friends. London, England. ISO (ASA) 400 Film. 1/60 second f/2.8

Robert Kretzer

Patrick Walmsley

You can use medium-speed film for existing-light night pictures if you put your camera on a tripod and make a time exposure. A long exposure will record only light streaks from moving traffic as it did in this shot made in London, England. The 1-second exposure at *f*/16 was long enough to capture bright streaks from the fairly dense passing traffic and short enough to preserve sharp details on the brightly lighted buildings. Made on EKTACHROME 100 Film.

The range of acceptable exposure outdoors at night is surprisingly broad. A bit of overexposure will lower contrast slightly and reveal shadow detail. A shorter exposure for this scene would have yielded a very different but equally interesting image. Made in Helsinki, Finland, on KODACOLOR VR 1000 Film.

Bob Clemens

Caroline Grimes

Since nighttime scenes usually include a lot of dark areas, exposure meter readings of the overall scene can cause overexposure. Make a close-up meter reading of the lighted subject excluding the black surroundings or try the exposures suggested in this book. For more assurance of proper exposure, bracket your estimated exposure. KODAK EKTACHROME 160 Film (Tungsten)

Lighted city streets are dazzling subjects for existing-light pictures. A high location, such as in a building, provides a good viewpoint for taking pictures. KODAK EKTACHROME 200 Film (Daylight), San Francisco, California

Herb Jones

You can record intriguing light patterns from traffic by making long exposures in areas where there is little or low-intensity ambient lighting. It may be helpful to use a low- or medium-speed film, such as EKTACHROME 100 Film.

John Menihan

A multi-image device attached to the lens (page 259) was used to make the explosive montage at left. The conventional photo at right was taken without the multi-image device. Made in London, England, on KODACOLOR VR 400 Film.

Patrick Walmsley

228

Seeing a picture taken by existing light is almost like your being there in person. Distant outdoor scenes at night are too far away to use flash. Hollywood Bowl, Los Angeles, California

Dale Newbauer

To remember the fun of camping, photograph your family or friends around the campfire. With 400-speed film and a fast *f*/2 lens there's enough light for you to take existing-light pictures. With all the blackness at night, determine exposure by making a close-up meter reading of your subjects.

Klaus M. Fischel

When you go to see the fireworks, take your camera along. The colorful, striking displays make spectacular pictures. You'll get the best results if you put your camera on a tripod, open the shutter on BULB, and record several bursts before you close the shutter. For KODAK EKTACHROME 200 Film (Daylight), set your camera lens opening on *f*/11.

If you don't have a tripod you can handhold your camera to take pictures, but you'll have to set the shutter speed on 1/30 second and the lens opening at *f*/2. With the brief exposure time necessary for handholding your camera, take the pictures when there are many firework bursts in the sky, as during the finale.

Caroline Grimes

229

SUGGESTED EXPOSURES FOR EXISTING-LIGHT PICTURES WITH *KODAK* FILMS*

Picture Subjects	KODACHROME 64 (Daylight) EKTACHROME 100 (Daylight) KODACOLOR VR 100	EKTACHROME 200 (Daylight) EKTACHROME 160 (Tungsten) normal processing KODACOLOR VR 200 PLUS-X Pan	EKTACHROME 400 (Daylight) normal processing — EKTACHROME 200 (Daylight)— EKTACHROME 160 (Tungsten)— with ESP-1 Special Processing† KODACOLOR VR 400 TRI-X Pan	EKTACHROME P800/1600 Professional (Daylight) at EI 800‡ EKTACHROME 400 (Daylight)†— with ESP-1 Special Processing KODACOLOR VR 1000
Home interiors at night— Areas with bright light Areas with average light	1/15 sec f/2 1/4 sec f/2.8	1/30 sec f/2 1/15 sec f/2	1/30 sec f/2.8 1/30 sec f/2	1/30 sec f/4 1/30 sec f/2.8
Interiors with bright fluorescent light§	1/30 sec f/2.8	1/30 sec f/4	1/60 sec f/4	1/60 sec f/5.6
Indoor and outdoor Christmas lighting at night, Christmas trees	1 sec f/4	1 sec f/5.6	1/15 sec f/2	1/30 sec f/2
Ice shows, circuses, and stage shows—for spot-lighted acts only	1/60 sec f/2.8	1/125 sec f/2.8	1/250 sec f/2.8	1/250 sec f/4
Basketball, hockey, bowling	1/30 sec f/2	1/60 sec f/2	1/125 sec f/2	1/125 sec f/2.8
Night football, baseball, racetracks, boxing‖	1/30 sec f/2.8	1/60 sec f/2.8	1/125 sec f/2.8	1/250 sec f/2.8
Brightly lighted downtown street scenes (Wet streets make interesting reflections.)	1/30 sec f/2	1/30 sec f/2.8	1/60 sec f/2.8	1/60 sec f/4
Brightly lighted nightclub or theater districts—Las Vegas or Times Square	1/30 sec f/2.8	1/30 sec f/4	1/60 sec f/4	1/125 sec f/4
Store windows at night	1/30 sec f/2.8	1/30 sec f/4	1/60 sec f/4	1/60 sec f/5.6
Floodlighted buildings, fountains, monuments	1 sec f/4	1/2 sec f/4	1/15 sec f/2	1/30 sec f/2
Fairs, amusement parks at night	1/15 sec f/2	1/30 sec f/2	1/30 sec f/2.8	1/60 sec f/2.8
Skyline—10 minutes after sunset	1/30 sec f/4	1/60 sec f/4	1/60 sec f/5.6	1/125 sec f/5.6
Burning buildings, bonfires, campfires	1/30 sec f/2.8	1/30 sec f/4	1/60 sec f/4	1/125 sec f/4
Aerial fireworks displays—Keep camera shutter open on BULB for several bursts.	f/8	f/11	f/16	f/22
Niagara Falls— White lights Light-colored lights Dark-colored lights	15 sec f/5.6 30 sec f/5.6 30 sec f/4	8 sec f/5.6 15 sec f/5.6 30 sec f/5.6	4 sec f/5.6 8 sec f/5.6 15 sec f/5.6	4 sec f/8 4 sec f/5.6 8 sec f/5.6

*These suggested exposures apply to daylight and tungsten color films. When you take color pictures under tungsten illumination, they look more natural when you use tungsten film. Daylight film produces pictures more orange, or warm, in color. You can use KODACOLOR Films in both kinds of light.

†You can increase the speed of KODAK EKTACHROME 400, 200, and 160 Films in 135 size 2 times by using the KODAK Special Processing Envelope, ESP-1, when you return the film to Kodak for processing. See page 57 for details.

‡KODAK EKTACHROME P800/1600 Professional Film (Daylight) can be rated at EI 800 with ESP-1 Special Processing (Push 1), at EI 1600 with push processing (Push 2) arranged by your photo dealer, and sometimes even at EI 3200. To use the EI 1600 film speed, merely *decrease* suggested exposure in this column by *one stop*, at EI 3200 *decrease* exposure by *two stops*.

§Tungsten color film is not recommended for use with fluorescent light. Shutter speeds 1/60 second or longer are recommended for uniform and adequate exposure with fluorescent lighting.

‖Shutter speeds 1/125 second or longer are recommended for uniform and adequate exposure with lighting from multi-vapor or mercury vapor high-intensity discharge lamps.

►Use a tripod or other firm support when you use shutter speeds slower than 1/30 second.

In color photography you can use filters to bring lighting and other environmental conditions to realistic terms with the film in your camera. You can also use filters to create dramatic interpretive views, such as the photo above, taken with a split-field sepia filter under hazy, uninteresting lighting in rural Sweden. Made on EKTACHROME 100 Film.

FILTERS AND LENS ATTACHMENTS

FILTERS FOR COLOR PHOTOGRAPHY

For most color pictures, no filter is necessary when you use a film with the light source for which it is balanced. However, there is one filter that many photographers like to have on hand. This is the No. 1A, or skylight, filter. The skylight filter reduces the bluishness of scenes photographed on overcast days or in the shade. It also helps reduce the bluishness in shots of distant scenes and in aerial pictures. Use a skylight filter only with daylight-type, color-slide films. The printer will cor-

rect for excess bluishness in color prints made from color-negative films. No exposure compensation is necessary with the skylight filter.

CONVERSION FILTERS

When you use a color film with a light source other than the one for which it was designed, you should use a conversion filter over the camera lens. The conversion filter adjusts the color of the light source to match that for which the film is balanced. The chart on page 233 contains film, light source, and filter combinations for Kodak color films.

231

A conversion filter adjusts the color of the light source—the sun for these pictures—to match the color balance of the film. The photos were taken on KODACHROME 40 Film 5070 (Type A). The one on the left was taken with a No. 85 conversion filter over the camera lens. The picture on the right, taken without a filter, is too blue.

These pictures were taken on daylight film with 3400 K photolamp illumination. A No. 80B conversion filter over the camera lens was necessary to adjust the color of the light for the daylight balance of the film. The photo on the right, taken without a filter, is too yellow. KODAK EKTACHROME 200 Film (Daylight)

CONVERSION FILTERS FOR *KODAK* COLOR FILMS

Light Source	KODACHROME 25 (Daylight) KODACHROME 64 (Daylight) EKTACHROME 100 (Daylight) EKTACHROME 200 (Daylight) EKTACHROME 400 (Daylight) EKTACHROME P800/1600 Professional (Daylight) KODACOLOR VR 100 and VR 200 KODACOLOR VR 400† and VR 1000†	KODACHROME 40 5070 (Type A)	EKTACHROME 160 (Tungsten)	EKTACHROME Infrared 2236
Daylight	None	No. 85	No. 85B	No. 12 or 15
Blue Flash	None	No. 85	No. 85B	No. 12 or 15
Electronic Flash	None*	No. 85	No. 85B	No. 12 or 15
Photolamps 3400 K	No. 80B	None	No. 81A	No. 12 or 15 plus CC50C-2
Tungsten 3200 K	No. 80A	No. 82A	None	—

*Use a No. 81B filter if your pictures are consistently too blue.
†For critical use

POLARIZING SCREENS

A polarizing screen looks like a simple piece of gray glass. However, you can put this handy screen to work performing such tasks as darkening blue skies and reducing reflections in your pictures.

Reflections. You can use a polarizing screen to reduce or eliminate reflections, except those from bare metal. If you look through a polarizing screen at reflections on a shiny surface and then rotate the screen, you'll see the reflections change. At one point they may be completely eliminated. The polarizing screen will have the same effect in your pictures when you use it over your camera lens.

When you're looking through the polarizing screen, if reflections from a shiny surface are not reduced enough, try a different viewpoint or camera

Pictures that include glass surfaces often show distracting reflections or glare.

John Menihan, Jr.

You may be able to remove or reduce the reflection or glare by using a polarizing screen.

The glare of the sun on this glossy tile mosaic has been almost eliminated by using a polarizing screen.

Colors may become more saturated when you use a polarizing screen because reflections are reduced.

With polarizing screen

Without polarizing screen

angle. Sometimes this will make the polarizing screen more effective.

You'll obtain the maximum effect with a polarizing screen in reducing reflections when the camera angle is about 35 degrees from the reflecting surface, depending on the surface material. At other angles the polarizing screen is less effective. At 90 degrees a polarizing screen has no effect in controlling reflections.

We mentioned earlier that you can get some great shots with backlighting. But backlighting often creates bright reflections from the sun (or other light sources) on water, foliage, boat decks, etc. You can use a polarizing screen to reduce or eliminate these reflections in your pictures. And since reflections desaturate the colors of a subject, reducing the reflections allows the colors in the photograph to be more saturated.

Dramatic Skies. You can make a blue sky darker in a color photograph without affecting the color rendition of the rest of the scene by using a polarizing screen. When you photograph the sky *at right angles to the sun,* you can control the depth of the blue, from normal to dark, simply by rotating the polarizing screen. The sky will look darkest when the indicator handle of the screen (if it has one) points at the sun. If your polarizing screen doesn't have a handle, you can determine the area of the sky the polarizer will darken by forming a right angle with your thumb and index finger. Point your index finger at the sun and as you rotate your hand, your thumb indicates the area in the sky that the polarizer can darken. With black-and-white film you can get night effects by using a red filter and a polarizing screen together. The sky effects created by a polarizing screen appear most striking with a very clear blue sky, but disappear completely with an overcast sky.

Patty Van-Dolson

You can use a polarizing screen to darken a blue sky without darkening other parts of the picture. You can control the degree of darkening by rotating the polarizing screen.

235

Robert Kretzer

A polarizing screen will darken only that portion of the sky 90 degrees from the sun. This photograph, taken through a polarizing screen, shows the area of the sky on the right that's at the proper angle to darken. The area of the sky to the left near the sun is at an improper angle so it didn't darken. The area in the sky that will darken with a polarizing screen is a large band across the sky. The band is large and wide enough so the edge of it will not usually show in pictures if you take them with your camera aimed away from the edge of the band.

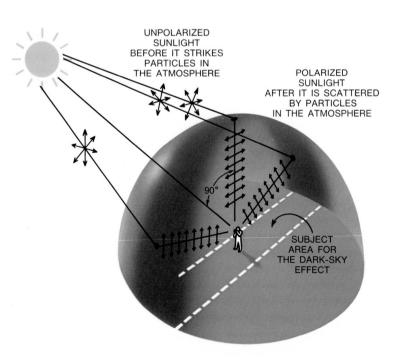

UNPOLARIZED
SUNLIGHT
BEFORE IT STRIKES
PARTICLES IN
THE ATMOSPHERE

POLARIZED
SUNLIGHT
AFTER IT IS SCATTERED
BY PARTICLES
IN THE ATMOSPHERE

90°

SUBJECT
AREA FOR
THE DARK-SKY
EFFECT

This illustration shows the area or band across the sky that will darken with a polarizing screen when you take pictures at right angles to the sun with the handle of the polarizing screen—if it has one—pointing at the sun.

236

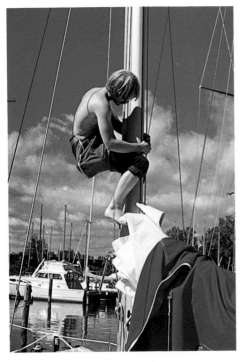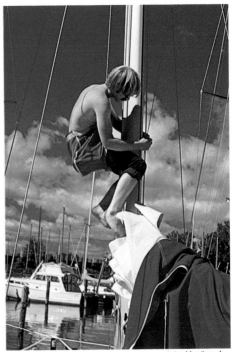

John Menihan, Jr.

This comparison shows the effects of using a polarizing screen. With a polarizing screen on the right, the sky is a deeper blue and the colors of the red tool bag and blue sail cover are more saturated.

If you use a polarizing screen on a single-lens reflex camera, you can see the effect it produces directly through the camera viewfinder as you rotate the screen. With other cameras, look through the screen as you rotate it, and when you see the effect you want, keep the screen in exactly the same orientation as you slip it over the camera lens.

You can also use a polarizing screen to reduce the appearance of atmospheric haze in distant views.

A polarizing screen has another application which you may find useful. Since you have to increase exposure with a polarizer over the lens (see page 239), you can use a larger lens opening to reduce depth of field, such as when you want the background out of focus to concentrate attention on the subject. This is especially helpful when you take pictures on a high-speed film in bright sunlight and you want less depth of field.

When the color of the sky is a lighter blue and not as saturated in color as it sometimes is, a polarizing screen will not darken the sky as much as when it's a deeper blue to begin with. When the sky is white as on an overcast day, a polarizing screen will have no effect. Annisquam Light. Cape Ann, Massachusetts.

With polarizing screen

Here the sky is a clear blue so the polarizing screen has darkened it considerably in the bottom photo. Capitol Reef National Park, Utah

Caroline Grimes

The use of a polarizing screen for the slide on the right has increased the brilliance of the eroded rock formations in Bryce Canyon, Utah.

Exposure. When you use a polarizing screen, you must compensate for the light it absorbs. For a normal front-lighted subject, increase the exposure by 1½ stops. This exposure increase applies regardless of the rotation position of the polarizing screen. If your subject is sidelighted or toplighted, as it will be when you are using the screen to get a dark-sky effect, give it an extra 1/2-stop more exposure or a total of 2 stops more than for a normal front-lighted subject. The extra 1/2-stop exposure increase usually is not necessary with a distant subject or a landscape where shadows are only a tiny part of the scene.

When you determine the exposure for subjects with bright reflections, remember that removing the reflections with a polarizing screen will make your subject appear darker than it was before. So in addition to the 1 1/2-stops more exposure required to compensate for the polarizing screen and any exposure increase necessary for the direction of the lighting, increase the exposure by another 1/2 stop when bright reflections have been removed from the subject.

Using the suggested exposure increase to compensate for a polarizing screen on the camera lens is more effective in obtaining the correct exposure than using an exposure meter to make the reading through the polarizing screen. A meter reading made through a polarizing screen with a meter built into a camera or with a separate exposure meter varies with the rotation of the polarizer. Such a meter reading can indicate the wrong exposure because as described before, the exposure increase required for a polarizing screen is the same regardless of the rotation of the polarizer. For example, when you use a polarizing screen to darken a blue sky, the meter reading would be affected by the darkened sky when it shouldn't be because you want the sky to be darker than normal in this situation. In addition, some cameras with built-in meters have semitransparent mirrors or prisms that cause erroneous meter readings made through a polarizing screen used on the camera lens. For these reasons you can't rely on exposure meter readings made through a polarizing screen.

The photographer used a No. 8 yellow filter to increase the contrast of the clouds against the blue sky. The print was made somewhat darker than normal which together with the effects of the filter creates a dramatic landscape in black-and-white.

Ralph S. Shepherd, KINSA

FILTERS FOR BLACK-AND-WHITE PHOTOGRAPHY

The two basic classes of filters for black-and-white photography are correction filters and contrast filters.

CORRECTION FILTERS

Panchromatic films respond to all the colors that the human eye can see but they don't reproduce them in the same tonal relationship that the eye sees. For example, although blue and violet normally look darker to the eye than green does, black-and-white panchromatic film is very sensitive to blue and violet. Consequently, these colors will be lighter than green in a black-and-white print.

Fortunately, you can easily change the response of the film so that all colors are recorded with approximately the same tonal relationship that the eye sees simply by your using a correction filter over the camera lens. To get this natural tonal relationship with Kodak panchromatic films, use a No. 8 filter in daylight or a No. 11 filter in tungsten light.

A No. 11 yellowish-green filter produces natural flesh tones, lightens green foliage, and darkens blue skies. Cape Cod, Massachusetts

John Fish

FILTERS FOR DAYLIGHT PHOTOGRAPHY WITH
BLACK-AND-WHITE PANCHROMATIC FILMS

Subject	Effect Desired	Suggested Filter	Color of Filter	Increase Exposure Time by This Factor	Or Open Lens This Many Stops
Clouds against blue sky	Natural	No. 8	Yellow	2	1
	Darkened	No. 15	Deep Yellow	2.5	1⅓
Blue sky as background for other subjects	Spectacular	No. 25	Red	8	3
	Almost black	No. 29	Deep Red	16	4
Marine scenes when sky is blue	Natural	No. 8	Yellow	2	1
	Water dark	No. 15	Deep Yellow	2.5	1⅓
Sunsets	Natural	None or No. 8	None or Yellow	2	1
	Increased brilliance	No. 15	Deep Yellow	2.5	1⅓
		No. 25	Red	8	3
Distant landscapes	Natural	No. 8	Yellow	2	1
	Haze reduction	No. 15	Deep Yellow	2.5	1⅓
	Greater haze reduction	No. 25	Red	8	3
		No. 29	Deep Red	16	4
Nearby foliage	Natural	No. 8	Yellow	2	1
		No. 11	Yellowish-Green	4	2
	Light	No. 58	Green	6	2⅔
Flowers	Natural	No. 8	Yellow	2	1
		No. 11	Yellowish-Green	4	2
Red, bronze, orange, and similar colors	Lighter to show detail	No. 25	Red	8	3
Dark blue, purple, and similar colors	Lighter to show detail	None or No. 47	None or Blue	6	2⅔
Foliage plants	Lighter to show detail	No. 58	Green	6	2⅔
Architectural stone, wood, fabrics, sand, snow, etc, when sunlit under blue sky	Natural	No. 8	Yellow	2	1
	Enhanced texture rendering	No. 15	Deep Yellow	2.5	1⅓
		No. 25	Red	8	3

CONTRAST FILTERS

A filter lightens its own color in a black-and-white print and darkens the complementary color. For example, a yellow filter lightens yellows and darkens blues.

You can use contrast filters to lighten or darken certain colors in a scene to create brightness differences between colors that would otherwise be reproduced as nearly the same shade of gray. For example, a red apple and green leaves that are equally bright would reproduce as about the same tone of gray in a print. To provide separation between the apples and leaves, you might shoot through a red filter. This would lighten the red apple in a print and darken the green leaves.

241

This photo shows the color and tone rendition of the original scene.

Exposed without a filter

Exposed through a No. 11 yellowish-green filter

Exposed through a No. 8 yellow filter

Exposed through a No. 15 deep-yellow filter

Exposed through a No. 25 red filter

242

EXPOSURE COMPENSATION WITH FILTERS

Since filters absorb some of the light that would normally reach the film, you must compensate by using a larger lens opening or a longer exposure time. Each color film has an ISO (ASA) speed for a particular filter which takes into account the exposure compensation. See the instructions packaged with the film. Just use the ISO (ASA) speed for the film and filter you're using on your exposure meter to determine the exposure.

Black-and-white films have a filter factor for each filter—a number that tells you how much more exposure you need with that filter. For example, a filter factor of 2 means that you need twice as much or 1-stop more exposure. You can either open the lens by 1 stop or use an exposure time twice as long. See the table on page 241 or the film instructions. Another way to apply the filter factor is to divide the film speed by the filter factor and then set the corrected speed on the film speed dial of your camera or your exposure meter.

Many cameras with built-in exposure meters measure the light through a filter when one is used over the camera lens. With most such cameras, you can set the film speed dial for the *speed of the film without a filter.* Then when you make the meter reading through the filter, the exposure compensation is made automatically. However, with some filters, this type of built-in exposure meter may require a correction in the film-speed setting to indicate the proper exposure. Check your camera manual for instructions on exposure with filters.

If your camera is manually adjustable with a built-in exposure meter that makes the reading through a filter you're using, there is a better method

Caroline Grimes

With a clear blue sky you can use a No. 25 red filter to produce a dark sky background for your subject. The No. 25 filter usually has a filter factor of 8 which requires an exposure increase of 3 stops depending on the film. See the instruction sheet packaged with the film.

that you can use with more precision to determine exposure. Make the meter reading *before* you put the filter over the lens. *With color film,* set the film speed dial for the *speed of the film with the filter;* then make the reading without the filter and use the camera settings indicated by the meter. *With black-and-white film,* first divide the speed of the film by the filter factor and set the corrected speed on the film speed dial. Then make the reading without the filter and use the camera settings indicated by the meter.

Marty Czamanske

For a stimulating, fresh approach to your picture-taking you can take advantage of filters and lens attachments to enlarge your creative experience. This picture was taken through a split-field sepia tone filter and vignetted by hand to frame the couple on the beach. Made on the Swedish coast with EKTACHROME 100 Film.

USING FILTERS AND LENS ATTACHMENTS FOR CREATIVE PICTURES

There are many dramatic effects you can obtain in your pictures by using filters and other lens attachments creatively. The use of color filters with color film can enhance or change the mood of a picture. You can use an orange or magenta filter to suggest rich, warm sunlight of late afternoon in your color pictures. With a blue filter you can portray the somber, cool effect of twilight or moonlight while the sun is

still above the horizon. You can also use filters of other colors depending on the effect you want to create. Just look through the filter for a preview of how the scene will look in the picture.

Determining the exposure is easy when you use filters to give the picture an overall cast of color. Since you are altering the appearance of the original scene and orange and blue filters are suggesting early or late times of day,

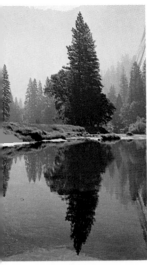 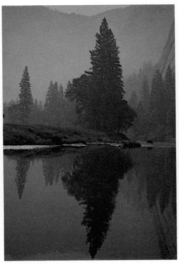 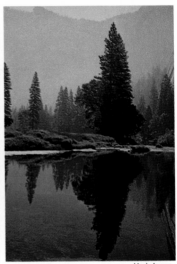

Normal scene— Blue filter Orange filter
no filter

You can use filters with color film to change the mood of a scene and its overall appearance. You can use a blue filter, such as a No. 80A filter, to suggest twilight of dawn or dusk or an orange filter, such as a No. 21 filter, to suggest the orange light from the setting sun. The hues of blue and orange filters seem to work best because these colors sometimes naturally appear to a limited extent during periods of dawn or dusk. As a result, scenic pictures with blue or orange tones are somewhat believable. KODACHROME 64 Film (Daylight)

the exposure is not critical. Less exposure, which results in darker pictures, implies dimmer lighting conditions while more exposure, which results in lighter pictures, implies brighter lighting conditions. Usually you can just follow the exposure indicated by a meter reading made through the filter. You may want to bracket your exposures so you have a choice of brightness in your pictures.

Most filters produce only one color. But there are also variable color filters available that let you adjust the intensity of the color from light to dark. Other variable color filters produce either of two colors or various shades in between, for example, yellow or red with shades of orange between the two extremes. Once you have a variable color filter adjusted for the color you want, you use it just like a conventional color filter.

You can obtain still other filters that are similar to conventional filters except that only half of the filter is colored while the other half is clear. This feature lets you change the color in only part of the scene, like the sky.

Rather than using color filters, you can use other kinds of filters over your camera lens for a different approach to creative pictures. These filters are constructed with various optical properties which produce effects such as diffusion, pointed star images, and streaks of light with bands of color in them. It's easy to use these filters because you can see the effects you'll obtain when you view the scene through the filter. When you use the filter over the lens on a single-lens reflex camera, you can see the effect through the camera viewfinder. With a camera that has a direct optical viewfinder (non-single-lens reflex), you'll have to view

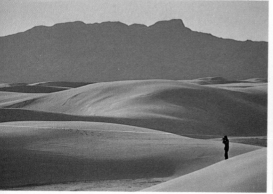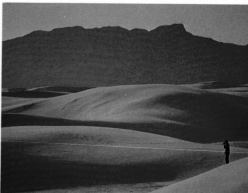

Herb Jones

An orange filter is good for scenes which include sand because this color effectively portrays the hot broiling rays of the sun. KODACHROME 64 Film (Daylight)

the scene through the filter first before putting it on your camera.

A diffusion filter will give you a soft-focus, diffused image which portrays a subdued dreamlike effect. These filters come in various degrees of diffusion which produce effects ranging from a slight haziness to pronounced diffusion with a misty appearance, soft highlights, and merging colors. Diffusion filters do not usually require any change in exposure unless you want to produce a light, misty, or fog effect with a minimum of dark tones. Then you should try from 1/3 to 1-stop more exposure depending on the degree of diffusion in the filter. See the manufacturer's instructions for your filters.

Star-effect filters produce pointed starlike images of light sources and specular reflections that look like points of light in the original scene. These filters create streaks of light that radiate outward from the point of light. You can get 4-, 6-, and 8-pointed stars depending on the construction of the filter. By rotating the filter, you can change the direction of the streaks of light. Usually no exposure increase is required.

A diffraction filter is another filter you'll find useful for creating pictures that are out of the ordinary. Diffraction filters separate the light from light sources and specular reflections in the picture into a rainbow of colors in exotic patterns. Diffraction filters are available from your photo dealer that form multicolored linear streaks of light in two, four, or several directions. Other diffraction filters form different multicolor patterns, such as a circular one. These filters too are easy to use since you can see the optical effect when you look through the viewfinder of a single-lens reflex camera with the filter over the lens. With nonreflex cameras, look at the scene through the filter while rotating the filter. When you see the effect you want, keep the filter oriented in that position as you put it on your camera. No exposure increase is required with diffraction filters.

For a different avenue to exciting and spectacular pictures, experiment with multi-image lenses. These lenses with multifaceted surfaces fit on the front of your camera lens. The facets produce multi-images of the scene repeated in a straight row or arranged in a circular pattern. The number of images transmitted to your film may be 3, 5, or 6. These variations in pattern and number of images produced depend

246

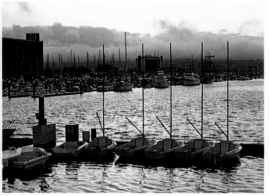

Here an orange filter has created the warm color of a setting sun. For exposure with the filter you can usually just go by the meter reading made through the filter. KODACHROME 64 Film (Daylight)

You can transform a gray, dreary overcast day into a bright, cheery one with an orange filter over your camera lens. KODAK EKTACHROME 200 Film (Daylight)

on the construction of the multi-image lens. You can rotate these lenses to obtain the most pleasing arrangement of the images in the picture. Since details surrounding the subject are also repeated, multi-image lenses work best with subjects against plain backgrounds like the sky, water, or a dark background with little detail.

The techniques for creative use of filters and lens attachments for intriguing pictures are limited only by your imagination. When you take creative pictures, there are no definite rules. Anything you find pleasing can be a rewarding picture. There are numerous variations of filter and lens attachments available so it's a good idea to explore the selection of this equipment at your photo store. If you want to learn more about the subject, you may want to purchase the KODAK Workshop Book *Using Filters* (KW-13), sold by photo dealers.

Neil Montan

Even though some colors produced by filters do not appear natural, it pays to experiment for rewarding, creative pictures. A deep-magenta filter was used for this after-sunset scene.

An orange filter over the camera lens and clever positioning of the subject's hands has created an eye-catching slide. KODACHROME 64 Film (Daylight)

Herb Jones

Patty Van-Dolson

A magenta filter is also a good choice for enhancing sunset pictures. Notice in this scene how orange, magenta, and purple tones have been recorded. Photographed through a KODAK Color Compensating Filter, CC40M, sold by photo dealers.

248

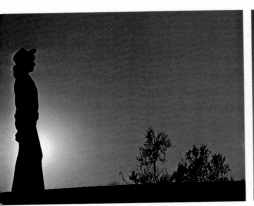

Herb Jones

For a surrealistic rendition, you can use a red No. 25 filter. The use of color filters to alter the normal appearance of the scene is more effective with backlighting, sunsets or sunrises, overcast skies, and misty or foggy days.

Neil Montanus

When you want just a slight amount of orange, you can use a No. 85 amber filter with daylight film.

You can use a deep-blue filter with a backlighted scene to create a moonlight effect. Try underexposing by 1 stop to produce the proper mood.

The atmosphere or mood suggested by an overcast day can be made even more somber when you photograph the scene through a blue filter.

Paul Kuzniar

Paul Kuzniar

250

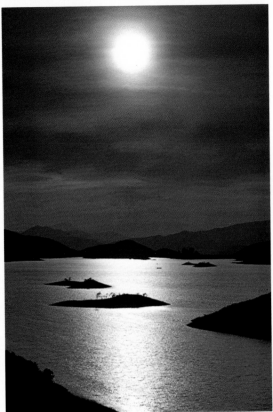

The appearance of the original scene has been altered only slightly by the use of a very faint, magenta filter—KODAK Color Compensating Filter, CC10M. KODACHROME 64 Film (Daylight)

Patty Van-Dolson

Only an orange filter was used for this picture. Compare the results here with the bottom photo.

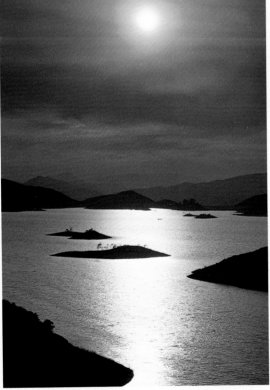

A No. 85 amber filter was used for the overall scene while an orange filter, such as a No. 21 filter, was used for only the top part of the picture from the horizon up. Photo dealers sell filters with the color in only half of the filter, the other half being clear. Or you can use a square piece of gelatin filter and hold it over part of your camera lens for the effect you want. You can see the results you'll get with a single-lens reflex camera when you look through the viewfinder with the filters in place.

A diffusion filter softens tones and produces haziness to give the scene a dreamlike quality when recorded on color or black-and-white film. You can improve informal portraits with a diffusion filter by reducing contrast and harshness which smoothes and flatters complexions. The amount of diffusion varies depending on the construction of the filter. A filter that produced minimum diffusion was used to make the illustration above. Below, a different filter produced a greater degree of diffusion.

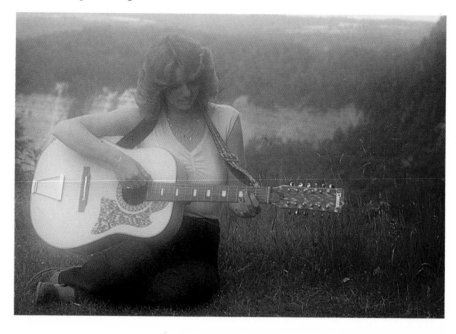

Herb Jones

Herb Jones

Herb Jones

A fog filter—a diffusion filter which gives a mist effect—with the backlighting of a late afternoon sun produced these rewarding slides. KODACHROME 64 Film (Daylight)

With star-effect filter Without filter

A star-effect filter creates starlike images of point-light sources. Tivoli Gardens, Copenhagen, Denmark

You can make some night scenes more interesting by using a star-effect filter. Usually no exposure increase is required with this filter. KODAK EKTACHROME 400 Film (Daylight)

The spectacular lighting used to illuminate performers often presents a good opportunity to improve the lighting effects even more by using a star-effect filter. Damascus Temple, Shrine Circus

A star-effect filter is particularly effective for outdoor night scenes. Compare this result with the top picture on page 228.

A starlike image of the sun masked by trees was produced by a star-effect filter. KODACHROME 64 Film (Daylight)

You can use a star-effect filter to create rays from the setting sun which can make a sunset picture even more appealing. Rio de Janeiro, Brazil, KODACHROME 64 Film (Daylight)

A star-effect filter will also create star-ray images from specular reflections in the scene.

Steve Kelly

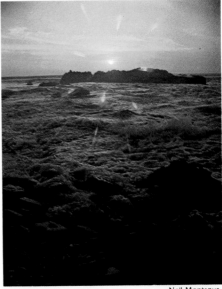

Neil Montanus

Diffraction gratings produce various multicolored patterns depending on the filter. For you to see the effect, the scene must include a light source or specular reflections. You don't have to change the exposure for this filter.

Herb Jones

The photographer recorded an interesting light fixture with a diffraction grating over the camera lens which produces a vertical color pattern. In the slide on the bottom, he combined a star-effect filter with the diffraction grating for an even more bizarre result. KODAK EKTACHROME 400 Film (Daylight)

When you see a photogenic light source that may be a good opportunity for an exciting picture with a diffraction grating filter, you can see the result you'll get by looking through the diffraction filter. You can rotate the filter to change the position of the pattern for the most pleasing arrangement.

Don Maggio

A multi-image lens repeats the image of the scene in a circular or straight-line pattern. The design of the multi-image lens determines the shape of the pattern it makes.

Jerry Antos

To use a multi-image lens, you fit it over the front of your camera lens. You can rotate the multi-image lens to position the images for the composition you like best. These lens attachments do not require any exposure compensation.

Herb Jones

A multi-image lens has generated a kaleidoscope-like image of this colorful neon sign.

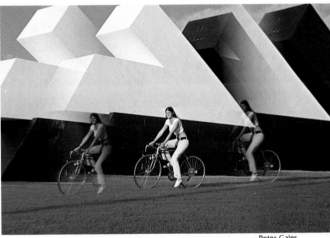

Peter Gales

It's best to photograph subjects with a plain or simple background with a multi-image lens. Otherwise too much detail in the background will be confusing when the image is repeated.

The world of close-up photography lets you show the intricate detail of small subjects.

CLOSE-UP PHOTOGRAPHY

Most 35 mm cameras will focus on subjects as close as 1½ to 2 feet without any special equipment. Although this is close enough for many subjects, you can find a whole new world of fascinating and unusual picture opportunities at closer distances. With close-up equipment, you can take compelling photographs of flowers, small animals, insects, coins, stamps, and scale models and more. You can make tabletop pictures and copies of pictures or documents. The world of close-up photography can keep your imagination occupied for some time.

CLOSE-UP LENSES

You can get into the close-up league with *any* camera simply by using close-up lenses. These are positive supplementary lenses that let you take sharp pictures at distances closer than those at which your lens would normally focus. Close-up lenses fit over your camera lens like a filter. They're available in different powers such as +1, +2, and +3. Each close-up lens is good for a limited range of close-up distances. The higher the number, the stronger the close-up lens and the closer you can get to your subject. The instructions that come with the lenses tell you what your subject distances should be at various focus settings and what area you'll be photographing at those distances.

You can use two close-up lenses together to get even closer to your subject. For example, a +2 lens and a +3 lens equals a +5 lens. Always use the stronger close-up lens next to the camera lens. Never use more than two close-up lenses together since this may affect the sharpness of your picture.

One benefit you have when you use close-up lenses is that no exposure compensation is necessary. Just expose as you would if you were photographing the same subject without a close-up lens.

An easy way to get into close-up photography is to use close-up lenses. You can use them with both rangefinder and single-lens reflex cameras. Close-up lenses fit on the front of the camera lens in the same way as a filter.

Close-up lenses are convenient to carry with you when you take pictures so they're available whenever you see a good subject for close-ups.

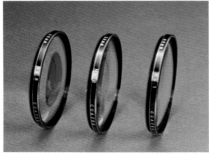

Close-up lenses are made in various powers. The higher the number, the greater the magnification of the subject. These lenses are light, compact, and relatively inexpensive. The image quality they produce is acceptable but not as good as that of camera lenses specially designed for optimum close focusing. Therefore, you'll get better sharpness if you use lens openings of f/8 and smaller when you use close-up lenses. You'll also obtain better depth of field using a small lens opening.

A close-focusing camera lens lets you take close-up pictures without using close-up lenses or lens-extension devices. Close-focusing lenses focus at shorter camera-to-subject distances than normal lenses.

The requirements for a steady camera for sharp close-up photography are similar to those for telephoto lenses. Since the image is magnified in close-ups, so is any unsharpness caused by an unsteady camera. You should use a shutter speed of at least 1/125 second or higher for sharp pictures with a handheld camera. A high shutter speed is also beneficial for stopping subject motion like live subjects or plants disturbed by a breeze.

You'll get better pictures of close-up subjects near the ground if you take your pictures from a low camera angle. Since framing the subject in the viewfinder and focusing are more critical for close-ups, a tripod that will hold your camera firmly in the right position is a big help.

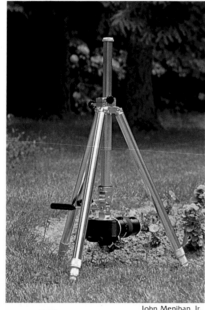

To hold your camera steady near ground level you need either a tripod that will adjust for low camera angles or a miniature tripod. Some tripods, such as the one shown here, have a center column that you can reverse which lets you position your camera at a low level.

CLOSE-FOCUSING LENSES

Some lenses, called macro or micro lenses, are designed for close-up photography. They let you focus as close as 4 or 5 inches and obtain life-size images on your film without using a supplementary close-up lens. These lenses are convenient because you can use them for close-ups and normal subject distances all the way to infinity without special attachments.

Close-focusing lenses require an exposure increase at the close subject distances. Sometimes the exposure compensation for different subject distances is marked on the lens barrel. If you use a close-focusing lens on a camera with a through-the-lens exposure meter, the meter will make the exposure compensation automatically. But if you use a separate exposure meter or flash, you'll have to make the exposure compensation yourself. If the exposure compensation is not marked on the lens you'll have to determine it. See the methods described under Lens-Extension Devices.

Patty Van-Dolson

Flowers with their colorful natural beauty are appealing subjects for close-ups. Photographing close-up subjects in bright sunshine helps produce brilliant colors and lets you use a small lens opening for improved sharpness and depth of field.

Beads of dew on flowers add sparkling highlights to Nature's colors. If there is no dew naturally present, you can add it yourself from an atomizer bottle of water. This is a useful aid to have along for close-up flower photography.

Barbara Jean

263

There are many varied subjects that make good close-up pictures like this kachina doll. The photographer positioned the doll in the soft light of open shade. A *slight* amount of weak sunlight filtered by trees adds highlights to the feathers on the doll. KODACHROME 64 Film (Daylight)

Gary Whelpley

Herb Jones

Bob Clemen

Learn to look at small segments of the overall scene for eye-catching close-up pictures.

Herb Jones

Existing light, especially existing daylight, is excellent lighting for close-up subjects. The sunlight on the carvings is from a nearby window. KODAK EKTACHROME 200 Film (Daylight)

Watch the background for close-up subjects so it doesn't become too busy. The translucent quality of the backlighting in this photo helps separate the blossoms from the background, but the background detail is still confusing.

If the background is too cluttered, you can use a black cloth or a piece of black cardboard behind your subject for a dark, unobtrusive background.

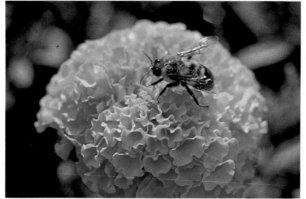

You can take extreme close-ups with an extension tube or bellows to extend the lens.

Norm Kerr

A bellows unit, shown here, or extension tubes provide another method of taking close-up pictures. These devices fit between the camera body and the camera lens. They extend the lens-to-film distance to permit close focusing. Depending on the lens extension you use, you can obtain image sizes larger than life size with this equipment.

Jerry Antos

When you use an extension tube or bellows to extend the lens, an increase in exposure is necessary. If your camera has a through-the-lens exposure meter that will make the meter reading with a lens extension device attached to the camera, the exposure increase will be made by the meter.

John Fish

LENS-EXTENSION DEVICES

Another common method of taking close-up pictures involves extension tubes or a bellows. Such a device fits between the lens and the camera body to let you make sharp pictures at close distances. Since an extension device fits between the lens and the camera body, it can be used only on a camera with interchangeable lenses that is designed to accept the tubes or a bellows.

Since the tubes or a bellows moves the lens farther from the film than it would be for normal picture-taking, you must compensate for the light loss by using a larger lens opening or a slower shutter speed. Some cameras do this automatically. Check your equipment instruction manuals. The longer the extension, the greater the exposure increase must be. The *KODAK Master Photoguide* (AR-21)

includes a Lens-Extension Exposure Dial that will tell you how much exposure compensation is necessary with lens-extension devices. This is helpful when you're using an exposure meter that does not make the meter reading through the lens or when you're using flash so that you have to apply the exposure compensation manually. You can also use the table on the next page to find how much you need to increase exposure when you use a lens-extension device with a 35 mm camera.

Some automatic electronic flash units that are specially designed for certain camera models are controlled by the light from the flash reflected by the subject coming through the camera lens. These camera/flash combinations automatically determine flash exposure with lens extension devices. See your equipment manuals.

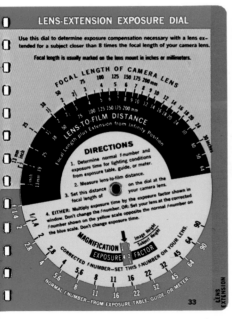

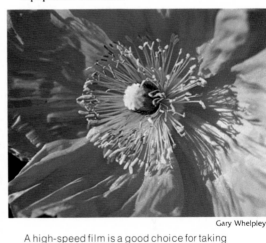

Gary Whelpley

If your exposure meter does not make the reading through the lens, such as a hand-held meter, or if you're using flash you must make the exposure compensation manually when you use a lens extension device on your camera. This calculator dial included in the *KODAK Master Photoguide* (AR-21) provides an easy-to-use method of determining the necessary exposure compensation.

A high-speed film is a good choice for taking pictures with an extension tube or bellows attached to your camera. The high film speed allows both a high shutter speed and a small lens opening for improved sharpness and depth of field. The larger the magnification of the image, the higher the shutter speed required for handholding your camera. For life-size images and larger magnifications, shutter speeds of 1/250 second and higher are necessary. KODAK EKTACHROME 400 Film (Daylight)

Exposure Increase for Extended Lens—35 mm Cameras with Lens of Any Focal Length								
Field Size Long Dimension (inches)	11	5⅛	3¼	2¼	2	1¾	1⅜	1
Open Lens by (*f*-stops)	⅓	⅔	1	1⅓	1½	1⅔	2	2½
Or Multiply Exposure Time by	1.3	1.6	2	2.5	2.8	3.2	4	5.7

To use the table:

1. Measure the field size—long dimension for 35 mm—at the subject distance you've focused upon.

2. Increase the lens opening by the amount shown, **or**

3. If you want to keep the lens opening constant, multiply the exposure time by the amount shown.

FOCUSING AND FRAMING

When you look through the viewfinder of a single-lens reflex camera, you're viewing the subject through the picture-taking lens, so you see the same area that will be recorded on the film. When the image looks sharp, you know your subject is in focus. For extreme close-ups, it may be easier to move the camera or the subject slightly closer or farther apart rather than to focus with the lens.

However, when you take extreme close-up pictures with a camera that has a direct optical viewfinder, you must measure the subject distance accurately to get sharp pictures. Also, the viewfinder doesn't show exactly what will be in the picture. This phenomenon called parallax occurs because the viewfinder and the taking lens are separated. You can correct for parallax by tipping the camera slightly in the direction of the viewfinder. Tip the camera until you can see about 10 percent more area at the edge of the viewfinder than you want to include in your picture.

FOCUSING AND FRAMING DEVICE

You can make a simple focusing and framing device for use with cameras that have direct-optical viewfinders. This device indicates the proper subject distance and the area that will be included in the picture at that distance.

All you need are a few minutes and a piece of cardboard. You can find the subject distance, A in the illustration, and the field size, B in the illustration, in the instruction sheet for the close-up lens or lens-extension device. Then cut the cardboard as shown and draw a line down the center. Each close-up card you make will be good for only one subject distance. To take the picture:

1. Hold the centerline of the cardboard at the center of the close-up lens, with the cardboard straight out from the camera.

2. Move in until the edge of the card touches your subject and your subject fits within the width of the card.

3. Drop the card and take the picture.

Most close-up lens instructions give distances to set on the lens focusing ring of a direct-optical viewfinder camera. Each different distance set on the lens corresponds to a different close-up distance depending on the power of the close-up lens. With an autofocus camera, use the focus-lock feature to lock the focus at infinity on a distant subject. Then use the distance in the close-up lens instructions that corresponds to the infinity setting.

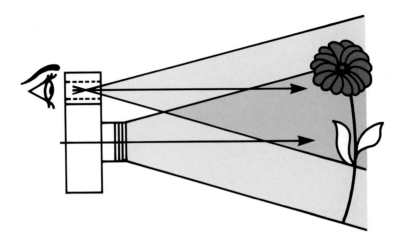

When you take close-up pictures with close-up equipment attached to a camera that has a direct optical viewfinder, the viewfinder doesn't show exactly what will be in the picture. This effect is called parallax.

Focusing and Framing Device

A Subject distance

B Width of the area included in the picture at subject distance A

Since you can't frame the subject accurately for close-ups through the direct optical viewfinder of a range-finder camera, a cardboard framing device will help you take the picture. Line up the card with your camera lens and subject. Hold the camera in position, drop the card, and take the picture.

John Menihan, Jr.

DEPTH OF FIELD IN CLOSE-UPS

No matter what method you use to make your close-up pictures, you'll find that depth of field is very shallow. Since small lens openings increase depth of field, it's a good idea to use the smallest lens opening that the lighting conditions allow. For optical as well as depth-of-field considerations, it's wise not to use lens openings larger than $f/8$ with $+1$, $+2$, and $+3$ close-up lenses or larger than $f/11$ with more powerful lenses. You can compute depth of field for $+1$, $+2$, and $+3$ close-up lenses with the Depth-of-Field Computer in the *KODAK Master Photoguide.*

Robert Holland

The out-of-focus background, which resulted from taking a close-up, gives a three-dimensional appearance by making the subject stand out against the blurred tones behind it.

Paul Yarrows

The soft blur of color in the background resulting from shallow depth of field harmonizes nicely with this nature subject.

Depth of field is quite shallow for close-ups, so focus carefully and use the smallest lens opening that the lighting conditions will allow. The high speed film—ISO (ASA) 400—let the photographer use a high shutter speed so he could handhold his camera

Robert Fish

LIGHTING FOR CLOSE-UPS OUTDOORS

For most of your outdoor close-ups you'll probably use the natural lighting on the subject. If part of your subject is in sunlight and part in shadow, you can use a reflector, such as crumpled aluminum foil or white cardboard, to reflect the sunlight into the shadow areas.

Backlighting and sidelighting can be quite effective for making close-ups of subjects like flowers and foliage. These types of lighting bring out the texture and emphasize the translucency and delicate qualities of such subjects.

Many advanced photographers like to use flash for their outdoor close-ups. Flash close to the subject allows you to use small lens openings to get the depth of field you need for close-ups. A camera and flash combination that lets you take flash pictures at fast shutter speeds—electronic flash at X sync, focal-plane bulbs at FP sync, or regular flash at M sync, depending on your equipment—offers several other advantages. Using a combination of a fast shutter speed and small lens opening with flash lets the background go very dark because there is so little exposure from the daylight. You can use this technique to tone down a distracting background or to photograph a bright, colorful subject against a dark background. Shooting at fast shutter speeds also minimizes subject movement, such as the swaying of flowers on a breezy day.

When you make extreme close-ups with flash it simplifies exposure calculation if you can use your flash off the camera, always at the same distance from the subject. Then regardless of your subject distance, your basic flash exposure with a specific film and flash combination will always be the same. Keep in mind, however, that a dark subject, such as a black woolly caterpillar, requires more exposure than a light subject, like a moth with white wings.

If you can't use an extension flash to move the flash farther away from the subject, don't use regular guide numbers to calculate exposure for close-ups. The inverse-square law, on which guide numbers are based, doesn't work when the flash is used at extreme close-up distances. You can use the table on page 276 as a guide in determining exposure for close-up flash pictures with color film. Or you may want to run your own exposure tests to determine the best exposure setting for your film and flash combination at various subject distances. Make exposures at half-stop increments from $f/8$ to $f/22$. Use one layer of white handkerchief over the flash to diffuse the light and to reduce its intensity. Keep a record of your exposures so that you can determine which lens opening produced the best exposure. Use that lens opening for any close-up pictures taken from the same subject distance.

If you're using an automatic electronic flash for close-up pictures, you may be able to let it determine the exposure automatically or you may have to use it on the manual setting, depending on the flash-to-subject distance. See your flash instruction manual. In order to use the flash unit on automatic, it may help to cover the flash reflector with one layer of handkerchief. Make sure though, that the handkerchief does not cover the light-sensitive cell in the flash unit. It's a good idea to take some trial pictures to see if your automatic electronic flash will produce good exposure for close-ups. If the trial pictures are too light —overexposed—use a smaller lens opening; if they are too dark—under-exposed—use a larger lens opening.

You can usually rely on frontlighting from sunlight to give you good close-up photos. You'll get better modeling on your subjects if you use a camera angle where the sun is off to the side at approximately a 45-degree angle. The highlights and shadows from this 45-degree lighting help give the picture a three-dimensional quality.

The photographer moved around the flower to get backlighting from the sunlight. Backlighting is very effective for flower photography. Compare the lighting here with that in the photo on the left.

The cactus spines, highlighted by backlighting, stand out in sharp relief against the shadowed background.

If this foliage had been photographed with frontlighting, the picture would be just ordinary. But the sunlight filtering through the green leaves has brightened them considerably and contributed to an attractive design with a plain dark background.

Herb Jones

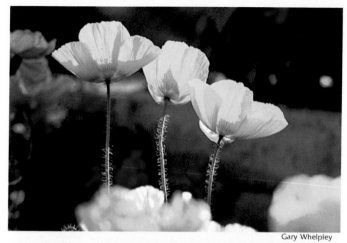

KODAK EKTACHROME 400 Film (Daylight)

Gary Whelpley

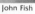

Backlighting brings out the texture and emphasizes the delicate, translucent quality of the flowers. KODACHROME 64 Film (Daylight)

John Fish

Art Trimble

Sidelighting combines some of the qualities of both frontlighting and backlighting. When the lighting comes from the side, it forms highlights similar to those from frontlighting on the side of three-dimensional subjects near the light source and shadows similar to those from backlighting on the opposite side of the subject. Sidelighting has the advantage of causing only part of the subject facing the camera to be in shadow.

Herb Jones

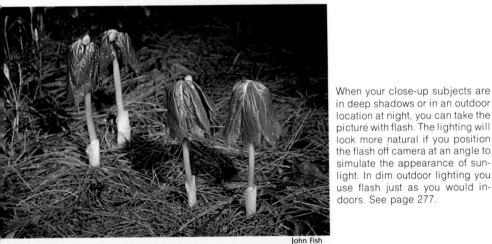

When your close-up subjects are in deep shadows or in an outdoor location at night, you can take the picture with flash. The lighting will look more natural if you position the flash off camera at an angle to simulate the appearance of sunlight. In dim outdoor lighting you use flash just as you would indoors. See page 277.

John Fish

Electronic flash is excellent for close-ups of live subjects to stop motion. Outdoors though, your subject must be in dim lighting, such as in deep woods, in order to use electronic flash to stop the action. Dim light is necessary so the flash will overpower the natural lighting and become the main light source. Determine the exposure the same way as you would indoors.

Tom R. Johnson, KINSA

275

LENS OPENINGS FOR CLOSE-UPS WITH FLASH (See instructions at right.)

| Type of Flash with one layer of handkerchief | Lens Opening* | |
	Subject Distance 10—20 inches	Subject Distance 30 inches
ELECTRONIC FLASH For manual electronic 700—1000 BCPS flash units and 1400—2000 BCPS automatic electronic 2800—4000 BCPS flash units set 5600—8000 BCPS on manual.	$f/11$ $f/16$ $f/22$ $f/22$ with two layers of handkerchief	$f/8$ $f/11$ $f/16$ $f/22$
FLASHBULBS Flashcube AG-1B, shallow cylindrical reflector	$f/16$	$f/11$
HI-POWER FlashCube AG-1B, polished bowl reflector M2B, polished bowl reflector	$f/22$	$f/16$
M3B, 5B, or 25B, polished bowl reflector 26B, polished bowl reflector, focal-plane shutter	$f/22$ with two layers of handkerchief	$f/22$

*For very light subjects, use 1-stop less exposure or place two layers of handkerchief over the flash reflector.

Note: If your flash manual provides only a guide-number measure of flash output, use the table on p. 108 to convert your guide number into BCPS.

Patty Van-Dolson

The soft lighting from overcast days is good for nature pictures. With this shadowless lighting, you don't have to concern yourself with the possibility of confusing shadows in the background.

Patty Van-Dolsc

When the sky is overcast, you can use flash to add brilliance to the colors of your subject. Set your camera shutter speed and lens opening the same way as for indoor close-up pictures with flash. Since the flash is so close to the subject you'll be able to use a small lens opening which increases depth of field. The photographer used a piece of black cloth to isolate the blossom from the background. Compare this shot with the one on the left.

276

FLASH EXPOSURE INFORMATION FOR CLOSE-UPS

This table applies directly to KODACHROME 64 and KODACOLOR VR 100 Films. Put one layer of white handkerchief over the flash. If you use KODAK EKTACHROME 100 Film (Daylight), set a lens opening 1 stop smaller than the table indicates or add an extra layer of handkerchief. If you use KODACHROME 25 Film (Daylight), set a lens opening 1 stop larger than the table indicates. With electronic flash and a focal-plane shutter, use the shutter speed recommended in your camera manual; with a between-the-lens shutter, use any shutter speed recommended for flash. With flashbulbs, use a shutter speed of 1/30 second.

LIGHTING FOR CLOSE-UPS INDOORS

While your outdoor close-up pictures might be of moving subjects, such as butterflies or buttercups swaying in the breeze, chances are that indoors you'll be photographing objects like coins, model cars, and still-life setups. Since you don't need to be concerned with stopping action with this type of subject, short exposure times and bright flash aren't necessary. Consequently, you can use photolamps including spotlights to see the effect of the lights on your subject *before* you take the picture. These lamps are sold by photo dealers.

If you're using color-slide film balanced for 3400 K illumination, such as KODACHROME 40 Film 5070 (Type A), you should use 3400 K photolamps. If the film is balanced for 3200 K tungsten illumination, such as KODAK EKTACHROME 160 Film (Tungsten), you should use 3200 K tungsten lamps. You can also use each of these films with both 3400 K and 3200 K light sources when you use the appropriate filter. See the table that follows this section.

When you take close-up pictures with flash, guide numbers are no longer valid. They will not indicate the correct exposure. Try the lens openings given in the table on the opposite page. With automatic electronic flash, see the flash instruction manual. You may have to use the unit on manual with the camera lens opening suggested in the table given here.

For this photo the photographer used his electronic flash unit off the camera, low, with the flash aimed up to illuminate the details underneath the flower blossom.

Robert Kretzer

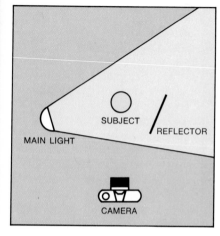

SUBJECT

MAIN LIGHT

REFLECTOR

CAMERA

Ray Cooper

Photolamps are convenient to use for indoor close-up subjects because you can see the lighting effects before you release the shutter. Another benefit is that you can use your exposure meter to determine the exposure. You don't have to have a complicated lighting arrangement to get good pictures. A simple one-light setup was used to photograph this toy soldier. The light was higher than the camera, off to the side at about a 60-degree angle to the camera-subject axis. A small reflector, similar to the one on page 223, was used on the right side to bounce light into the shadows. Reflectors are easy to use for close-up pictures because you can place them fairly close to the subject without seeing them in the picture.

With KODACOLOR VR Films and daylight-type color-slide films, you can use either 3400 K photolamps or 3200 K tungsten lamps when you use the filter recommended in the table. When you want to take black-and-white pictures, you can use either light source with no filter.

You can take fine indoor close-ups by using only one, two, or three photolamps. The diagrams above and on the following pages illustrate some basic lighting setups.

When you want to emphasize the contours and shape of a subject, you can photograph the subject against a relatively dark background and rimlight

it by placing lights slightly behind the subject. When you do this, make sure the camera lens is shielded from the direct light of the lamps. You can emphasize surface textures by skimming the light across the surface of the subject.

When you make a reflected-light exposure-meter reading of a small subject, the meter reading will be influenced by a bright or a dark background. For this reason, it's a good idea to make reflected-light readings from a KODAK Gray Card. Or you can use an incident-light exposure meter to make a reading from the subject position.

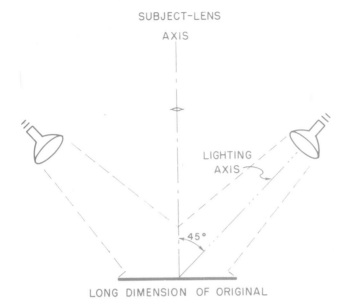

SUBJECT-LENS AXIS

LIGHTING AXIS

45°

LONG DIMENSION OF ORIGINAL

STANDARD SETUP

Use two photolamps to copy flat objects like stamps or paintings.

FILTERS AND ISO (ASA) FILM SPEEDS FOR PHOTOLAMPS

KODAK Color Film	3400 K Photolamps	3200 K Tungsten Lamps
KODACHROME 40 5070 (Type A)	None **40**	No. 82A **32**
EKTACHROME 160 (Tungsten)	No. 81A **125**	None **160**
KODACOLOR VR 100 KODACOLOR VR 200	No. 80B **32** **64**	No. 80A **25** **50**
KODACOLOR VR 400 KODACOLOR VR 1000	No. 80B **125** **320**	No. 80A **100** **250**
KODACHROME 25 (Daylight)	No. 80B **8**	No. 80A **6**
KODACHROME 64 (Daylight)	No. 80B **20**	No. 80A **16**
EKTACHROME 100 (Daylight)	No. 80B **32**	No. 80A **25**
EKTACHROME 200 (Daylight)	No. 80B **64**	No. 80A **50**
EKTACHROME 400 (Daylight)	No. 80B **125**	No. 80A **100**
EKTACHROME P800/1600 Professional (Daylight)	No. 80B **250*** **500****	No. 80A **200*** **400****

*With ESP-1 Special Processing (Push 1)
**With push processing (Push 2) available from your photo dealer.

Use close-up techniques to create titles for slide shows. This subject was made by laying clear acetate with transfer letters over an 8 x 10-inch enlarged aerial of Stockholm, Sweden. Two 3200 K tungsten lamps (one on each side) held at 45° angles to the subject provided relatively glare-free illumination while a polarizing filter helped to eliminate reflections and tone down the highlighting of dust specks and minute scratches in the acetate. Made on EKTACHROME 160 Film (Tungsten).

Sometimes you can use the existing lighting for a close-up view of a fascinating activity, such as this model ship nearing completion for insertion into a bottle. The photographer took the picture on KODAK EKTACHROME 160 Film (Tungsten) which was appropriate for the existing tungsten lighting over the workbench area.

This hand-crafted jewelry was photographed in the existing lighting of the craftsman's workshop. The lighting is a combination of the tungsten lighting from the overhead shop lights and daylight on the front of the objects from a window behind the photographer. KODAK EKTACHROME 400 Film (Daylight)

You can also use outdoor lighting to photograph close-up subjects that you normally expect to see indoors. Here this gem display was illuminated by the shadowless lighting of an overcast sky.

The pottery was photographed outdoors under a weak hazy sun. A piece of red cloth draped over a table and up over a fence behind the table forms the colorful background.

281

It's easy to use photolamps to illuminate three-dimensional subjects like a flower arrangement. You can make the lighting as simple or elaborate as you want. These are only basic lighting setups. You can move the lights to illuminate your subject to suit your needs or personal taste.

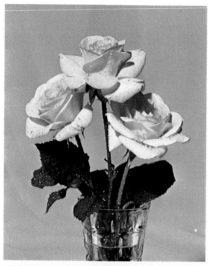

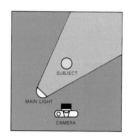

This picture was taken with just one light, the main light close to the subject, higher than, and away from the camera position.

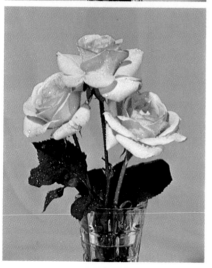

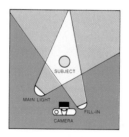

A second light was added as a fill-in for this photo to lighten the shadows. The fill-in light was placed near the camera position at the same height as the camera, but on the opposite side from the main light.

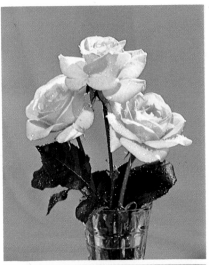

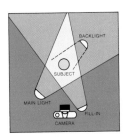

In addition to the main light and fill light, a backlight was used here to put rim-lighting on the rose petals. The backlight was placed high behind the subject, somewhat off to the side.

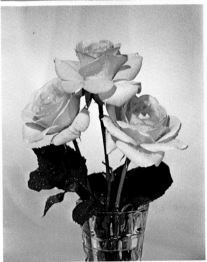

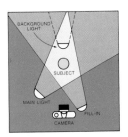

If you have only three lights, instead of using a backlight you can use the third one to brighten the background which helps separate the flowers from it. The background light should be close enough to the background to lighten it but not so close as to overexpose it so that the background looks too light in the picture.

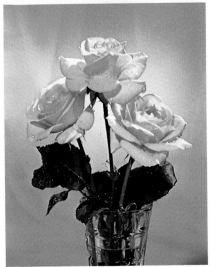

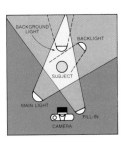

With four lights, the subject can benefit from both backlighting and a background light.

John Menihan, Jr.

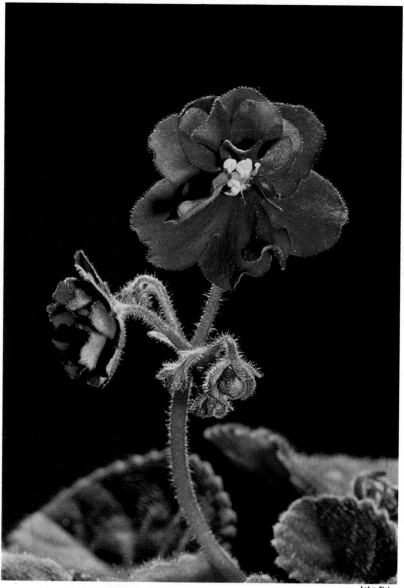

John Fish

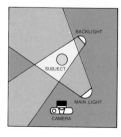

This exquisite shot shows what you can do with just two lights. A main light illuminates the front of the subject while a backlight creates rim-lighting which emphasizes the hairlike detail of the plant so effectively.

INDEX

285

The Kodak materials described in this book are available from those dealers normally supplying Kodak products. Other materials may be used, but equivalent results may not be obtained.

Eastman Kodak Company

KODAK Guide to 35 mm Photography
KODAK Publication **No. AC-95S** Paperback

CAT 112 0005 Paperback

Rochester, New York 14650

Revision 10-84-FX Printed in U.S.A.

ISBN 0-87985-347-6